The Traveling Photographer

A Guide to Great Travel Photography

rockynook

Sandra Petrowitz (www.sandrapetrowitz.com)

Editor: Joan Dixon
Project Editor and Copyeditor: Jocelyn Howell
Proofreader: Sue Irwin
Translator: David Schlesinger
Layout: Jürgen Gulbins
Cover Design: Helmut Kraus, www.exclam.de
Cover Photo: Sandra Petrowitz
Printer: Friesens
Printed in Canada

ISBN 978-1-937538-33-0

1st Edition
© 2014 by Sandra Petrowitz

Rocky Nook Inc.
802 East Cota St., 3rd Floor
Santa Barbara, CA 93103
www.rockynook.com

Copyright © 2012 by dpunkt.verlag GmbH, Heidelberg, Germany.
Title of the German original: Reisefotografie
ISBN: 978-3-86490-028-0
Translation Copyright © 2014 by Rocky Nook. All rights reserved.

Library of Congress Cataloging-in-Publication Data

Petrowitz, Sandra.
The traveling photographer : a guide to great travel photography / by Sandra Petrowitz.
 pages cm
ISBN 978-1-937538-33-0 (softcover : alk. paper)
1. Travel photography. 2. Photography--Technique. I. Title.
 TR790.P485 2013
 770--dc23

 2013026817

Distributed by O'Reilly Media
1005 Gravenstein Highway North
Sebastopol, CA 95472

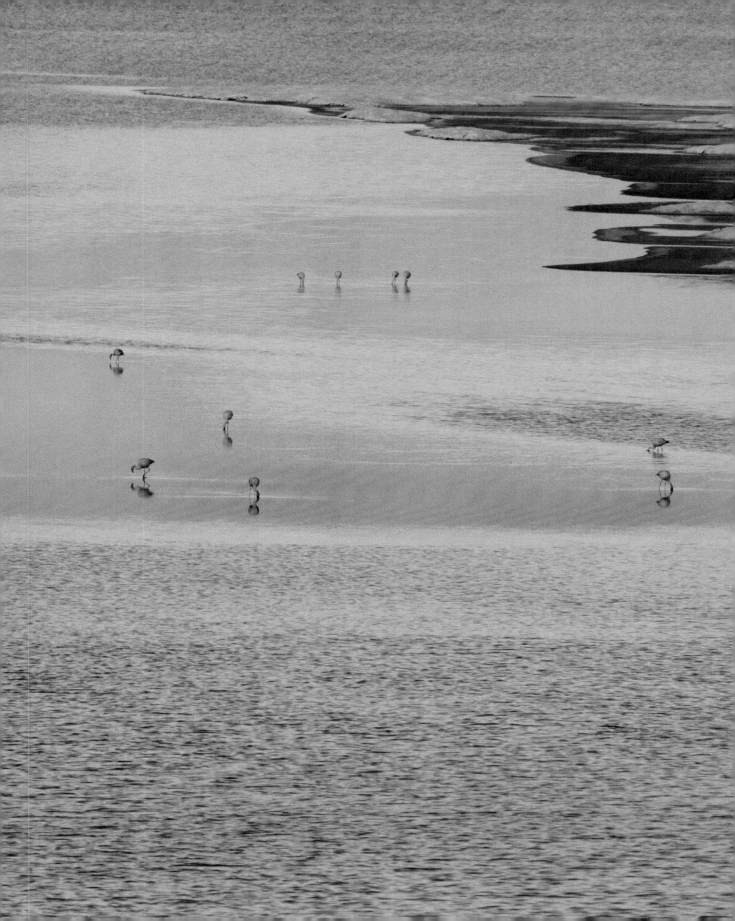

Contents

Foreword 6

1 On Traveling and Photographing 8
Take Your Time

2 From Conventional To Unique 16
Commonplace Photos and Your Own Point of View

3 Off Center 30
Why Subjects Should Move a Bit to the Side

4 Into the Picture 38
Subjects Need Their Space

5 The Benefits of a Foreground 48
On the Search for the Third Dimension

6 The Diagonal 58
Embracing the Slant

7 Horizon 64
So Nothing Goes Askew

8 A Matter of Perspective 68
Down Low or Up High

9 Everything Is Relative 79
A Sense of Scale

10 Ninety Degrees More or Less 84
The Underrated Portrait Format

11 Less Is More 92
On Photographic Minimalism

12 Opening Up 100
About Photographing People

13 Fill Flash 112
Preventing Shadows from Stealing the Show

14 In the Best Light 118
Early Mornings and Late Evenings

15 There's No Such Thing as Bad Weather 133
It's Just Rain, Fog, Snow, Storms…

16 Tell It Like It Is 142
The Value of Documentary Images

17 The Small Traps 146
A Plea for Concentration

18 On To Something New 153
Seven Tips for More Variety

19 Get To Know Your Camera 161
Exposure Modes, Metering, Focus

20 Equipment 174
Cameras, Lenses, and Filters for the Road

21 Steady Now 186
The Need for Stability: Tripods & More

22 Better Safe Than Sorry 197
Transporting and Protecting Photographic Equipment

23 Safeguarding Data 206
Image Backup While Traveling

24 There Is Life Without a Camera 213
Why You Shouldn't Take Pictures If You Don't Feel Like It

25 Further Reading 214

Thanks 218

Index 219

Foreword

Traveling and photography go hand in hand – you're never at a loss for subjects worthy of your attention. But it can be challenging to take pictures that stand apart from the familiar views of famous sites and attractions and to create images with your own accent.

The goal when photographing your travels is to create a picture that captures not only what you saw, but also how you saw it and what you felt at the time. Only these creative and personal elements – your personal concept, perspective, angle of view, composition, and emotions – will transform a plain visual reproduction into a unique photograph that exhibits your personal style.

This book is not an instruction manual for a camera nor is it a travel guide, but it does serve well as a complement to both. It's intended for anyone who is interested in advancing his or her photographic craft or who is looking for ways to create different, distinct, or better images. While this book is primarily directed toward beginning and intermediate photographers, those who aren't satisfied with their travel photography or who are looking for suggestions on what to do differently will find it useful as well.

The following pages contain tangible recommendations for what to do when you're out and about – whether for a brief trip in the city, an extended tour of a foreign country, or a weekend trip with friends – to arrive at better pictures with simple equipment and little effort. The tips presented here are first and foremost steps to develop a conscious method of photography. If you take some time to consider why and how to take a picture, you won't snap away without purpose. Often it's this indiscriminant torrent of snapshots that prevents you from achieving truly attractive and well-composed pictures.

Therefore, image composition and design is a big part of this book. I found it important to provide advice that is useful regardless of the type of camera you're using and that doesn't require you to purchase extra equipment. Whether you use a compact camera that fits nicely in your pocket or

an advanced digital single-lens reflex camera, if you enjoy traveling and taking pictures, you'll find countless recommendations, suggestions, and ideas for taking pictures while traveling on the following pages.

I hope you enjoy this book and your trip and, above all, I hope that you take pleasure in your photography wherever and whenever you reach for your camera. This is, and always will be, the most important prerequisite for creative, outstanding pictures.

Sandra Petrowitz

1 On Traveling and Photographing

Take Your Time

At first glance, photography and traveling are a match made in heaven. What could be more perfect than capturing what you see and experience on your journey, both for yourself and for the people at home? It can be exciting and at the same time relaxing to take your favorite hobby with you to locations you've never visited before, where a fascination with the unknown and the magic of first encounters propels you onward. As photographers, who among us is not thrilled to use our camera to discover new worlds and energized when searching for new subjects and perspectives?

A closer look at the relationship between traveling and photography, however, reveals a potential for tension: travelers are always on the move. Taking a picture requires pausing, if only for a brief moment. A traveler generally wants to see as much as possible – a quest that's limited by the time spent on location. A photographer, on the other hand, is interested in stopping, observing, waiting to discover and acquire a picture and the perfect moment for it. Good, creative, unique images rely to a large degree on a question of time. And time is something that you have to allow yourself.

With this in mind, the first and maybe most important piece of advice for improving your images is simply to give yourself some time. Your pictures will thank you for it.

A few extra moments are enough to allow you to evaluate and improve the camera's settings and your composition. Taking a few minutes to chat with someone before photographing him or her will better your chances of capturing a great portrait. An anonymous snapshot taken in passing leaves neither side satisfied. The subject will feel strangely targeted and reduced to a photographic object, and you'll know (or suspect) that you would have been able to produce a better photo with a little more effort. A few extra minutes will also give you time to search for a new angle of view, peer beyond a street corner, or explore a hidden courtyard. And a couple of hours will offer you practically limitless photographic possibilities – almost everywhere in the world.

The amount of time to set aside for taking pictures will to a large degree depend on whether the primary purpose of your trip is travel or photography. Photographing while traveling is different than traveling to photo-

Heading into the ice-covered waters of the White Continent on an expedition cruise in Antarctica. The unusual perspective makes the photo puzzling – at least at first sight. | Nikon D700 • 24 mm • 1/500 s • f/11 • ISO 400

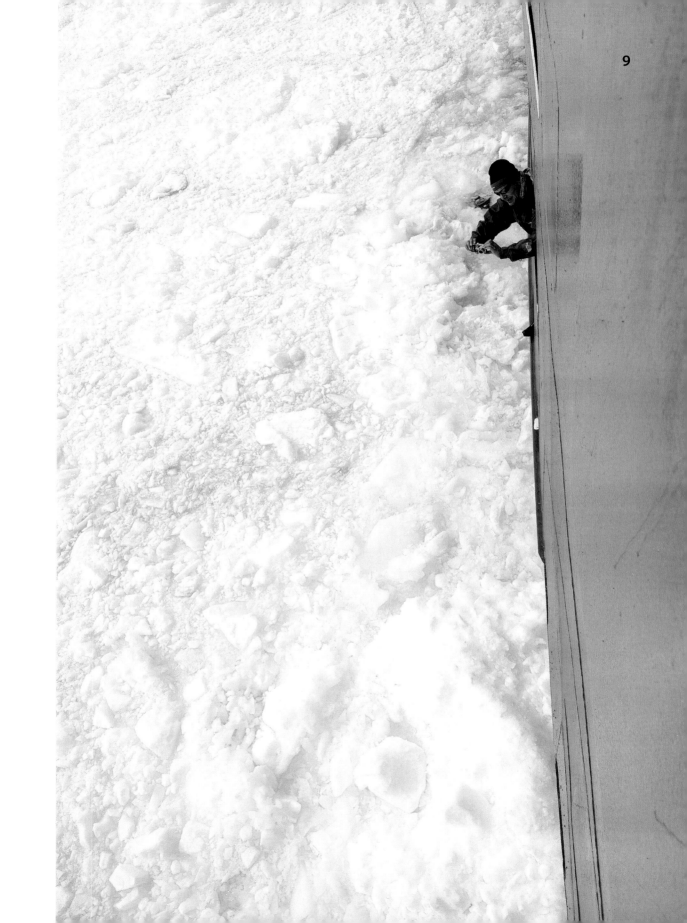

graph. When traveling to photograph either on your own or as a part of an organized photo tour, the pace of your trip slows down to accommodate the photography. Organized photo tours are an effective way to receive direction or support from experienced photographers and to develop your skills, and all in exciting locales to boot! Individual photo trips are something of an ideal case, but they can be costly and time-consuming. From the photographer's point of view, it is ideal when sufficient time for photography is worked into the itinerary and the number of stops follows the motto, "Less is more." (This motto can also be applied to photography itself. You'll find more on this topic in the chapter with that very name starting on page 92.)

Conversely, taking pictures while traveling is always a balancing act between busy daily activities and the momentary pause needed to take a photo – at least a good one. So where do you find the time? Temporary respites can usually be found pretty easily. If you're traveling in a group that has a strict itinerary, it's helpful to find others who are of the same mind as you. Four or six eyes can see more than two; taking pictures in a group can spark the imagination; and you may be able to skip out

African adventure: Traveling in a canoe on the Chongwe River, Zambia. The low point of view, wide-angle lens, and inclusion of the boat's hull in the picture allow the viewer to ride along. | Nikon D700 • 22 mm • 1/640 s • f/6.3 • ISO 1600

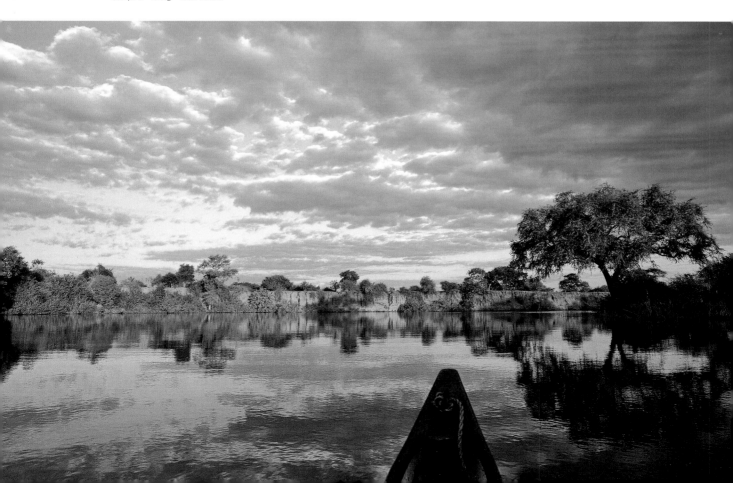

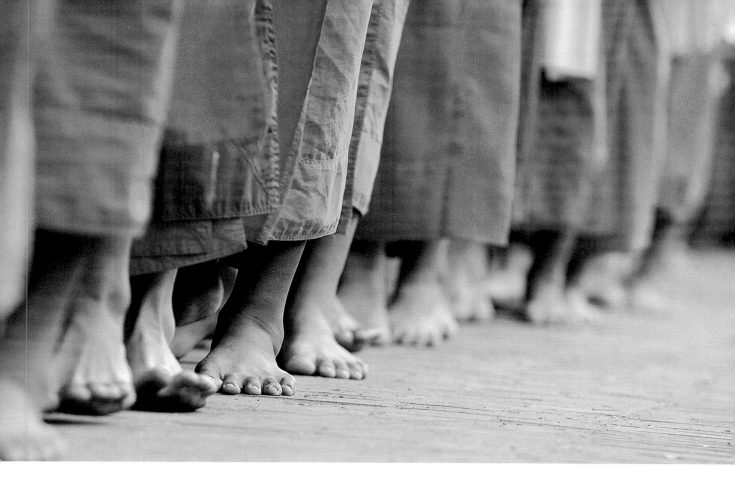

Perfectly in step: Monks at the morning alms round in Luang Prabang, Laos. Sometimes you only need to take a seat on the street to find an unexpected perspective. Previously, I had tried the shot with a more conventional point of view. | Nikon D300 • 230 mm • 1/80 s • f/4.5 • ISO 1000

on some scheduled events in favor of taking pictures if you're in a situation where you can't head off on your own unless you're in a small group. Maybe the scheduled daily activities don't start until after sunrise, which leaves you with the first couple of hours of the day to take photographs, even if that means going without an hour or two of sleep. And who says that breaks in your agenda also need to be breaks from your photographic pursuits?

You should start saving time for taking pictures on your trip well before departing. Putting in some preparation before your trip will pay off later when you're able to use every spare minute for taking pictures. This sort of preparation includes not only brushing up on the conditions, customs, and practices of your destination country and learning a few key terms and phrases, but also giving some photographic thought to what's ahead. What sorts of photographic opportunities are available where you're headed? What environmental conditions should you expect? What type of equipment will help you meet your photographic objectives? At what time of day do you want to capture specific places? What

On Traveling and Photographing

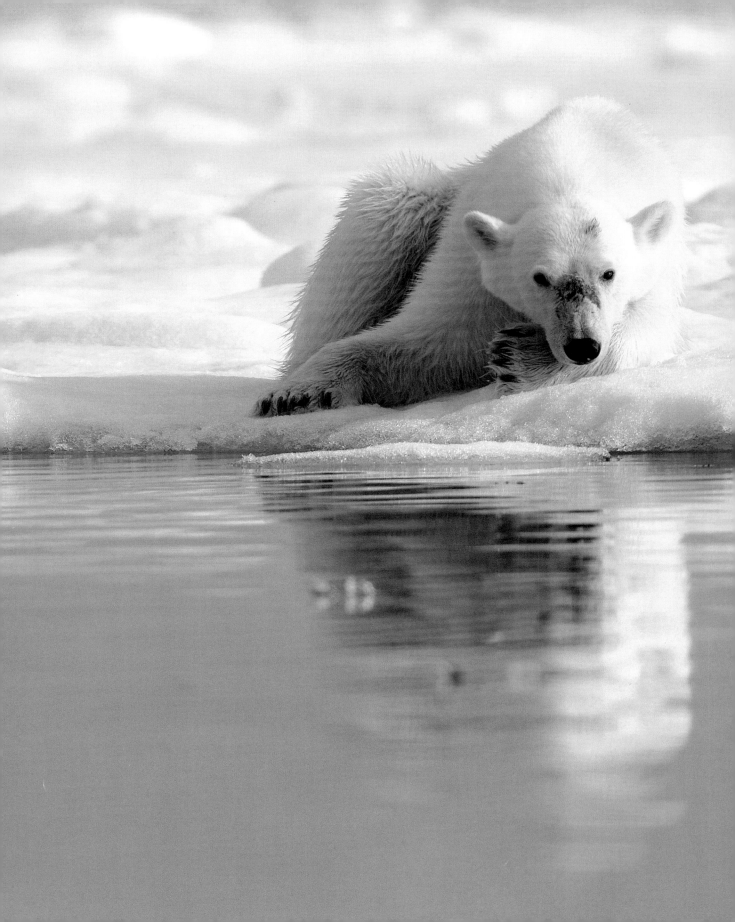

sights could be left out in a pinch? Where might it make sense to stay a bit longer?

Take a look at pictures that other photographers have taken of locations you're planning to travel to. Look for subjects that grab your attention or spark your imagination. You can engage with these subjects in your own photography by trying to make your interest, fascination, and curiosity visible in your images. In other words, take pictures of what speaks to you emotionally, both in a positive and negative way. Good pictures generally arise when you have established an emotional connection to your subject. If you feel half-hearted about a particular subject or scene, or if you're not actually sure why you're taking a picture, viewers will detect your ambivalence in your photo.

Preparation isn't everything, but thinking ahead can be of real value, not least because it will ratchet up your excitement for your trip. You won't be able to plan everything, of course – once at your destination, you will encounter unexpected, fascinating moments and subjects well worth capturing. Even then, though, adequate preparation will pay off by ensuring that you've got what you need to handle the photographic challenges on site. In addition, it will allow you to spend as much of your time on location as possible concentrating on what matters most to passionate photographers: taking pictures.

Prepararing yourself includes choosing the appropriate equipment for the photographic tasks you plan to encounter in advance. (Chapter 20, titled "Equip-

Polar bear on the ice in Hamiltonbukta, Spitsbergen. The animal and its reflection were photographed from a rubber dinghy, using a long focal length. | Nikon D300 • 600 mm • 1/1600 s • f/5.6 • ISO 400

On Traveling and Photographing

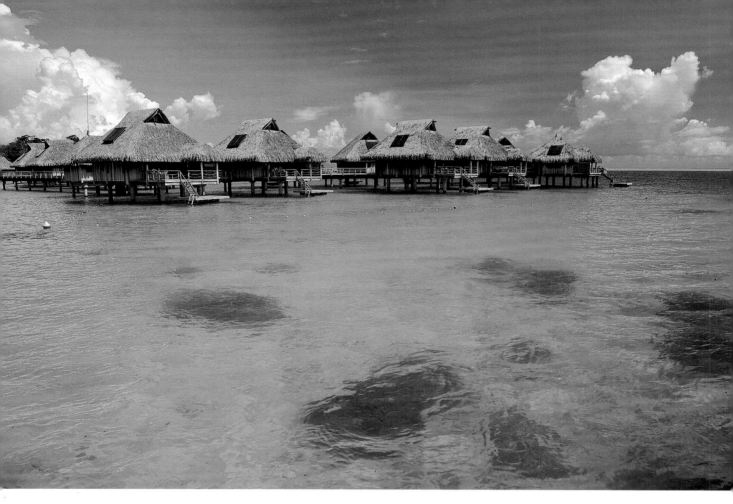

Like in a picture book: Overwater bungalows in Bora Bora, French Polynesia. Even somewhat documentary images like this will understandably appeal to anyone in need of a vacation. | Nikon D700 • 24 mm • 1/250 s • f/8 • ISO 200 • polarizer

ment" and starting from page 174, discusses this topic in more detail.) Ambitious photographers will find themselves in a quandary here, being torn between the needs of a traveler and the needs of a photographer as mentioned before. You want your equipment to be light and portable so it doesn't hinder your movement, but you also want to be prepared for photographing a wide variety of situations. Those who choose their equipment wisely and who know how to use it will find a good solution. Doing so requires knowledge, experience, and practice.

Selecting your equipment doesn't get any easier when you consider that travel photography comprises many photography genres: landscape photography, portraiture, architectural photography, photojournalism, and so on. This might feel like a challenge, but it's better to think of it as an inviting, infinitely large playground.

The most carefully selected and high-quality equipment won't be of any use if

you can't reach it fast enough at the critical moment. Many photo opportunities emerge spontaneously, so the photographer who has his or her camera handy and set up appropriately – with shooting mode, focal length, shutter speed, aperture, ISO – will have the upper hand over one who needs to first retrieve their equipment from a photo bag.

Anticipate that thrilling photographic opportunities can arise at any time, and take joy in the unexpected moments of photographic serendipity. In the end, this joy is what is most important – the joy of photographing, the joy of traveling, and the joy of taking pictures while traveling.

Like in a fairy tale: Our Tuareg guide prepares tea in the traditional way over a campfire in the Libyan Sahara. A headlamp set in a plastic container provided additional light. | Nikon D700 • 1/5 s • 27 mm • f/4.5 • ISO 2500 • tripod

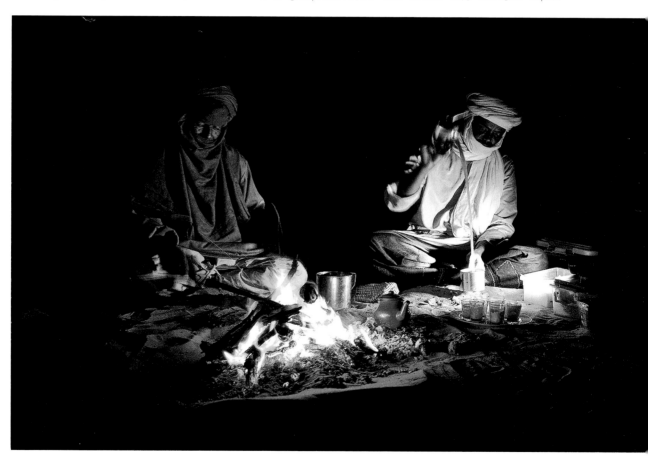

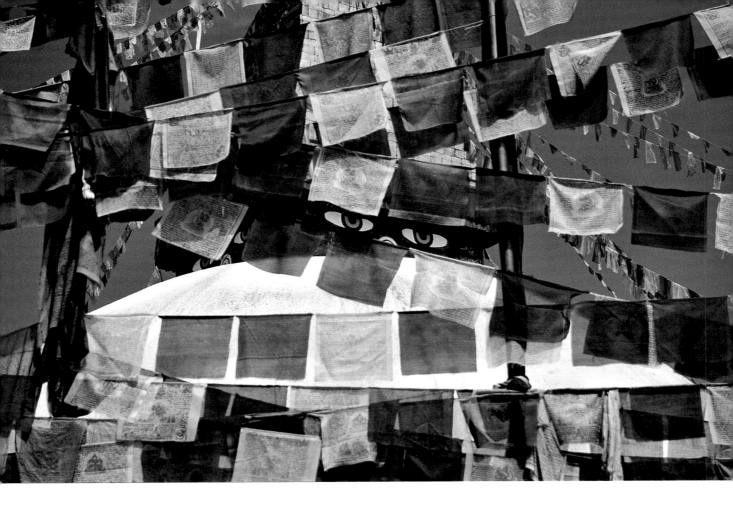

2 From Conventional To Unique

Commonplace Photos and Your Own Point of View

Sometimes you have pictures planned out in your head before you set out on a trip. They may even be the reason for taking the trip in the first place. Who does not recognize the perfect symmetry of the Taj Mahal lit by dawn's gentle colors? Or the most photogenic side of Switzerland's legendary Matterhorn? Who wouldn't love to press the shutter button when viewing the orange-red Dune 45 in Sossusvlei, Namibia?

Wherever you go, you can be relatively certain that other photographers have already been there. It's always tempting to imitate well-known photos of world-famous sites or limit yourself to the obvious post-card view of your subject. As satisfying as the former and as

convenient as the latter may be, take your own pictures of the world – don't just imitate those of others. This sentiment is legitimate, but don't stop photographing after you have the photo that you wanted on your memory card.

After the obligation comes the choice: Search for additional points of view, surprising perspectives, alternative standpoints, and inconspicuous details that possess their own charms. Look out for your angle, your perspective, your view. Be critical, ironic, reflective, playful, bold, loose; leave the well-trodden paths; and always stay curious.

Think about a photograph not as something that is readily available, but as something that you can shape and design. You are the one to decide how your picture will look. Your photo shouldn't simply reflect what you saw; it should also reflect how you saw it and how you want it to affect your viewer. Ideally, your thoughts and sensations will be embedded in your picture. Achieving this is easier said than done, but it's always worth the effort.

The Treasury is likely to be the most-photographed subject in the ancient Nabataean city of Petra, Jordan. Visitors wander through the

Opposite: An alternative view of the famous Stupa of Boudhanath (Nepal) emphasizes the prayer flags. You might not spot Buddha's eyes at first glance. | Film photograph, exposure details unrecorded

Below: This classic view highlights the Stupa's symmetry, its distinctive coloring, and its accessibility. Film photograph, exposure details unrecorded

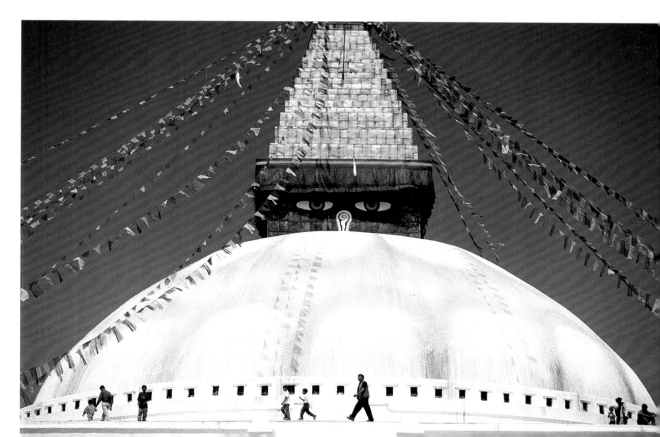

canyon as-Siq, with its vertical sandstone walls, towards the rock-hewn monumental structure that remains invisible. Only in the final yards does the view open up, and at this specific spot in the canyon, you'll almost always find a crowd of photographers. This is the place from which to create the classic postcard view of Petra, and for good reason. It is without question a breathtaking view and a fascinating perspective: light and shadow, natural structures and manmade shapes, curved lines and strict geometry, vertical and horizontal lines, color and colorlessness, warm and cool, bright and dark – all in one picture. But aside from this obvious view, there are so many more photo-graphic opportunities to show the Treasury, to tell stories about it, and to position it within a much broader context.

Some of these are evident and easily accessible while others require walking or climbing. Some can be planned, such as "Petra by night," when the space in front of the Treasury is illuminated only by candles; others are the product of chance. You'll need curiosity and a bit of time, but what's most important is the photographer's attitude: the will to seek out an individual image and the joy of working creatively.

Photography is a creative means that leads to a very personal result. A photographer

The city of stones – to go: Mini depictions of the most famous facades in Petra (Jordan) wait to be purchased at a souvenir stand. | Nikon D700 • 35 mm • 1/125 s • f/5 • ISO 250

Chapter 2

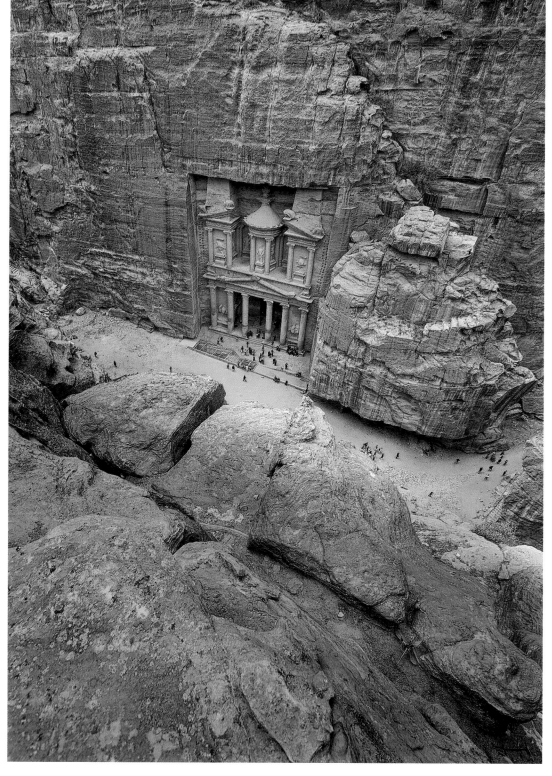

She who rises, sees more: A short hike led me to this viewpoint over the Treasury in Petra, Jordan.
Nikon D700 • 17 mm • 1/320 s • f/9 • ISO 250

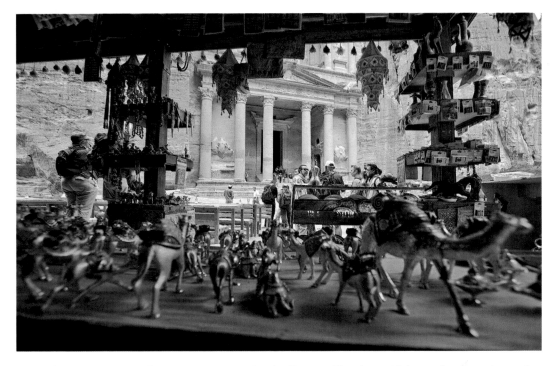

Unusual viewpoint: A view from a souvenir stand at the Treasury. The shop with keepsakes, batteries, and disposable cameras belongs to Petra just as much as the famous facade in the background of the picture.
Nikon D700 • 17 mm • 1/100 s • f/5 • ISO 200

shows viewers his or her selection of what he or she has discovered from his or her subjective perception. You can think of this subjectivity as a manipulation of reality, but also as a possibility for shaping and designing: a picture – our picture, your picture – is made.

Ansel Adams's observation, "You don't take a picture, you make it," hits the nail on the head. A photographer plays an active role and does more than capture what is readily available for the taking. The process begins with perception and the selection of a subject, and continues through the selection of the actual image, perspective, focal length, aperture, and shutter speed, all the way to image editing.

The creative process – or the manipulation of reality – doesn't start on the computer or in the darkroom, as is often supposed; it's much earlier than that. Every picture illuminates the subjective view of the person who photographed it, regardless of how much or how little it has been post-processed.

Many times the desire to create a picture arises spontaneously, and in the first moment you may not even realize what it was that triggered the impulse. It's useful to analyze this subconscious drive, however, because the more precisely you understand what image you want to make and why, the better you can concentrate on achieving it.

Photography is about focusing, not only in the technical sense, but also figuratively. It's all about the mental focusing required to distill the essence of an image and delve into the idea. It's about removing what is unessential and emphasizing what matters. It's about refining an image until it shows what you want it to – nothing more, nothing less.

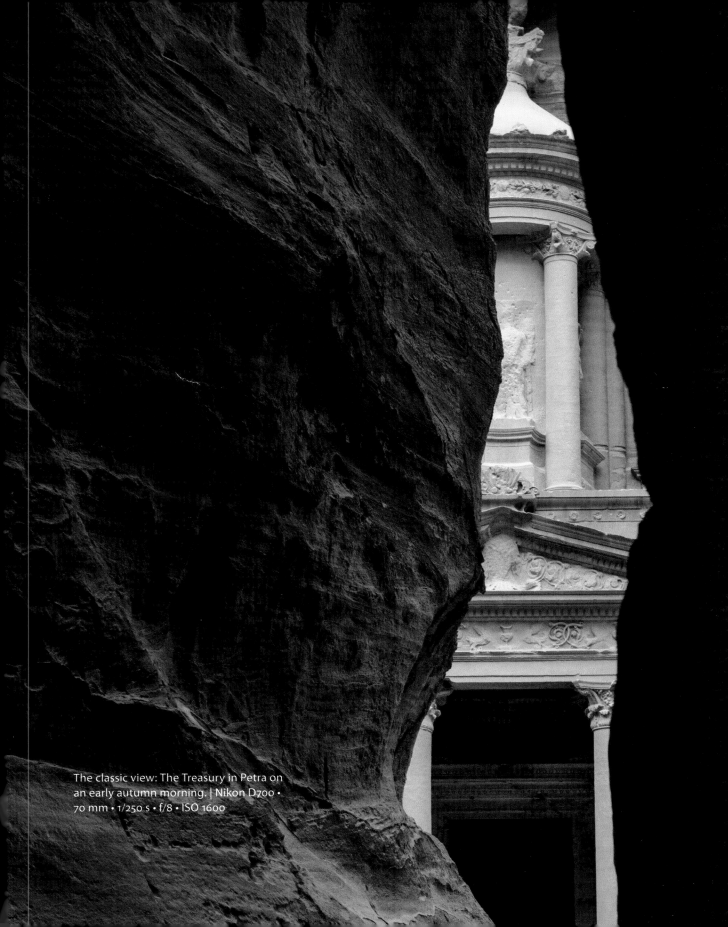

The classic view: The Treasury in Petra on an early autumn morning. | Nikon D700 • 70 mm • 1/250 s • f/8 • ISO 1600

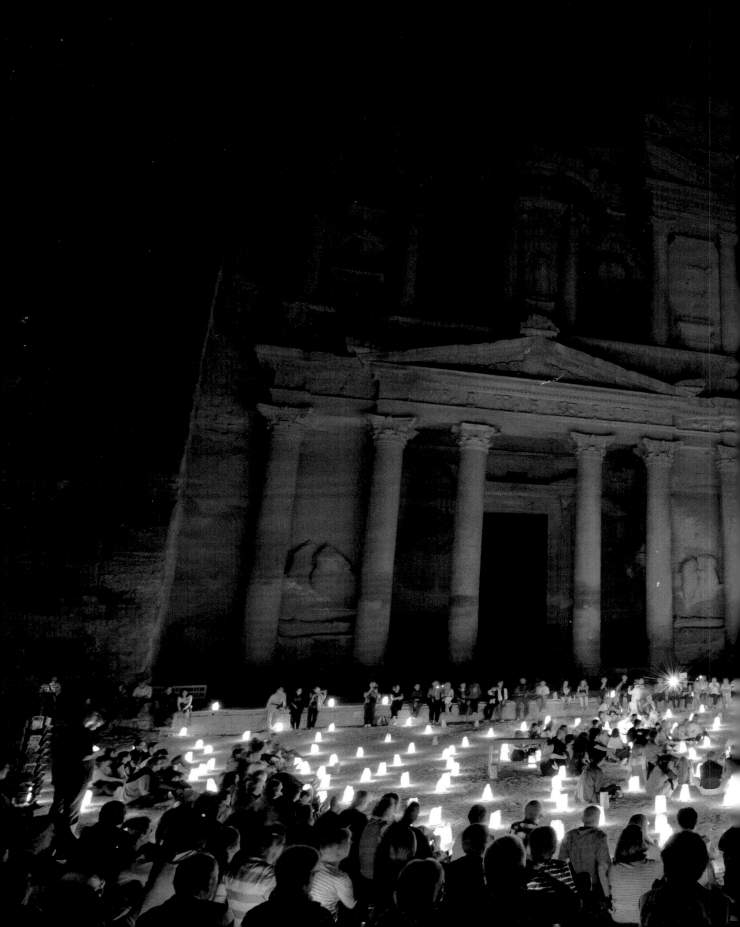

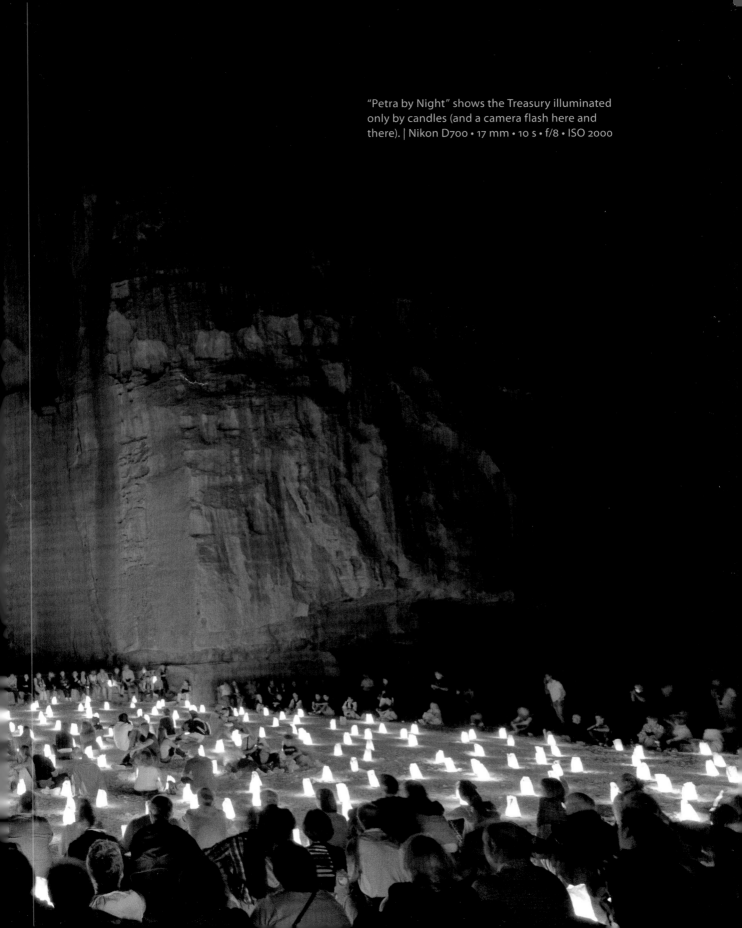

"Petra by Night" shows the Treasury illuminated only by candles (and a camera flash here and there). | Nikon D700 • 17 mm • 10 s • f/8 • ISO 2000

Focusing also means concentrating as exclusively as possible on the image at hand. As a photographer, you will need (and want) to pay attention to your surroundings to some degree, but nothing productive comes from constantly suspecting that there might be other photographic opportunities being wasted while you're working on the one at hand. Of course there will be, but that does not matter too much: It's impossible to be everywhere at once, and you can't take a photo of everything, anyway. Taking every conceivable picture aligns better with indiscriminate snapping rather than with the intentions and effort that are needed to create purposeful photographs.

Photography – especially when traveling – requires compromise. Time passes, light fades, opportunities expire. But even when unused opportunities feel like a loss, in my experience it's usually more productive to meaningfully engage with a few photos rather than capture and produce a plethora of half-hearted and hasty pictures, of which none are outstanding. On top of that, becoming so involved with a

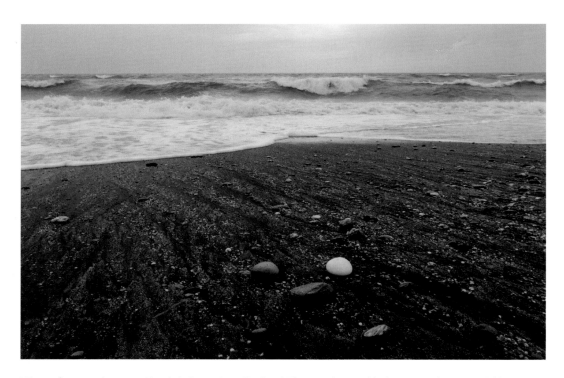

What a fantastic location: Knight's Point, New Zealand. The weather and lighting conditions could have been better… | Nikon D70 • 27 mm • 1/200 s • f/9 • ISO 200

…but they were almost ideal for detail shots of the stones on the dark sand. "Four Stones" remains to be one of my favorite pictures from New Zealand. | Nikon D70 • 70 mm • 1/160 s • f/6.3 • ISO 200

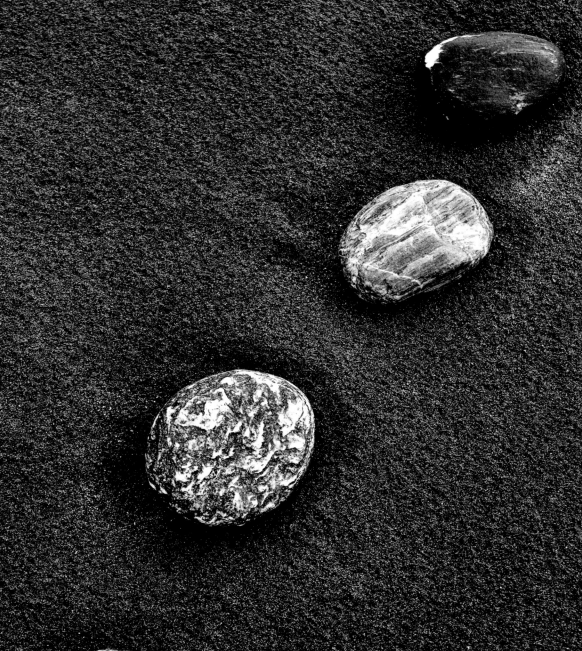

particular subject or scene can result in nearly forgetting about yourself and your surroundings; there is something almost meditative about it. You can train yourself in this type of concentration, just as you can practice how to use a camera and its settings.

Whenever the impulse to shoot a picture pops up, try to figure out what appeals to you about the particular subject. Is it the special light? A contrast of colors? A pattern of lines? The atmosphere of a specific town square? The expression on a face? Why does this scene speak to you and what is it that the viewer should connect to it? What makes the subject so important that you want to share it with others? Try to work out these questions. Don't be discouraged by difficult circumstances, and don't feel unsettled if you can't immediately determine what it is exactly that you want to photograph. In most cases, you'll be able to work this out by spending some time with your subject, by approaching it, observing it (even without taking any pictures), exploring it, walking around it, and letting it inspire you.

An example from New Zealand: We discovered the beach at Knight's Point by accident. I can't even recall why we stopped at this particular spot to begin with. Rain was coming down from a thick cloud cover that almost reached the ground, and my first attempts at a wide-angle overview shot were accordingly disastrous. It was wet, cold, and unpleasant, but I had no intention of giving up. The distinctive pebble formations on the dark sand grabbed my attention at first sight – their playful diversity, their conspicuous contrast with their nearly monochrome background, their elegant arrangements. They were a whim of nature with an unerring sense of design and proportion. These arrangements were all over, each one even more beautiful than the last. I had found my subject – the essence of Knight's Point – and to this day, this picture of the four stones (page 25) is one of my absolute favorite pictures from New Zealand.

Admittedly, you won't always have the time, the leisure, or the right frame of mind to engage thoroughly with the things that you see, experience, discover, and learn while traveling. Sometimes ideas for images come fast and easy, but on other days it can be a real struggle. Sometimes you'll intuitively figure out a great image composition without giving it much thought; other times working out a photo takes quite some effort. And sometimes a snapshot, the unique moment that lacks technical or compositional perfection, turns out to be the best and liveliest photo.

Use the obvious perspective, the postcard view, the iconic image, the picture that's been created umpteen times as your anchor on the scene and as a starting point, but don't content yourself with it. Stick around and give your curiosity some space, try to feel special moments, try out something new, dare yourself to do something, develop your own ideas, and focus on capturing them in your photo. It's worth the effort. Ideally, you will go back home with photos that no one else has, and with the good feeling that you didn't just copy something but you photographed your own personal view of things.

A classic snapshot of a waterfall in Milford Sound, New Zealand. | Nikon D70 • 50 mm • 1/125 s • f/5.6 • ISO 200

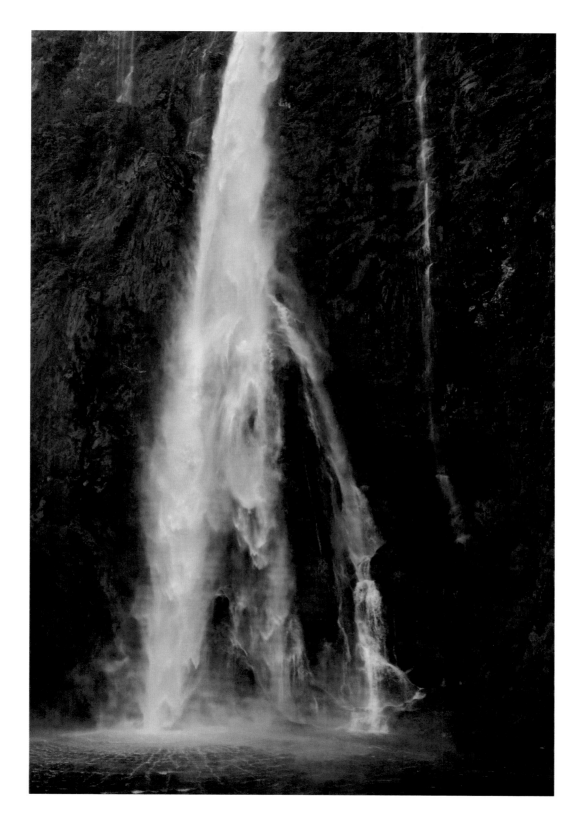

From Conventional To Unique

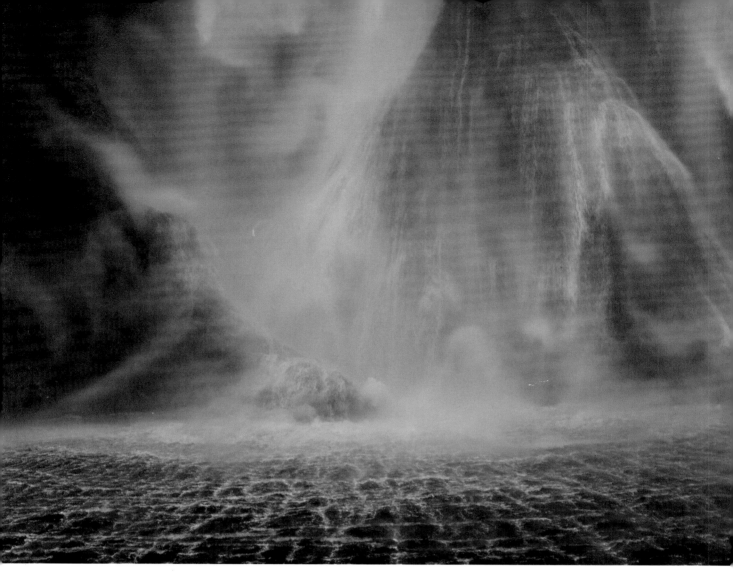

Top: Close-up of the waterfall on page 27. This image is centered around the cascades, the spray, and the marble-like patterns at the bottom of the falls. | Nikon D70 • 105 mm • 1/200 s • f/7.1 • ISO 200

Right: Same waterfall, different distance, different angle, different framing. It's all about what you see when looking at a scene – I saw a hooded figure emerging from behind the water curtains… | Nikon D70 • 78 mm • 1/200 s • f/7.1 • ISO 200

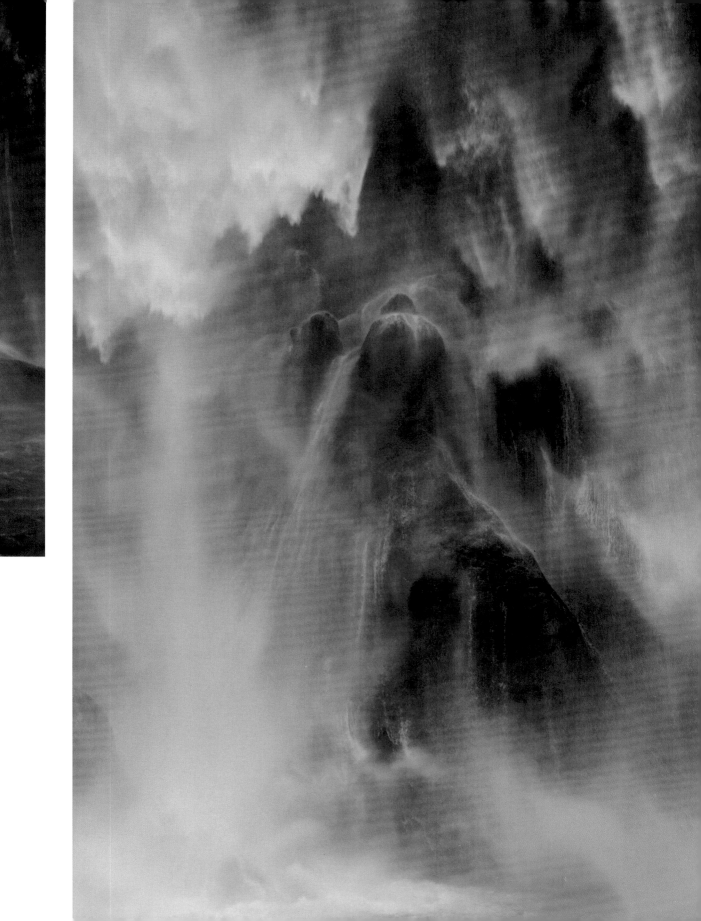

3 Off Center

Why Subjects Should Move a Bit to the Side

When you take a picture, where do you instinctively position your main subject – the center of your image? Smack-dab in the middle, where the central autofocus point or area makes it easiest to get a sharp image; where the subject – whether it's a person, flower, building, or mountain – receives undivided attention; where nothing will challenge its dominance. You place it where the logical position for your main subject seems to be.

But only at first glance. If you end up with a bull's eye composition for all of your photos, they will all look the same – predictable, monotonous, outright boring. After the first look, the viewer will discover the main subject in the obvious position, and won't have any reason to continue engaging with the photo to discover what else might be there. It's an image composition devoid of tension, and what's even more, you're robbing yourself of all other creative composition possibilities. Always opting for central positioning means disregarding the endless play between the main subject and secondary details, and missing the opportunity to create a balanced, but nonetheless exciting, image composition.

So, if you'd like to go beyond that, where do you position your main subject? It's up to you: Even a modest shift is sufficient to move your subject off-center, but you may also opt for an extreme composition by placing it next to the image border or into one corner. It all depends on the image, your intention, your willingness to experiment, and the circumstances. In most cases, a slight shift of the main subject is enough to provide a more engaging composition, which brings us to a popular design technique: the rule of thirds.

I'm rather reluctant to use terms like "rules of design." A rule can be seen as a helpful hint but also as something that comes close to a commandment. Aside from that, following formal rules of design won't necessarily lead to pleasing photographs. Nevertheless, I consider it important and highly useful to be familiar with these design rules – universal aesthetic principles that can provide a basis for composing attractive, harmonious, interesting photos – and how they work, even if it's only so you can intentionally overstep and play with them.

The rule of thirds is based on the proportions of the golden ratio, an aesthetic concept that was well known in antiquity. It is based on a specific aspect ratio and comes up often in the natural world as well as in the world of art. As a simplified principle of design it's easy to remember, and it can be applied before an exposure is made as well as (within limits) afterwards during the post-processing stage. Divide any photo with two sets of evenly spaced parallel lines – one pair horizontal and the other vertical – and you'll end up with nine square

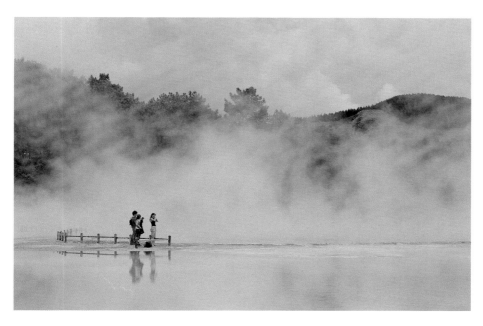

Earth is alive: A scene from the "thermal wonderland" Wai-O-Tapu on the north island of New Zealand. | Nikon D70 • 66 mm • 1/250 s • f/8 • ISO 200

Below: Guiding lines divide the image into nine equal areas. According to the rule of thirds, important subjects should be positioned near to where the lines intersect.

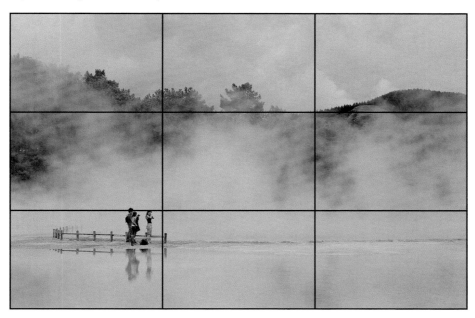

areas of the same size (see bottom photo on page 31). The height and width of the image area will be cut into thirds. Now position your subject at one of the intersections, along the lines, or even somewhere near one of the intersections or lines, and you'll automatically avoid positioning your subject in the center.

With time, it becomes second nature for many photographers to generally avoid a bull's eye composition, and it is just as natural for them as it is for beginning photographers to center their subjects.

Evaluate your photos and those of others to figure out how they work, especially if you're just getting your toes wet in the field of pho-

tography. Ask yourself questions about what you see: Does this picture appeal to me? If so, why? What feeling does it convey? How does it affect me? Where did the photographer position the main subject, and are there reasons for this indicated within the picture?

Examining as many different pictures as possible enables you to develop more and more confidence in your ability to evaluate scenes and subjects, which will in turn improve your own photography. Examining the work of other photographers is just as applicable for advanced photographers, by the way; everyone can benefit from outside ideas at any time.

Floral fascination in Zimbabwe: The main subject is positioned away from the center, and the blurry leaves in the foreground provide depth. | Leica D-LUX 5 • 70 mm • 1/125 s • f/3 • ISO 80

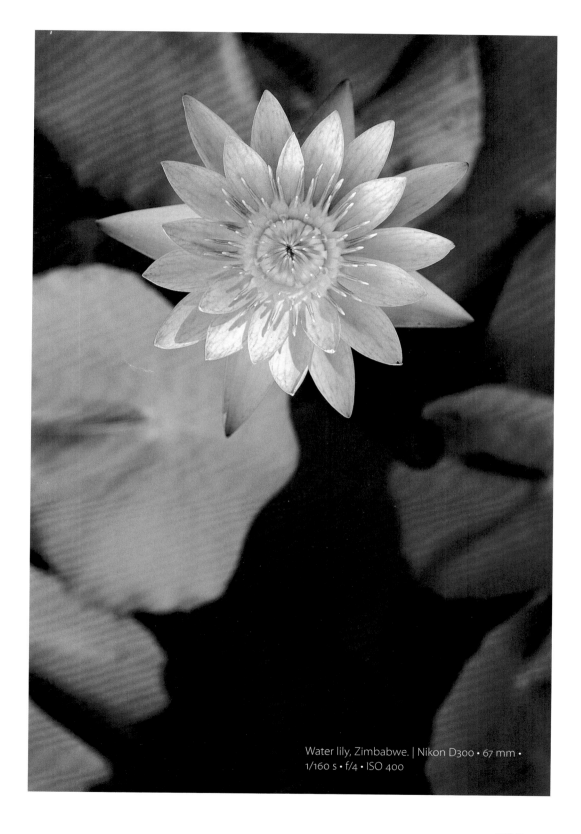

Water lily, Zimbabwe. | Nikon D300 • 67 mm • 1/160 s • f/4 • ISO 400

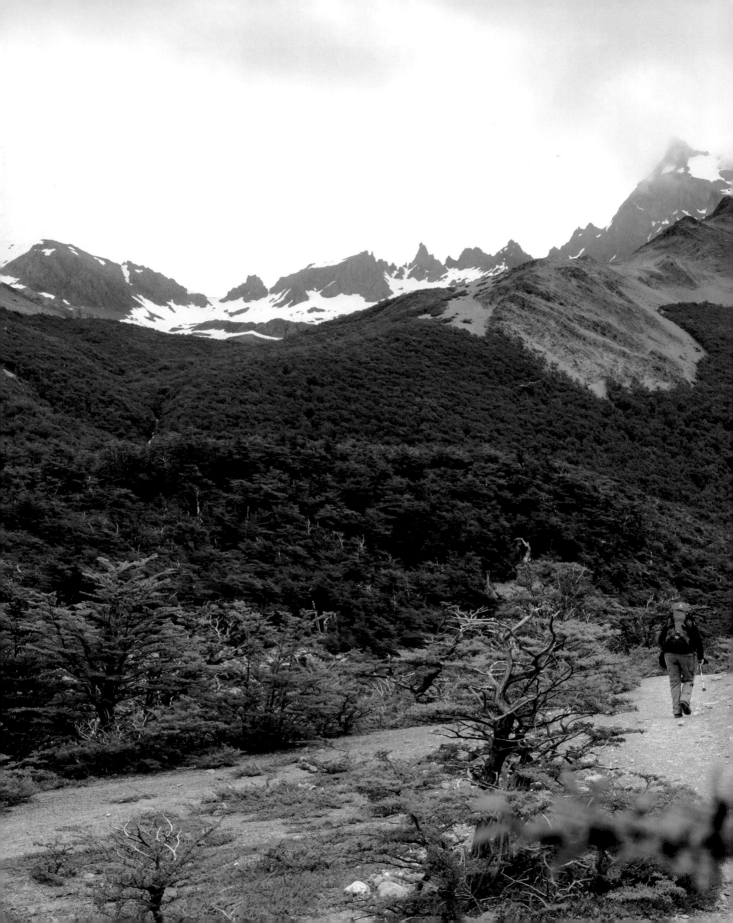

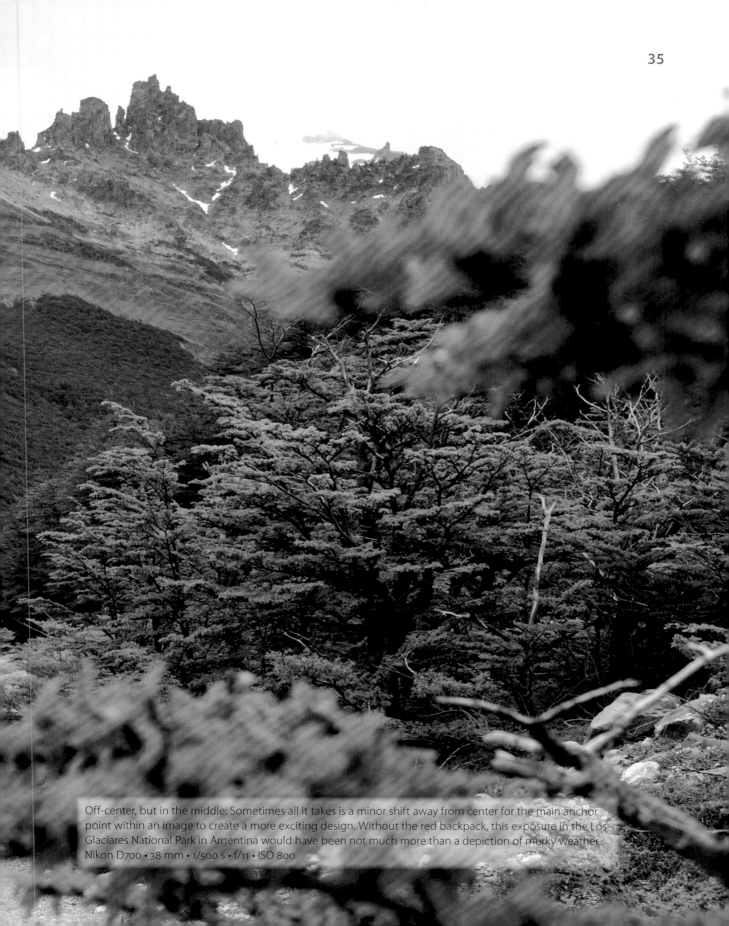

Off-center, but in the middle: Sometimes all it takes is a minor shift away from center for the main anchor point within an image to create a more exciting design. Without the red backpack, this exposure in the Los Glaciares National Park in Argentina would have been not much more than a depiction of murky weather.
Nikon D700 • 38 mm • 1/500 s • f/11 • ISO 800

Getting back to your own images and the urge you might feel to center your photos around the main subject: If you are not sure about your composition, take a moment before you press the shutter button to examine the positioning of your subject. Try moving it out of the middle, unless there's a good reason not to. With more experience this process will become automatic, and it almost always results in a more appealing composition.

Having said all this, it's important to state that there's no rule without exceptions. Certain subjects more or less require a central positioning or a symmetric composition, otherwise they will appear as failed attempts. There are many examples of such subjects, including interior and architectural photos of spaces such as libraries, naves, and church domes; reflections as the one in the bottom photo; geometric shapes, such as the rear view of the tour bus in New Zealand (page 175); and detail exposures.

You also might want to design an image with its subject in the middle or create a symmetrical composition to deliberately break up a series of photos with off-center subjects – or if you have another good reason for doing so. Think of the rule of thirds as a suggestion rather than an obligation. It's ultimately up to you what style of design and composition best suits the picture at hand and your intentions for it.

Antarctic reflection: A building belonging to the Argentine research station Almirante Brown on the Antarctic Peninsula. I made this picture from a zodiac, a sturdy rubber dinghy.
Nikon D700 • 32 mm • 1/800 s • f/6.3 • ISO 200

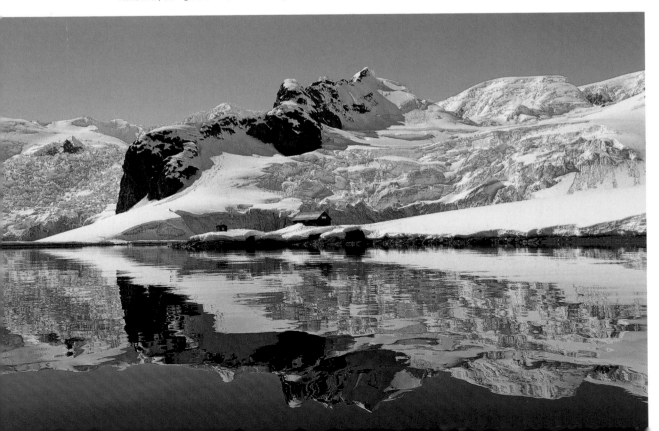

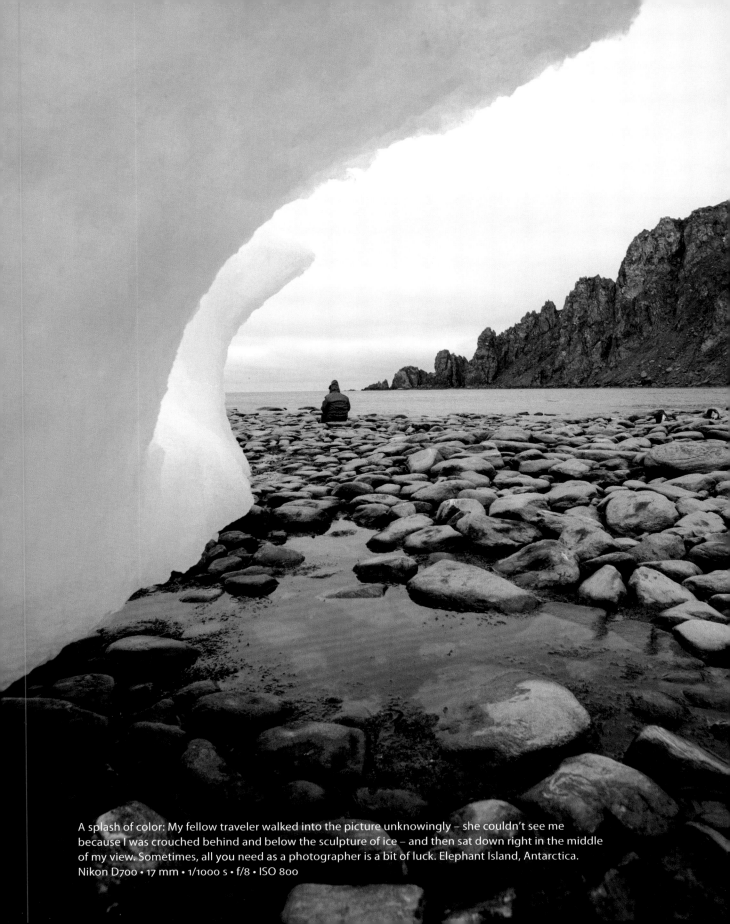

A splash of color: My fellow traveler walked into the picture unknowingly – she couldn't see me because I was crouched behind and below the sculpture of ice – and then sat down right in the middle of my view. Sometimes, all you need as a photographer is a bit of luck. Elephant Island, Antarctica.
Nikon D700 • 17 mm • 1/1000 s • f/8 • ISO 800

4 Into the Picture

Subjects Need Their Space

In the previous chapter, we discussed opting not to position the main subject where everyone expects it. But where to place it instead? There is no simple, universal answer to the question as each particular photo is different. And the position of the subject isn't everything; the subject's line of view or direction of movement and the desired message all make their contribution.

In addition to the rule of thirds that has already been mentioned, there is another rule of thumb that's just as practical – unless, of course, you have a deliberate reason to ignore it: Give any main subject that is looking or moving in a particular direction some visual space in the area at which it is looking, moving, driving, or flying. Make it clear to the viewer what the subject is looking at or moving toward. In other words, a subject should look or move into your image rather than looking or apparently attempting to move beyond it. Viewers subconsciously wonder what a subject is looking at or where it's going, and instinctively try to follow that path with their own gaze to find out. If your subject is looking or moving beyond the edges of your photo, viewers won't be able to find any answers to their questions, at least not within the frame.

For portraits, this might mean that you need to provide some space in the direction

of the subject's gaze rather than place the subject near the edge of the photo looking outward. The subject's line of sight will influence the viewer's gaze. If the subject is looking beyond the edge of the frame, the viewer has to assume that whatever has captured the subject's attention is not within the picture. There are good reasons you might want to do this to create tension – for

Served up bite-size: The Roller throws the captured insect into the air so it can swallow it with greater ease. There is plenty of space in the bird's line of sight. | Nikon D300 · 600 mm · 1/3200 s · f/4 · ISO 800

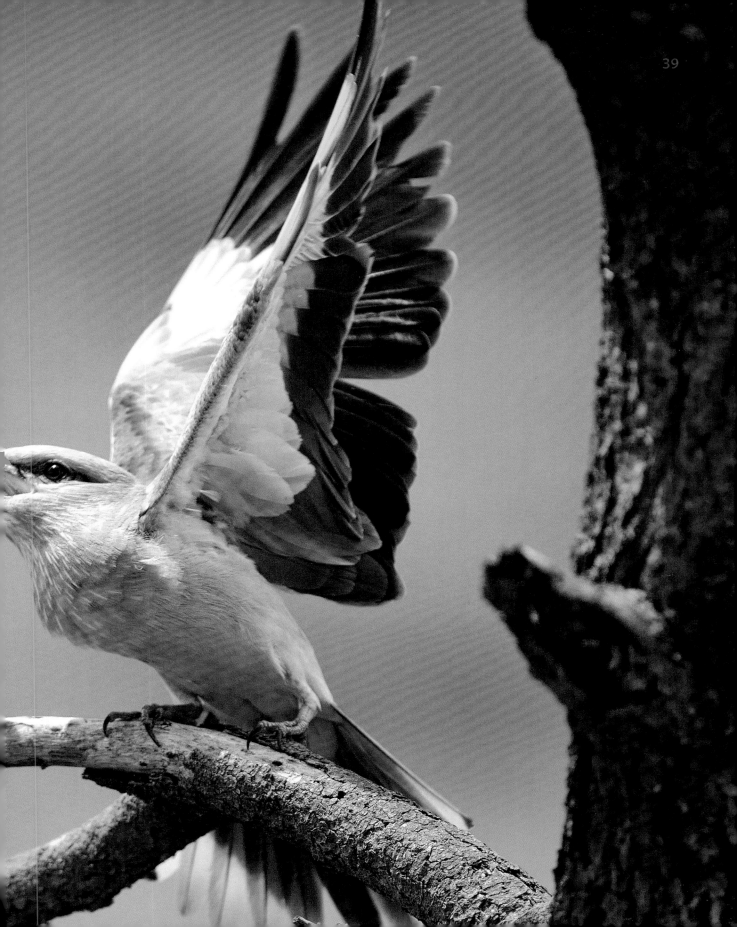

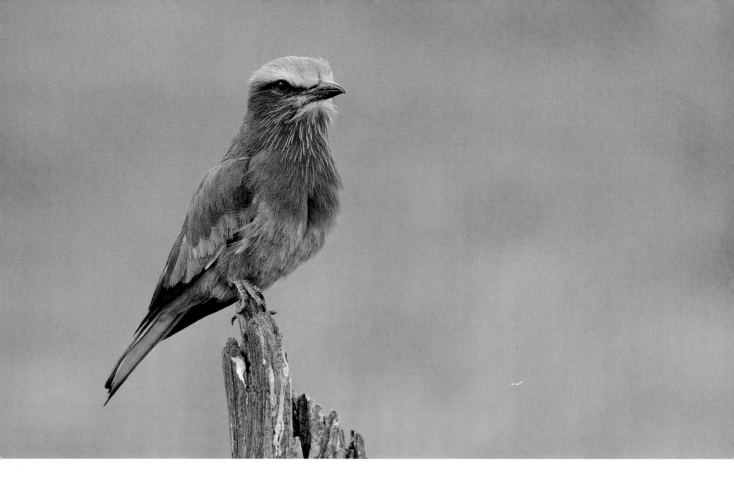

Colorful and flighty: This Lilac-breasted Roller kept still – for once! – as I took my photograph in Tarangire National Park, Tanzania. | Nikon D300 • 510 mm • 1/640 s • f/5.6 • ISO 800

example, if you want your photo to emphasize how shy the subject was while you were photographing him or her. However, this is more likely to be the exception rather than the rule. In most situations, it's worthwhile to have the subject's gaze contained within the image or to at least create a little space in the line of sight. You can always experiment with alternative compositions and designs after capturing the initial photo. Generally, all of this applies not only to portraits of people, but also to portraits of animals.

When taking portraits of all kinds, pay close attention to the background in relation to your main subject and its direction of sight. Building edges, fences, railings, or horizon lines that pass directly into your subject's head can ruin otherwise attractive photos. The key to success is carefully evaluating the scene in your viewfinder or on your camera's monitor. Often, you can avoid distracting background elements by adjusting your position slightly. If that won't solve the problem, you might opt for a larger aperture or create a larger distance between your subject and its background to minimize the distracting elements.

Whether to position your main subject in the top third or bottom third of your image

depends on the subject, its surroundings, and the situation of your photo. For landscape photos, this question often comes up when deciding whether to shift the horizon line upward or downward from the center of the frame. Let the subject at hand drive your choice: If the sky features interesting clouds or attractive lighting conditions, then give it some space. If the foreground is more important or the sky is uninteresting thanks to a uniform cloud cover, shift the horizon up near the top of your photo. You might even go so far as to remove the sky from your photo entirely. It's worth considering this option especially with high-contrast photos if it will make it easier to retain detail in the darker foreground or if the sky would otherwise end up being blown out.

The feeling that you intend to convey with your photo also plays a role. If you position your subject near the lower border, the larger part of the picture above it can tend to weigh down on it in some circumstances. Conversely, if the main subject is higher up in the top third, your photo often will have a lighter feel.

In the ranger station at Mana Pools National Park, Zimbabwe. The safari guide's outstretched arm, the blur in the foreground, and the fall of light direct the viewer's attention to the displayed specimens.
Nikon D700 • 24 mm • 1/60 s • f/4 • ISO 1600

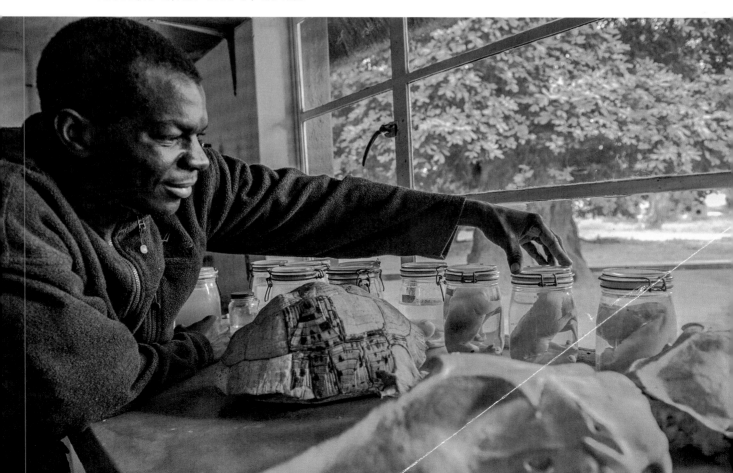

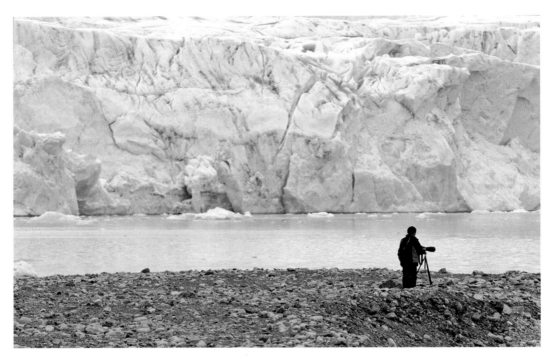

Above: The photographer's viewing direction sends the viewer's gaze out of the picture. Below: In this take, the viewer has a much better sense of what the depicted photographer is looking at. | Nikon D300 • 600 mm • 1/320 s • f/9 • ISO 400

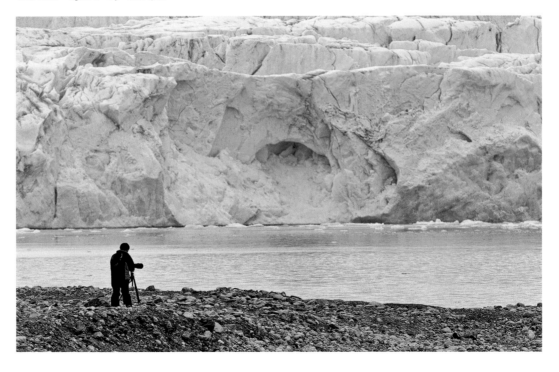

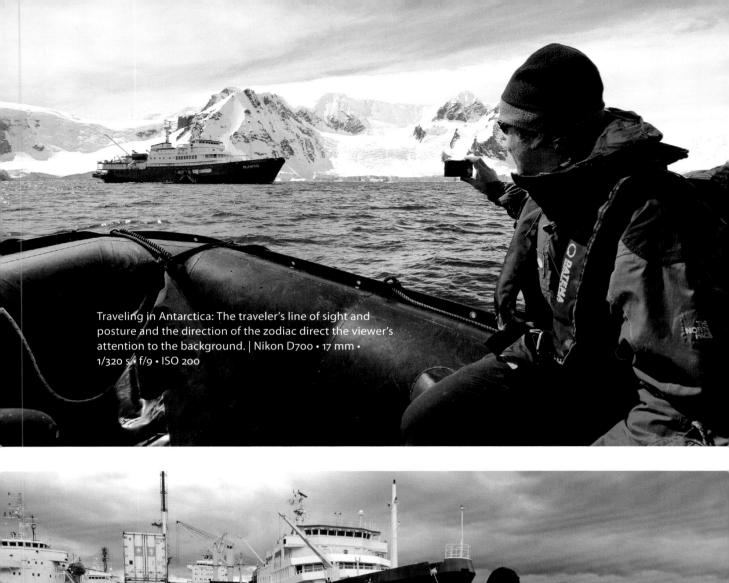

Traveling in Antarctica: The traveler's line of sight and posture and the direction of the zodiac direct the viewer's attention to the background. | Nikon D700 • 17 mm • 1/320 s • f/9 • ISO 200

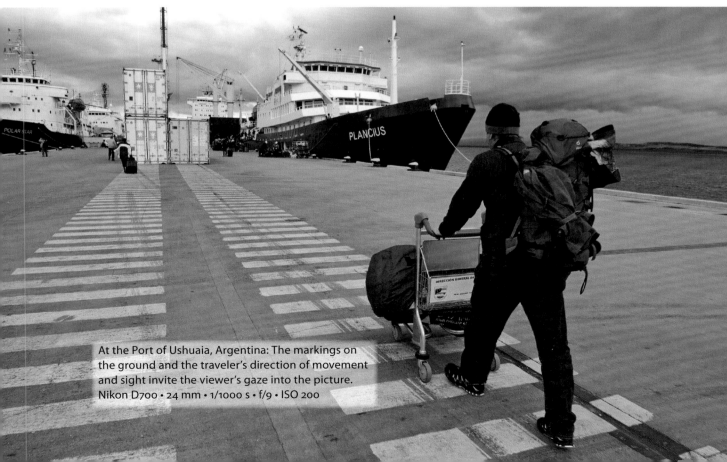

At the Port of Ushuaia, Argentina: The markings on the ground and the traveler's direction of movement and sight invite the viewer's gaze into the picture. Nikon D700 • 24 mm • 1/1000 s • f/9 • ISO 200

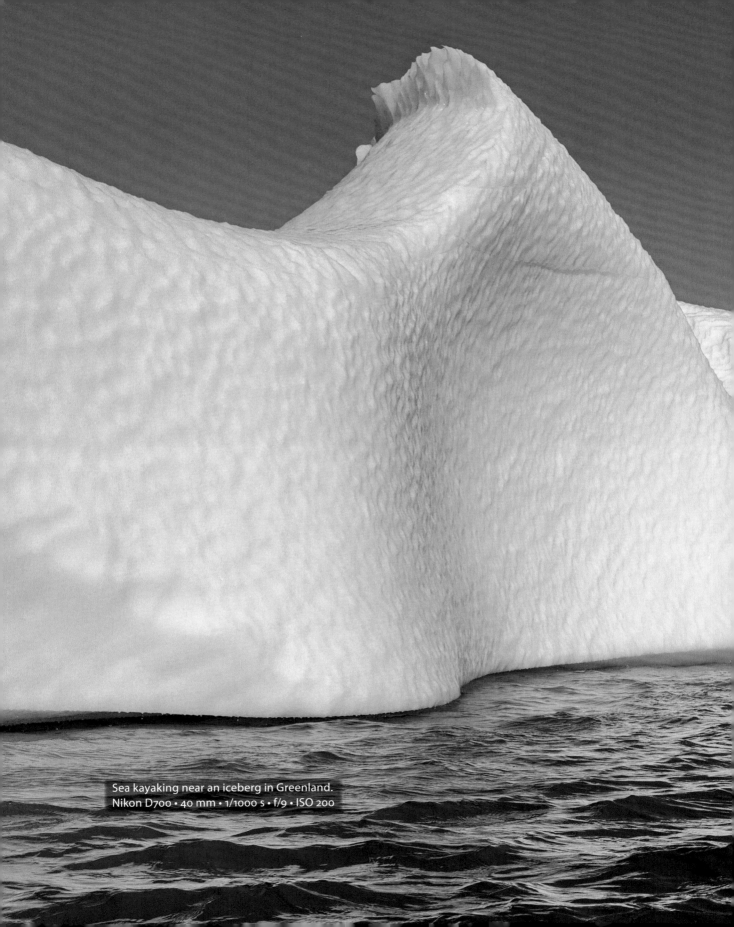

Sea kayaking near an iceberg in Greenland.
Nikon D700 • 40 mm • 1/1000 s • f/9 • ISO 200

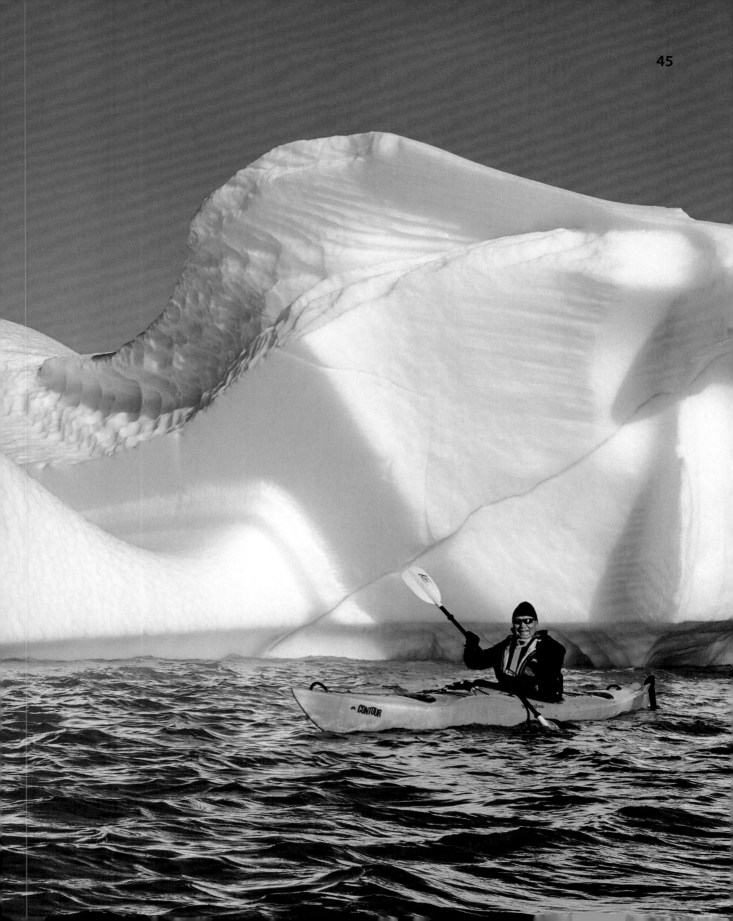

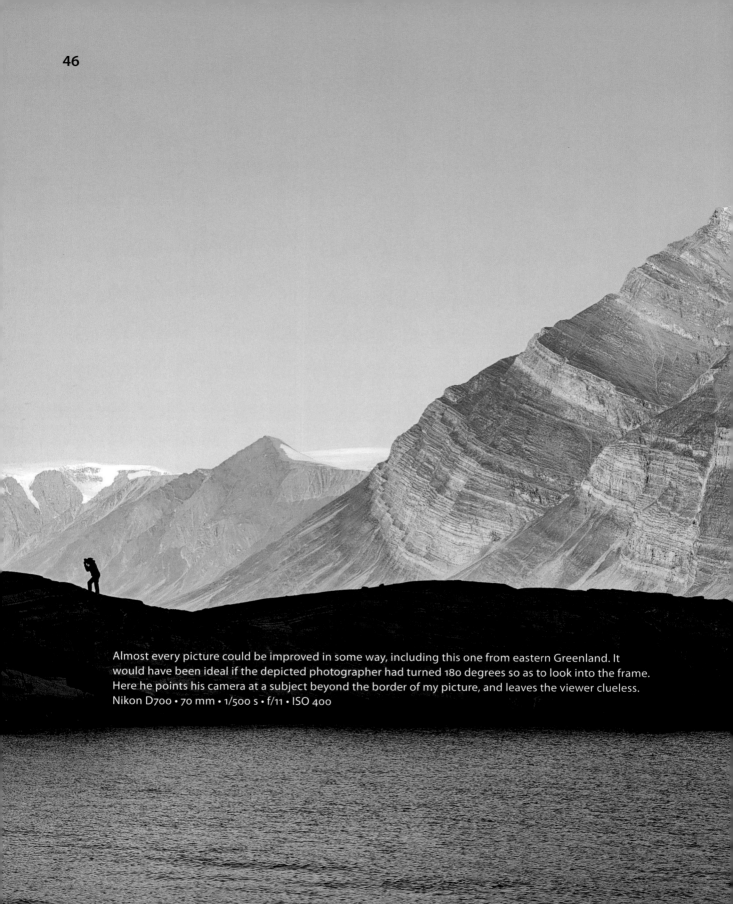

Almost every picture could be improved in some way, including this one from eastern Greenland. It would have been ideal if the depicted photographer had turned 180 degrees so as to look into the frame. Here he points his camera at a subject beyond the border of my picture, and leaves the viewer clueless.
Nikon D700 • 70 mm • 1/500 s • f/11 • ISO 400

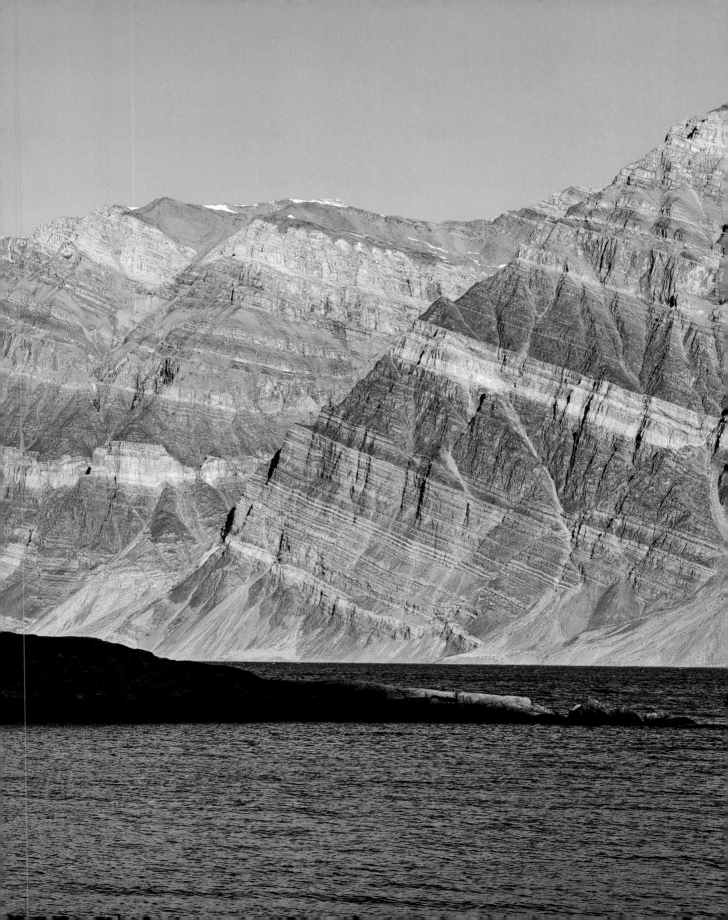

5 The Benefits of a Foreground

On the Search for the Third Dimension

There's a German saying about photography that literally translates into "Foreground makes a picture sound." It's sort of a buzzword but fairly easy to remember, and there's more than just a grain of truth to it. Anyone who's seen a successful landscape photo has probably noticed that the photographer placed an emphasis on the foreground of his or her image. You would do well to do the same. Strive to find appropriate foregrounds for your images, even when you're not into landscapes. Your pictures can only benefit from this effort, especially in terms of depth.

One of the fundamental challenges of photography is mapping the three-dimensionality of a subject onto the two-dimensional photographic representation. As photographers, it's our task to master this challenge through thoughtful image composition. A sense of depth is needed to give a two-dimensional picture the look and feel of three-dimensional reality. Viewers automatically pick up on this when the composition includes visual clues to guide their perception. By working with clearly distinguishable layers positioned at different distances from the camera, photographers can provide viewers with information about the spatial relationships of the indi-

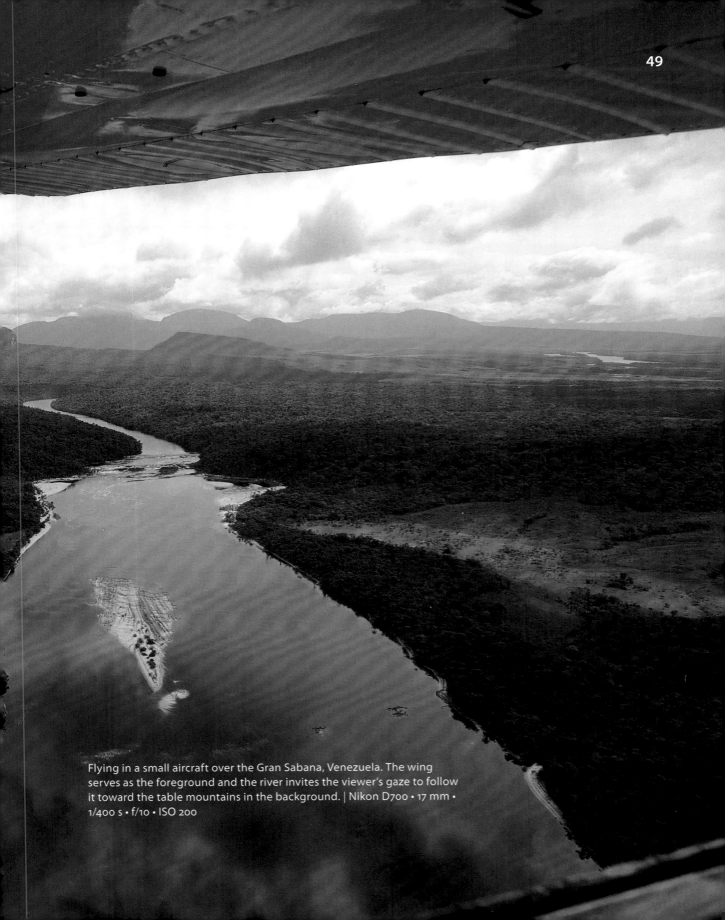

Flying in a small aircraft over the Gran Sabana, Venezuela. The wing serves as the foreground and the river invites the viewer's gaze to follow it toward the table mountains in the background. | Nikon D700 • 17 mm • 1/400 s • f/10 • ISO 200

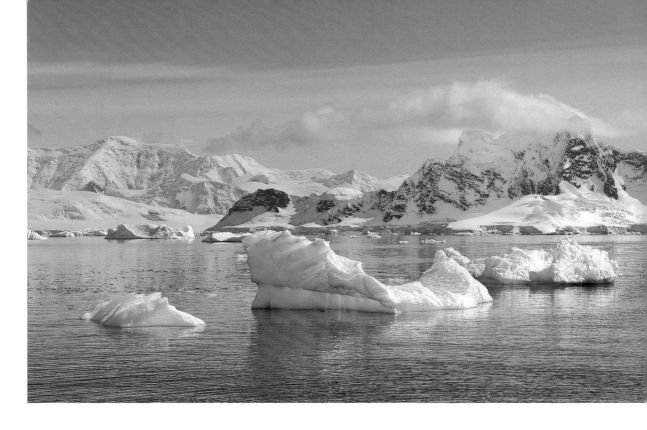

Antarctica without penguins? Unthinkable! But that's not the only reason the top photo lacks depth, despite the fantastic scenery of Paradise Bay. The bottom picture clearly benefits from an added dimension created by including the rocks and the Gentoo penguin up front. | Nikon D700 • 60 mm • 1/1250 s • f/8 • ISO 200

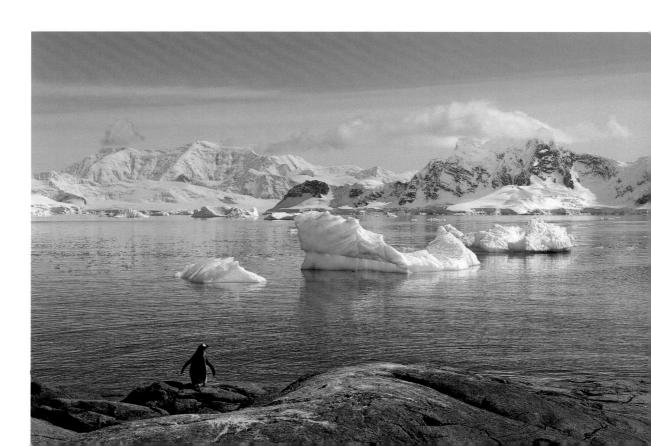

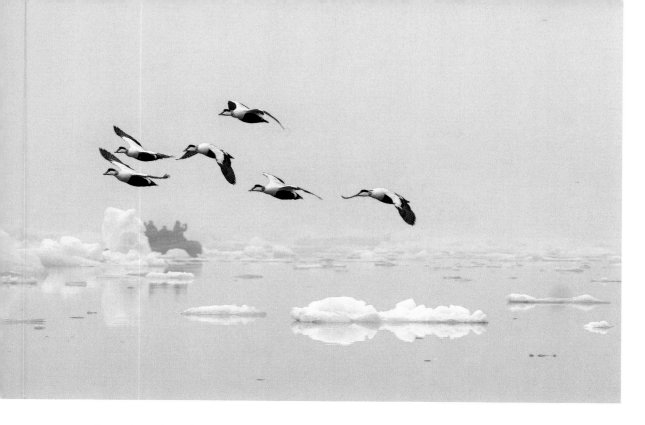

Flying through the fog: Eider ducks cross Hamiltonbukta (Spitsbergen) above floating icebergs and a rubber dinghy. The birds in the foreground provide a third dimension. The image was created while sitting in another inflatable. | Nikon D300 • 300 mm • 1/800 s • f/9 • ISO 500

In landscape photos, photographers often create levels of depth by emphasizing or at least deliberately including the foreground. Landscape photos without a foreground usually come across as flat and boring; they lack depth. More abstract photos, on the other hand, generally do well without a pronounced third dimension. If graphical elements such as lines, shapes, colors, or textures are the focus of an image, spatial depth is less important.

Ideally, the relationship between the foreground and the background extends beyond the optical level on to the content level. In pictures of mountains, for example, this is often achieved by including stones in the still water of a lake that reflects the peak behind it. Other photos incorporate a sense of depth by including a person who's traveling through a landscape in the foreground. Roads, paths, or marked lines that lead into the picture can also connect the foreground to the background and guide the viewer's eye. Whether you choose flowers, driftwood, pebbles, a gnarled tree, a sheep, your feet, or a tidal creek in a mudflat to serve as your foreground – the possibilities are limited only by your imagination, and whatever works is fine.

Another way to arrange a photo into distinct dimensional layers is by applying sharpness and blur in a calculated way (even if the goal when creating classic landscape photos is usually to have the largest depth of field possible to render everything in focus, from the foreground to the background). In some cases,

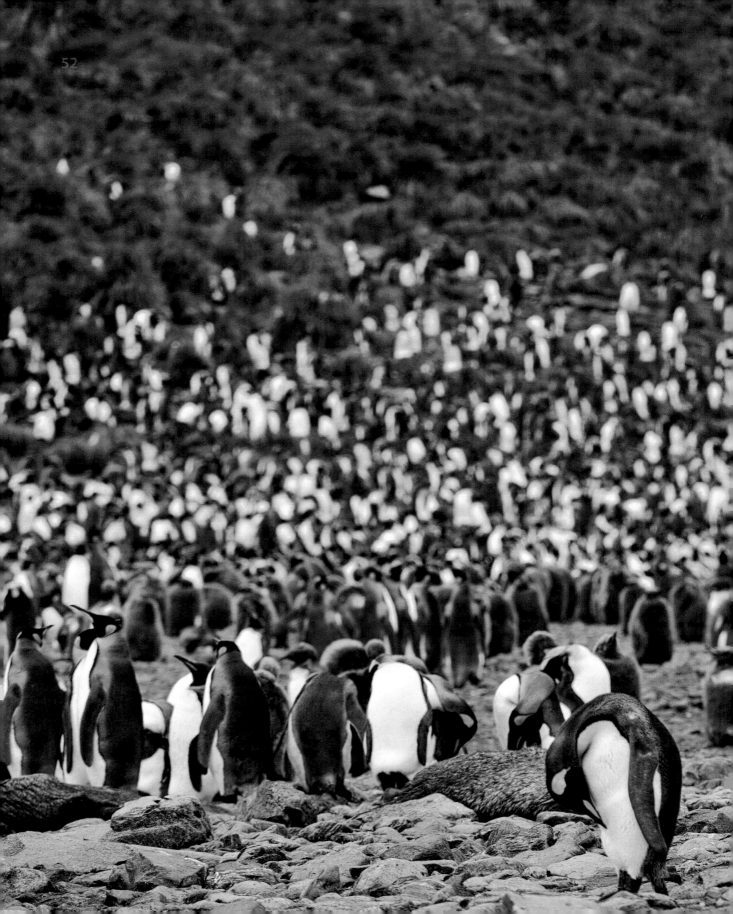

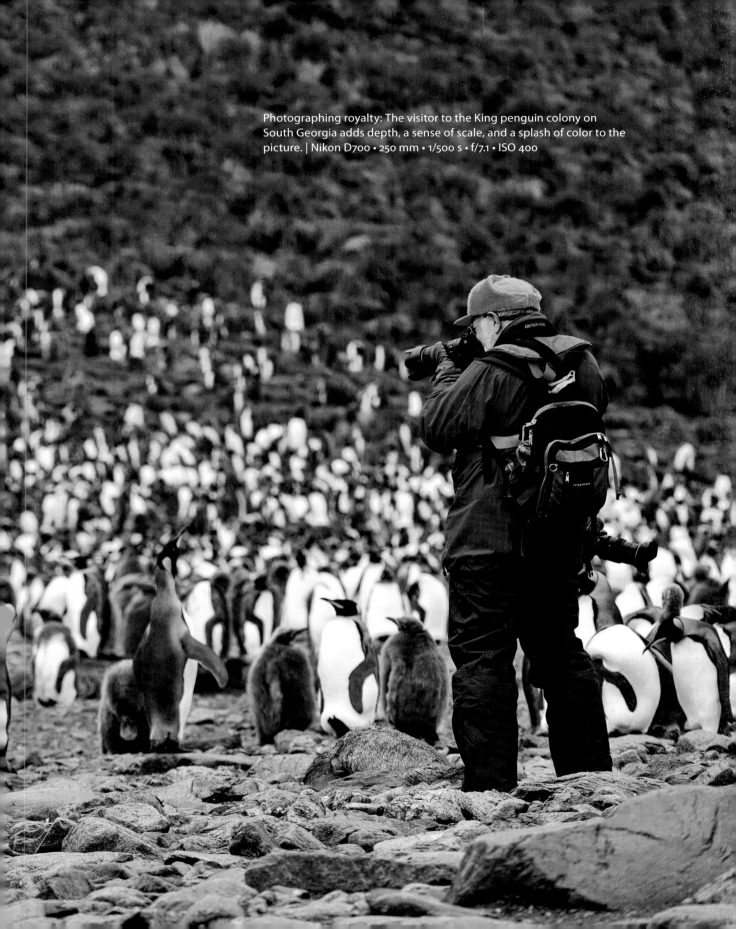

Photographing royalty: The visitor to the King penguin colony on South Georgia adds depth, a sense of scale, and a splash of color to the picture. | Nikon D700 • 250 mm • 1/500 s • f/7.1 • ISO 400

Composing images is possible with all types of cameras: The top picture was produced by a compact camera while the bottom one was made with a DSLR. Cordillera Huayhuash, Peru. | Above: Nikon P7100 • 35 mm • 1/160 s • f/6.3 • ISO 100. Below: Nikon D700 • 24 mm • 1/100 s • f/8 • ISO 400 • polarizer

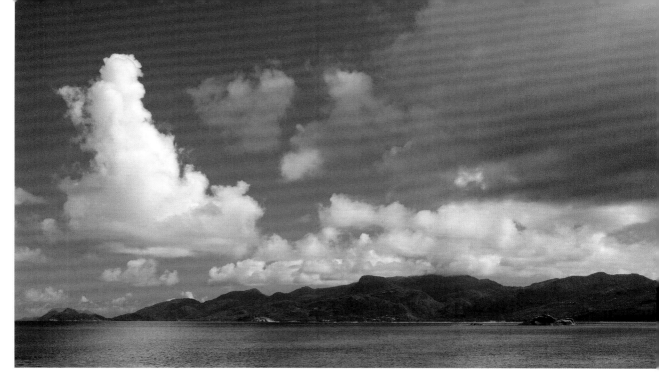

A foreground came floating by: Without the canoe, this view of Mahé, an island in the Seychelles, lacks depth. | Above: Nikon D70 • 38 mm • 1/320 s • f/9 • ISO 200 • polarizer. Below: Nikon D70 • 52 mm • 1/320 s • f/9 • ISO 200 • polarizer

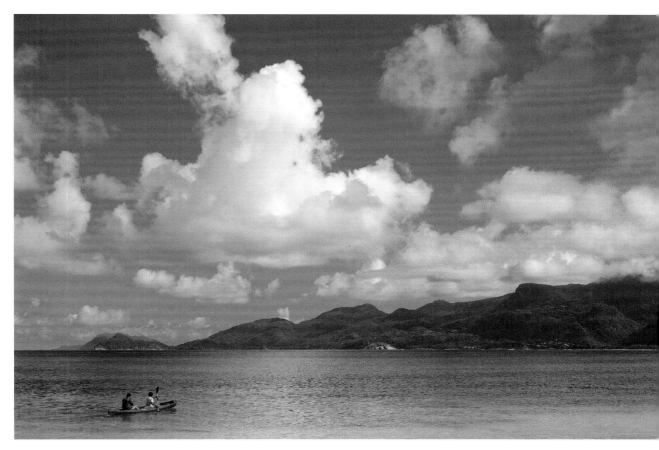

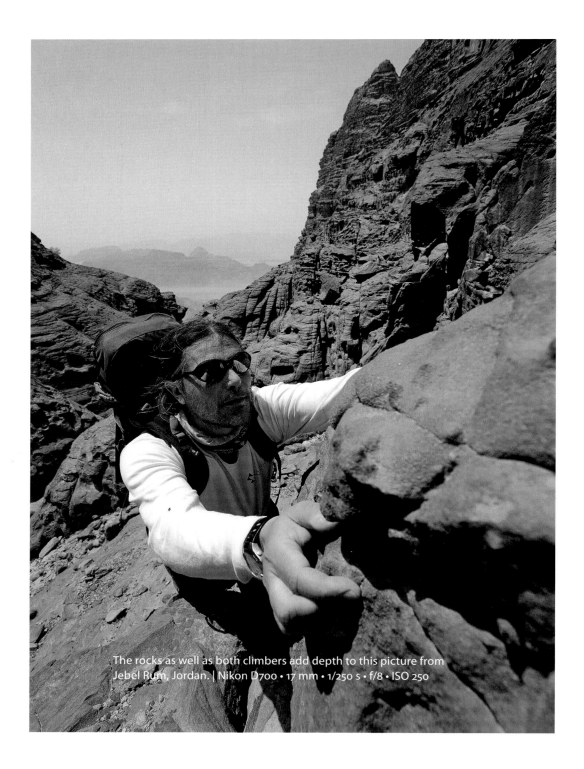

The rocks as well as both climbers add depth to this picture from Jebel Rum, Jordan. | Nikon D700 • 17 mm • 1/250 s • f/8 • ISO 250

you may open up the aperture to intentionally introduce depth through blur. When portions of a photo are not in focus, the sense of depth is almost automatic. Whether you decide to obscure the background or the foreground depends on which element is more important to your picture. Often, one of the two options will appear more harmonious than the other.

Admittedly, the play with depth of field belongs to the domain of larger camera sensors. Users of compact digital cameras might find themselves to be technically limited in this regard, since a compact camera's relatively tiny sensor in combination with its wide-angle optics tends to produce sharpness throughout the frame it captures, even with a nominally large aperture.

If it seems like I've been going on about landscape photography, then that's because it's a realm in which it's particularly useful to explain concepts related to the benefits of including a foreground. But many more photos benefit from added depth when you spring for a third dimension. Give it a try!

Without the photographer in the foreground this would have been a fairly standard picture from the Libyan desert. | Nikon D700 • 48 mm • 1/250 s • f/8 • ISO 200

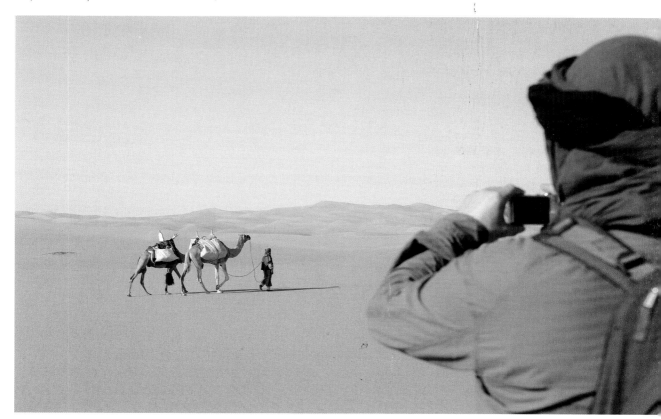

6　The Diagonal

Embracing the Slant

The diagonal has a long and honored place in photos. Using the longest length of an image – stretching from one corner across to the opposite one – is a compositional technique that allows photographers to add drive and tension to their pictures and create a marked sense of depth. Roads, paths, and fences are common examples of subjects that lead into a picture. On this double-page spread, it's a stream in the Wadden Sea. The viewer's gaze follows the stream, traveling up from the foreground into the background, which almost automatically gives the image a sense of spatial depth.

Not every diagonal line is the same. We associate lines that rise from the lower left to the upper right with energy, movement, ascent, speed, and excitement, even if these connections are mostly subconscious. In general, this type of diagonal introduces a dynamic element to a photo. A falling diagonal that

goes
from the upper left
of an image to the lower right has
a less dynamic effect. Within our culture area, this
diagonal has connotations of descent, perhaps even deterioration. Keep these connotations in mind when taking photographs, even if you can't always influence the direction of a diagonal line that you want to include in an image.
So diagonal lines build tension and add depth, but what about slanted lines that don't span the entire cross-section of the photo? They too can bring additional vibrancy to photos. It's for good reason that photographers are often keen to include such lines even when, at first glance, there is no obvious need to do so. Consider a subject from the realm of nature photography, the anatomy of leaves. The most attractive of these types of images often show that the

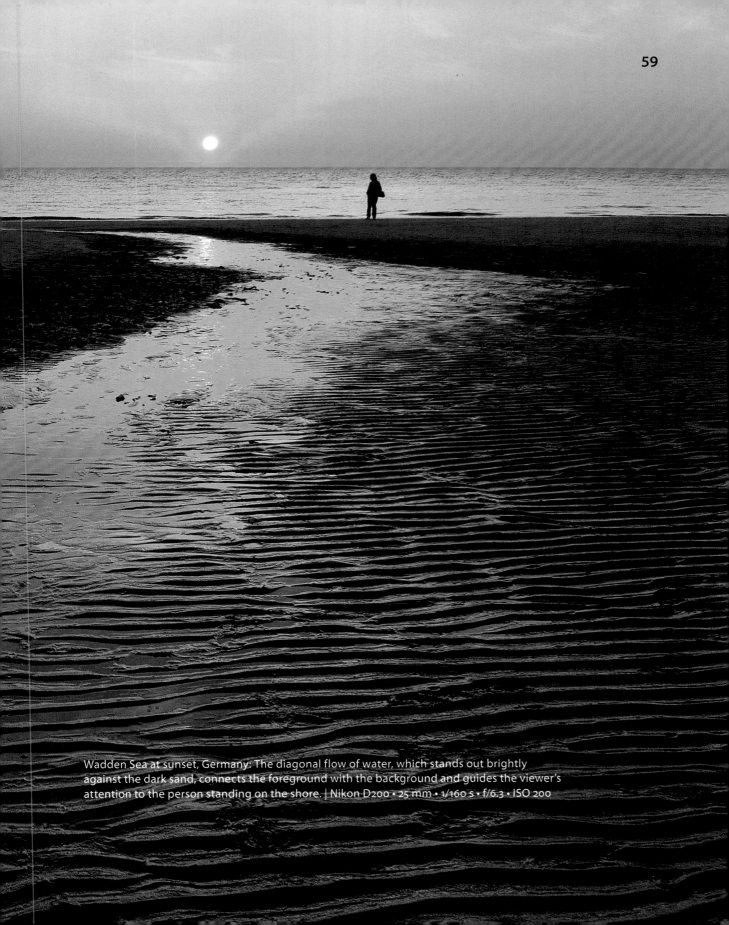

Wadden Sea at sunset, Germany: The diagonal flow of water, which stands out brightly against the dark sand, connects the foreground with the background and guides the viewer's attention to the person standing on the shore. | Nikon D200 • 25 mm • 1/160 s • f/6.3 • ISO 200

photographer made the deliberate choice to set a leaf's natural structures as slanted lines rather than as lines parallel to the image border. In architectural photography, too, a slanted line can create a more dynamic feeling. As mentioned, it doesn't need to be a complete diagonal, but when a straight line is available, as is often the case in pictures of streets or canals (think of a consistent frontage, for example), the image composition can be improved if a diagonal or straight line runs directly to the corner.

Bent or curved lines often have an even stronger dynamic effect than straight lines. And they are usually easier to find, especially in nature; you just have to keep an eye out for them. As is the case with many other elements of image design and composition, once you become conscious of diagonals, you start to spot them in the most diverse subjects and in the most unusual circumstances. Eventually you might even start to search for them actively.

Above: A story told by the sea. I found this still life at ebb tide of the Wadden Sea in the North Frisian Islands, Germany. | Nikon D200 • 72 mm • 1/160 s • f/6.3 • ISO 100

Above right: Near St. Peter-Ording, Germany. The surface of the water reflects the sky and guides the viewer's attention through the picture. | Nikon D70 • 105 mm • 1/200 s • f/7.1 • ISO 200

Right: A passing moment in Venice, Italy. Every alley, canal, and open square is rich with subjects in this city. Nikon D700 • 35 mm • 1/1000 s • f/8 • ISO 800

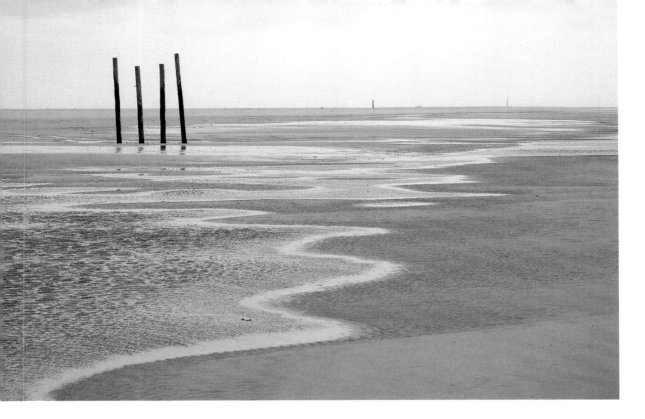

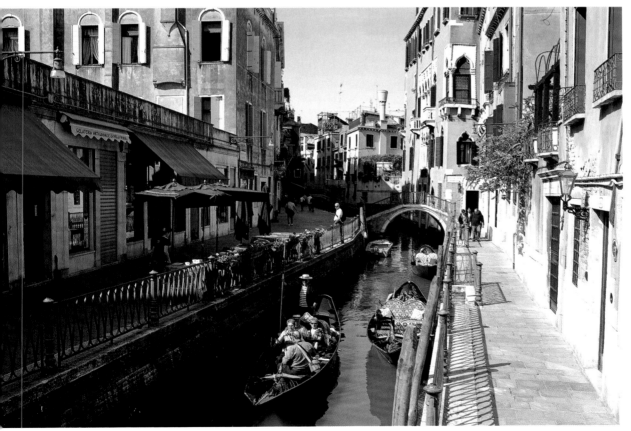

The picture below of resting elephant seals in South Georgia came about unexpectedly. Originally, I had a completely different photo in mind – a portrait format image showing one animal peeping out from behind the back of another (opposite page). But the almost parallel lines of the snuggling animals' backs sparked the idea to include the rising diagonal as a means of composition. In the end, it was the landscape format photo I liked better than the portrait variety, first and foremost because of the diagonal line and the dynamic element it brings into the picture.

Below: Having pleasant dreams – a moment in the life of an elephant seal, South Georgia.
Nikon D700 • 400 mm • 1/1000 s • f/4 • ISO 1000

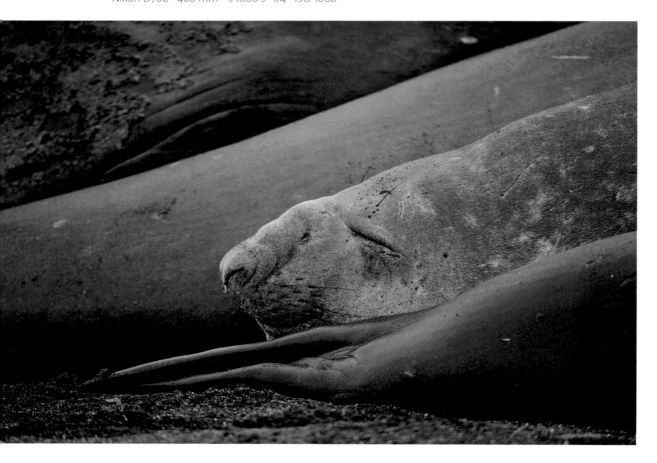

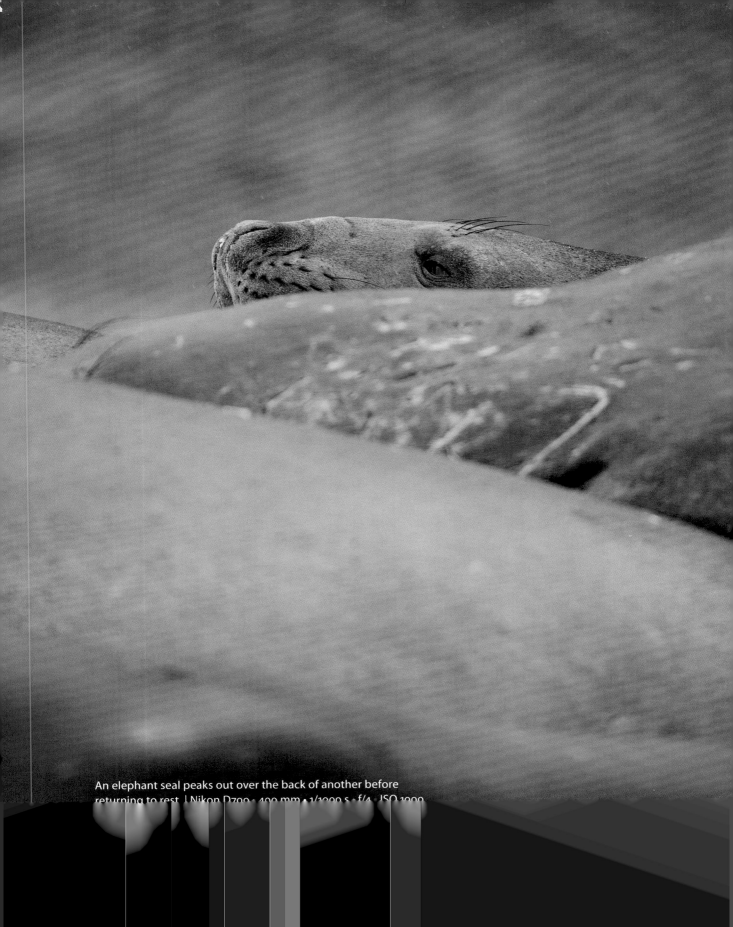

An elephant seal peaks out over the back of another before returning to rest. | Nikon D700 · 400 mm · 1/1000 s · f/4 · ISO 1000

7 Horizon

So Nothing Goes Askew

If you have a photo with the ocean slanting to one side, or a building teetering dangerously, or everyone running slightly uphill on level ground, then something's gone askew and it's time to take a look at the horizon. If you pay close attention when taking photographs you'll likely discover that you tend to take slightly unlevel pictures, often tilted to the same side. (The ocean is particularly useful for detecting any unevenness, since it's so unnatural to see the horizon there with even the slightest slant.)

Many photographers find themselves producing slightly off-level images, but that's not a big problem since it's relatively easy to remedy; it's often just a matter of concentration. If you consciously attempt to hold your camera level, you will usually align it properly. At some point, you will no longer need to concentrate in this way, and the process will become second nature.

Even so, it still happens that I'll take a look at one of my photos and think, "Something's gone askew here." This usually happens when I'm in a position where I need to work quickly or when there's no natural horizon line within the image. It's unfortunate, but the best thing you can do is be aware of the problem and look out for it in the future.

Cameras offer up some helpful tools to prevent slanted pictures. Some will allow you to superimpose an artificial horizon line (a sort of built-in level) in the viewfinder or on the display. With others, you may be able to activate grid lines, which can help you orient the camera. (If your camera model offers this feature, I strongly recommend that you make use of it. Grid lines can also help improve the image composition.)

Many tripods have built-in levels that are quite helpful. Alternatively, you can purchase a mini level for the flash mount; however, I'm of the opinion that the flash mount is meant to accommodate a flash or a wireless flash trigger.

Generally, image editing processes are another option for taking care of this problem. Every image editing software has relevant solutions. But these methods are less than ideal for two reasons: First, you want to spend as much time as possible taking pictures rather than sitting on your computer editing them. Second, the retroactive straightening process leads to a loss of image area and visual data. As a result of the necessary rotation, triangular areas at each corner of the image will need to be trimmed off (unless you decide to clone information from other parts of the picture).

If you have positioned important visual elements near the border of your image, this rotation and the subsequent cropping can quickly lead to problems if something critical gets cropped out or becomes at least partially clipped. Furthermore, the image rotation can

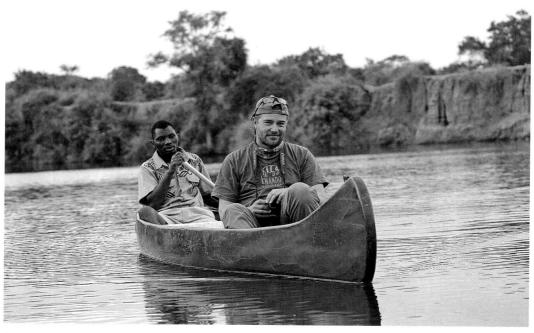

A canoe safari on the Chongwe River, Zambia. The slanted surface of the water in the background and the reflections make it apparent that the camera was off kilter. The version below was digitally corrected afterwards. | Nikon D700 • 120 mm • 1/320 s • f/6.3 • ISO 3200

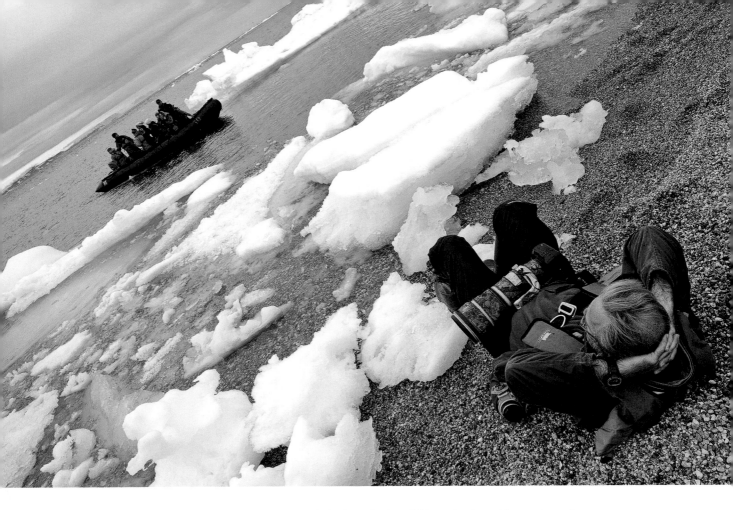

Necessity is the mother of invention: With the lens I had available at the time, this was the only way to capture both the boat and its onlooker in the same frame. If I straightened this image in post-processing, there wouldn't be much of it left. | Nikon D300 • 36 mm • 1/320 s • f/9 • ISO 400

compromise the composition, even if only to some extent. The example from Zambia on the previous page shows that the corrective digital rotation significantly reduced the amount of space in front of the canoe and caused the tree in the background to move precariously close to the top border.

What if there's no horizon line in the photo at all? Good question. Most pictures contain a passable substitute for figuring out what is straight and what isn't. For example, the bank of a river or the edge of a building can act as a substitute for the horizon. A reflection in water can be used as a guide for aligning your image properly – if the image is level, the subject will appear directly above its reflection. Your gut instinct can also be helpful. And sometimes it just doesn't matter whether the horizon is level, as with detail pictures, for example, or when you want your picture to be obviously slanted. If this is your intention, don't just tilt your camera one or two degrees – go all in. You need to

make it clear to the viewer that it was a deliberate compositional choice, not an accident.

In addition to horizontal lines, photographers should also keep an eye on vertical lines. As a rule of thumb, vertical lines in architecture photography should run parallel to the image border. Slanted vertical lines can be corrected digitally; however, in this case you'll want to leave enough space around the building to allow for the correction later and to ensure that the eventual crop doesn't leave any white areas behind. Or you make a virtue of necessity and leave the converging verticals in your image to illustrate the architectural dimensions or to create an unexpected and dramatic impression. If this is the route you choose, again, don't hold back. Make your intentions unambiguously clear so no one thinks you've made a mistake.

This freehand shot of an iceberg in Antarctica can't be saved with a digital rotation. Much of the picture, including the reflection, would be lost. Which makes this photo junk, unfortunately. | Nikon D700 • 24 mm • 1/800 s • f/6.3 • ISO 200

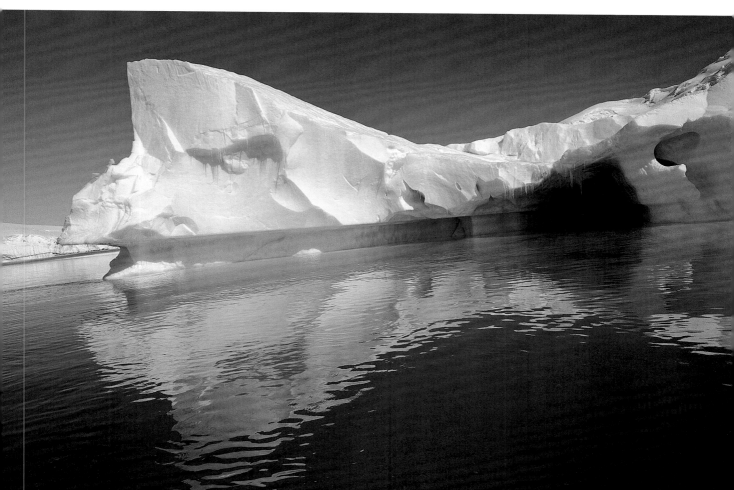

8 A Matter of Perspective

Down Low or Up High

Set yourself up in front of your subject, hold up your camera, frame your shot – click. That's how most photos are taken: from our normal angle of view, at our everyday level of sight. We look up to see and take pictures of anything above eye level and we look and photograph down at anything below it. There's nothing wrong with that, but if you take all your pictures from this perspective, you risk your photos becoming predictable and dull on account of the all-too-familiar point of view. This is especially true when several pictures placed next to one another have the same perspective, perhaps in a vacation travelogue, in a photo book, or in a slideshow. For this very reason, it's advisable to liven up your photos a bit by changing your perspective. Climb up on a tower, stand on a chair, step up to the next floor, crouch down, take a knee, have a seat, lie down on the ground – (almost) everything is possible.

The main constraint related to the play of perspective is the same related to the foreground: photographers should attempt to map three dimensions of reality onto a two-dimensional medium. The missing dimension – spatial depth – is left up to the viewer's imagination. Viewers subconsciously use clues in the picture for help, and this is where the perspective comes into play.

Perspective is all about how you capture spatial objects in two-dimensional representations. Your camera's position determines the perspective of a photo. And since you decide where to position yourself and your camera for a shot, it's your responsibility to select the perspective. Doing so amounts to one of the most critical factors in a picture's composition because it has a tremendous influence on how your picture will ultimately be perceived.

Taking a picture in the traditional way of holding the camera to your eye and exposing the scene that is directly in front of it gives the viewer the impression that he or she is at eye level with the subject (if it's relatively close to human-size). This is our daily perspective, which makes it feel familiar, but also conventional and unspectacular. Always using the same perspective – particularly the normal perspective, because it's the most comfortable to establish and usually the most self-evident option – is one of the main reasons photos come across as boring.

Having said that does not mean that you should avoid the normal perspective. But there is a lot that speaks in favor of not using it for every single picture. Because the normal perspective matches the natural angle of view at which we take in our surroundings,

Elephants in Kafue National Park, Zambia (aerial photo). Fast shutter speeds are necessary when photographing from a helicopter. | Nikon D700 • 70 mm • 1/1000 s • f/3.2 • ISO 1250

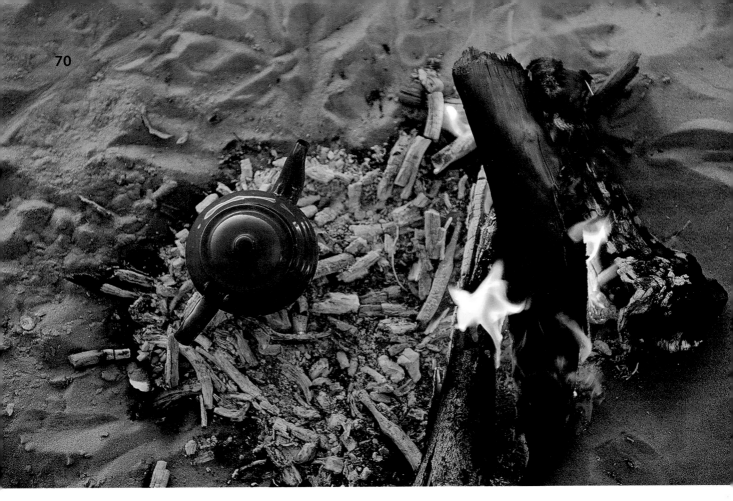

Before the evening tea ritual in the Libyan Sahara: A view of the campfire and teakettle from an unusual perspective. | Nikon D700 • 62 mm • 1/40 s • f/2.8 • ISO 3200

applying an unusual perspective can be a particularly effective manner of capturing a subject in a surprising way.

A general rule to keep in mind is that a good perspective supports the overall intention of a photo, and it should be evident to the viewer that the photographer gave some thought to his or her position and angle of view. This isn't tantamount to saying that any photo is a good one if it features an unconventional perspective. The success depends on the subject and the motive of the photographer, and each perspective has certain char-

acteristics that can benefit or detract from the strength of a photo.

Taking a picture from above, from a bird's eye view, causes the subject to appear small and compressed. If you want to convey that your subject is diminutive, then this perspective is perfect for you. A bird's eye view also provides a good overview of a situation, such as the view from a mountain over the surrounding landscape and valleys; a photo from the grandstands of the entire playing field, stadium, and crowds; or a shot from the top deck of a ship surrounded by ice floes.

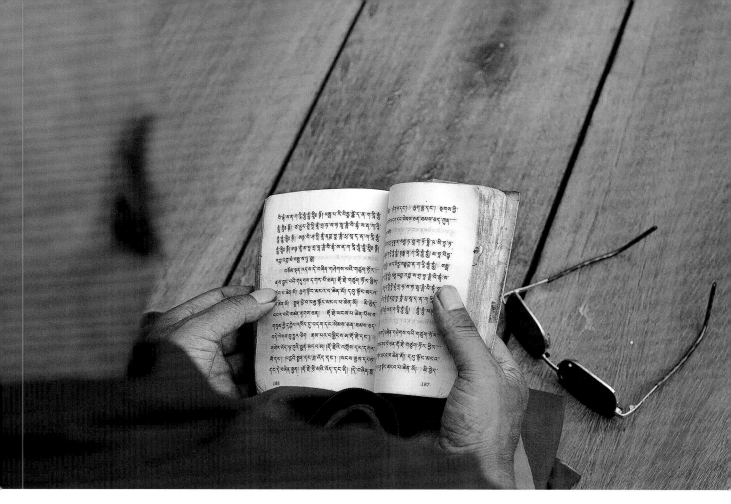

Looking over the shoulder: Absorbed in reading, a Tibetan monk sits at the Stupa of Boudhanath, Nepal.
Nikon D700 • 70 mm • 1/320 s • f/5.6 • ISO 640

However, other photos taken from this perspective can appear condescending depending on the subject. This is especially true when sitting, crouching, or kneeling people are photographed. Photographers often carelessly shoot from their standing position because they don't want to take the trouble to sit, crouch, or kneel down. It's pretty much the same with photographing children: An adult photographer needs to kneel down to take pictures of children at eye level. Doing so will not only reduce or avoid perspective distortions. Getting yourself down to the kids' eye level is also highly advisable to avoid ending up with photos of more or less wide-eyed youngsters looking up at the much taller photographer. (You may, of course, have good reason to set up a photo this way.)

Finally, meeting a subject at eye level is not only a question of optical equality. It takes time and consideration, respect and readiness to strive for a successful picture. For this reason alone, the attempt is worthwhile no matter what your subject is.

Eye level is also important when it comes to animal and safari photography. Appealing

pictures of animals are often created with the camera at or near the eye level of the animal – the floating grebes would be photographed not from the elevated shore of a lake, but from a camouflaged hide a few centimeters above the water surface; the antelope not from the safari jeep, but from the ground.

Getting a low camera position that roughly corresponds to the normal perspective of certain animals isn't always easy when on safari. But you can try to avoid taking pictures from the top of your safari vehicle with a sharp downward angle, for example, and instead opt to photograph through a window. This will bring your vantage point down a few feet

so that you're closer to the eye level of zebras, gnus, or antelope.

In your excitement when taking pictures, don't forget about your surroundings and the prevailing conditions. To get the shot of the chinstrap penguin jumping out of the water shown on the opposite page, I had to crouch down on some wet, slippery rocks while holding my camera out in front of me at ground level. Prefocusing and a quick shutter speed established the necessary sharpness; the low position of the camera enabled me to capture the animal at eye level and allowed for the inclusion of the foreground, which brings depth to the image and conveys information

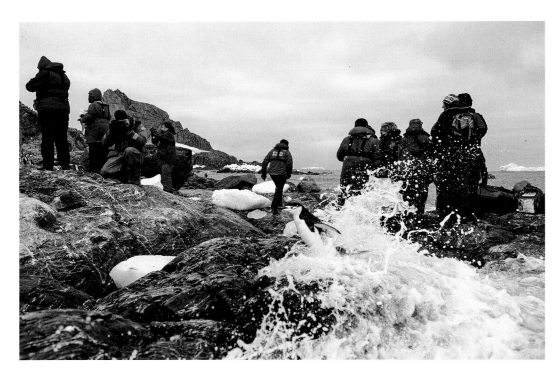

Got up just in time: A wave breaks over the rock formation where I had been crouching down to get the low-angle picture of the penguin (opposite page). The two images were separated by only a few seconds.
Nikon D700 • 24 mm • 1/1250 s • f/5.6 • ISO 400

Chapter 8

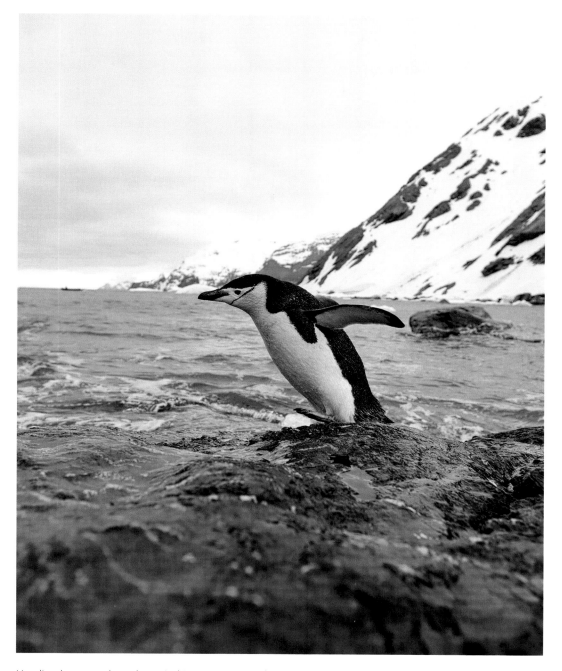

Heading home to the colony: A chinstrap penguin hops onto land on Elephant Island, Antarctica.
I positioned my camera close to the ground with an outstretched arm to get as low a position as possible.
Nikon D700 • 24 mm • 1/1250 s • f/5.6 • ISO 400

A Matter of Perspective

Close together: Live toads sit in a basket at the morning market in Luang Prabang, Laos.
Nikon D700 • 70 mm • 1/100 s • f/2.8 • ISO 320

about the penguin's habitat. Only seconds after taking the photo, a wave crashed over the rock almost submerging my camera and lens. The photo on page 72 was taken just a few seconds after the picture of the penguin; you can see the water breaking over the rocks. By sheer luck my equipment sustained no damage.

Taking a picture from a worm's eye view – upward from below – makes subjects appear dominant and powerful. Small objects appear large, large ones appear huge. Vertical lines like trees, edges of buildings, and lamp posts appear longer than they actually are and the perspective distortions reveal the relatively low position of the camera. Looking up at an object

or person can also convey wonder or reverence for the subject.

With people, the worm's eye perspective can quickly lead to unflattering images. The chin gains prominence and the nostrils are given more attention than is advisable. For portraits it's usually best to use the normal perspective or position your camera slightly above your subject's eye level.

There are a couple of other things to consider when taking pictures with an upward angle: first, the often extreme contrast between a dark subject and a bright sky, and second, the fact that the camera's exposure meter may be fooled by the excessive quantity of light

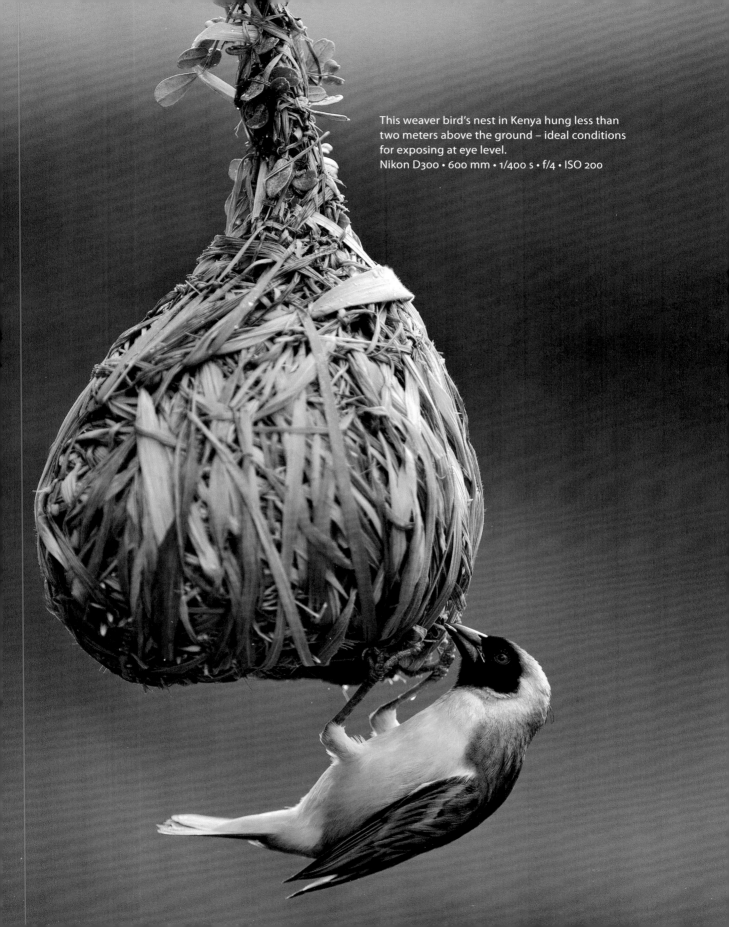

This weaver bird's nest in Kenya hung less than two meters above the ground – ideal conditions for exposing at eye level.
Nikon D300 • 600 mm • 1/400 s • f/4 • ISO 200

entering the camera's lens, resulting in under-exposure. The latter problem you can correct manually. The contrast problem, however, is a fundamental one. To prevent your subject from becoming an unwanted silhouette, or your sky from becoming a wash of white lacking any detail when you meter for a correct exposure of the foreground, you will either need to change your camera's position to find a darker background or use fill flash to brighten the foreground and reduce the contrast at least a bit. Chapter 13 (page 112) covers this in greater detail.

Way up high: At 328 meters (1,076 ft), the Sky Tower is a symbol of Auckland, New Zealand. Being busy with determining a composition that included the reflection, I completely overlooked the flagpole in the foreground – a case of selective perception. | Nikon D70 • 27 mm • 1/250 s • f/8 • ISO 200

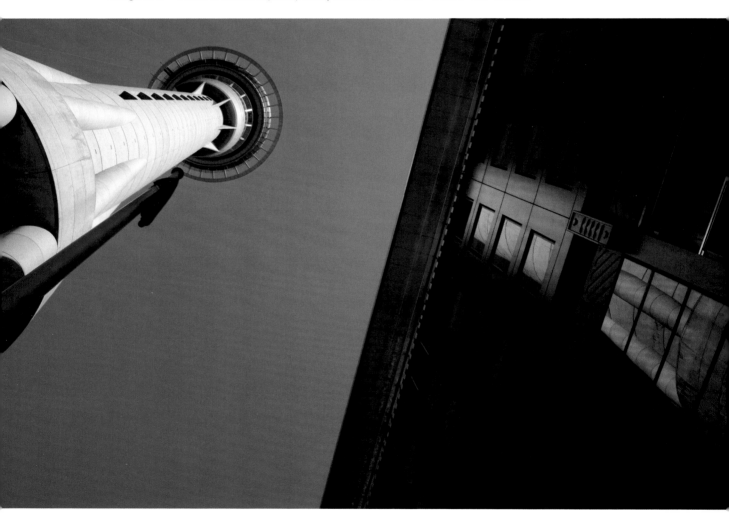

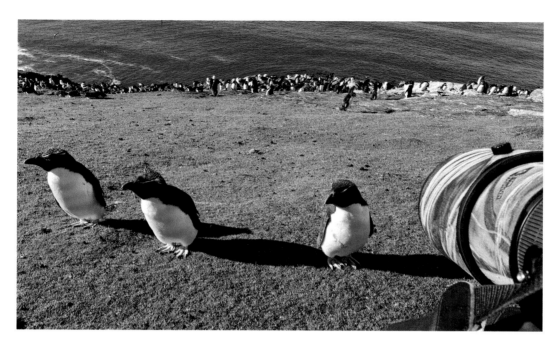

Looking downward, by necessity: Rockhopper penguins on the Falklands come within arm's reach.
I made this documentary picture using a compact camera. | Leica D-LUX 6 • 24 mm • 1/1600 s • f/4 • ISO 160

Looking downward, by design: A foreign visitor to the penguin world (Falklands). The elevated standpoint produces a good overview of the scene and the animals' habitat. | Nikon D700 • 260 mm • 1/6000 s • f/5.6 • ISO 200

A Matter of Perspective

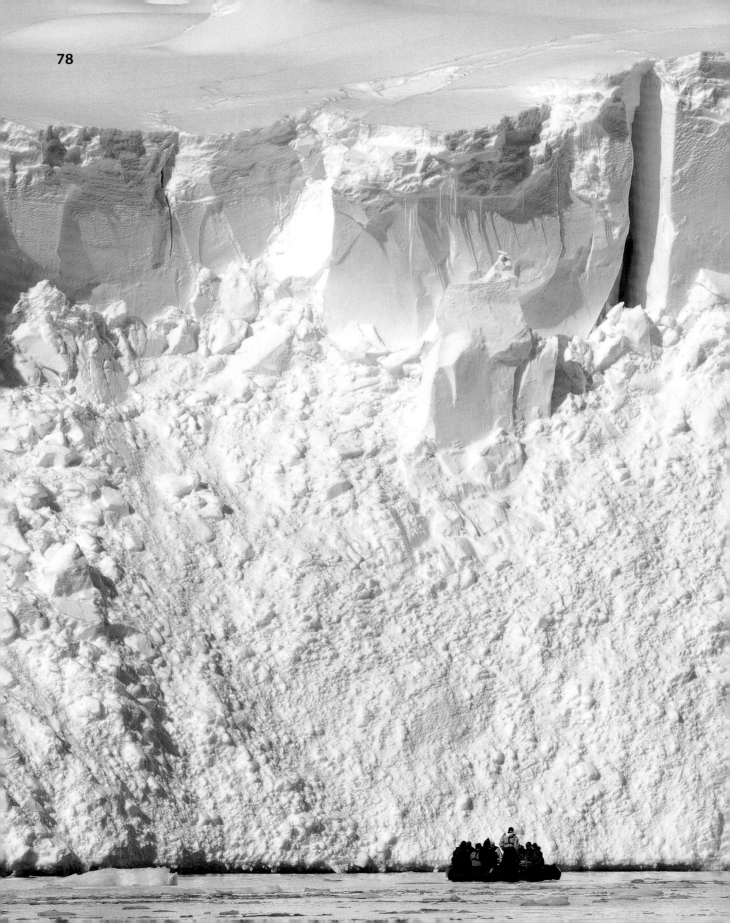

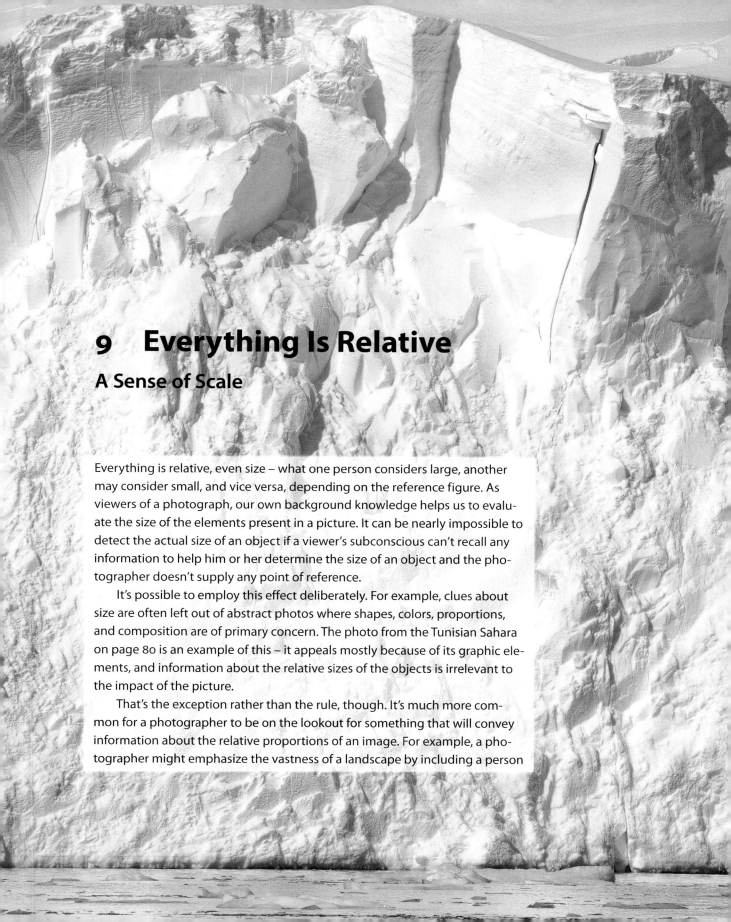

9 Everything Is Relative

A Sense of Scale

Everything is relative, even size – what one person considers large, another may consider small, and vice versa, depending on the reference figure. As viewers of a photograph, our own background knowledge helps us to evaluate the size of the elements present in a picture. It can be nearly impossible to detect the actual size of an object if a viewer's subconscious can't recall any information to help him or her determine the size of an object and the photographer doesn't supply any point of reference.

It's possible to employ this effect deliberately. For example, clues about size are often left out of abstract photos where shapes, colors, proportions, and composition are of primary concern. The photo from the Tunisian Sahara on page 80 is an example of this – it appeals mostly because of its graphic elements, and information about the relative sizes of the objects is irrelevant to the impact of the picture.

That's the exception rather than the rule, though. It's much more common for a photographer to be on the lookout for something that will convey information about the relative proportions of an image. For example, a photographer might emphasize the vastness of a landscape by including a person

Wind-combed sand dunes at the Grand Erg Oriental, Tunisia. It's not easy to determine the height of these sand formations or the distance between them. | Nikon D70 • 75 mm • 1/200 s • f/6.3 • ISO 200

The hiker in the Venezuelan Andes makes a significant contribution to this photo, developing the feeling of getting lost in the green of the jungle. He serves as a reference for size, a splotch of color, and an eye catcher all at once. | Nikon D700 • 17 mm • 1/125 s • f/5.6 • ISO 1000

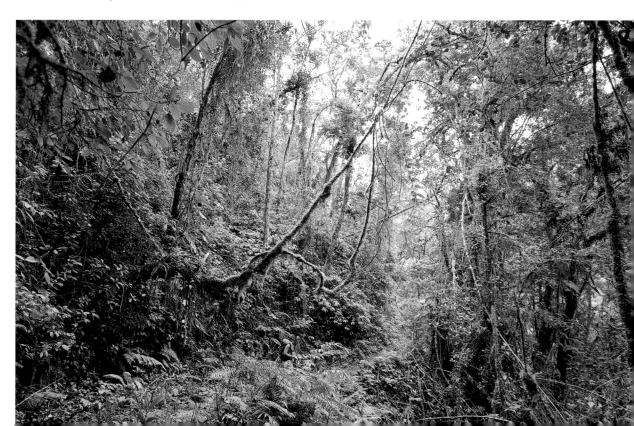

who appears tiny within it. This kind of information about proportions supplements and often even constitutes the message of a photo: Look how imposing the glacier's escarpment on the previous spread looks next to the (relatively) tiny rubber dinghy! Without the raft and the people in it this photo would lose most of its power because there would be no point of comparison to comprehend the massiveness of the ice cliff.

Furthermore, the details of this photo convey additional information about its origin (somewhere with such mighty glaciers; in this case, the Antarctic Peninsula), and it inspires associations with coldness, loneliness, wander-lust, respect, and fear. Without the boat and the people, none of this would come about.

For these reasons, it's a good idea to incorporate clues about the (relative) size of your subjects whenever you feel you should do so to provide additional information. It's usually not all that difficult to do, since many objects can establish a point of reference as long as viewers have a clear understanding of their approximate size. Photographers very often use people or cars to indicate the size of their main subject; but animals (if the viewer is familiar with their size), paths or roads, buildings or parts of buildings, footprints, and even your finger can also do the trick.

Here the photographer had to serve as a frame of reference. This reed frog in the Okavango Delta in Botswana is hardly larger than my thumbnail. I took this photo during a tour in a dugout canoe.
Leica D-LUX 5 • 90 mm • 1/125 s • f/3.3 • ISO 80

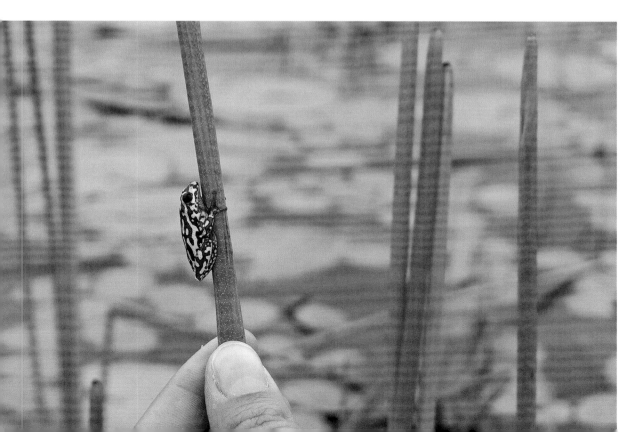

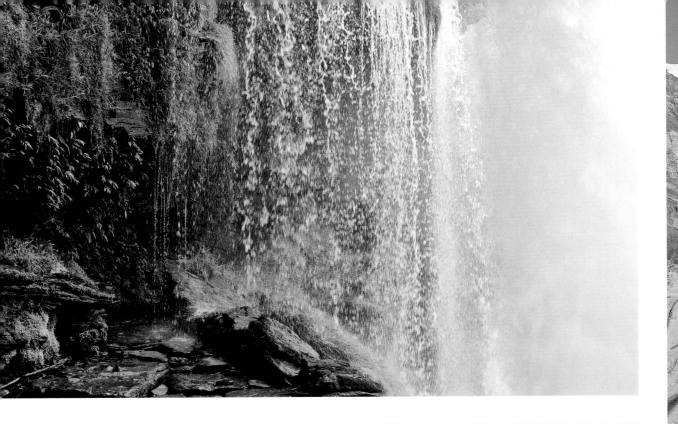

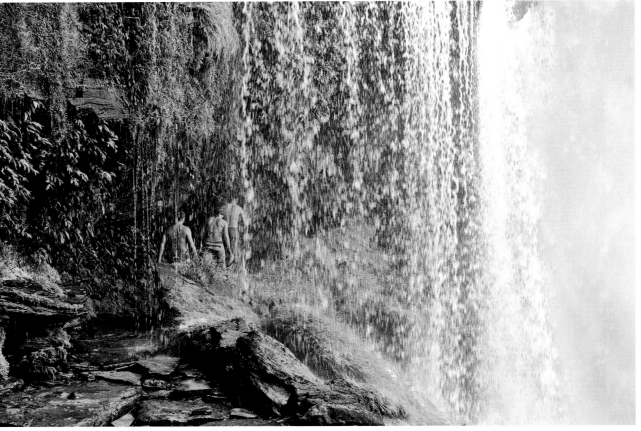

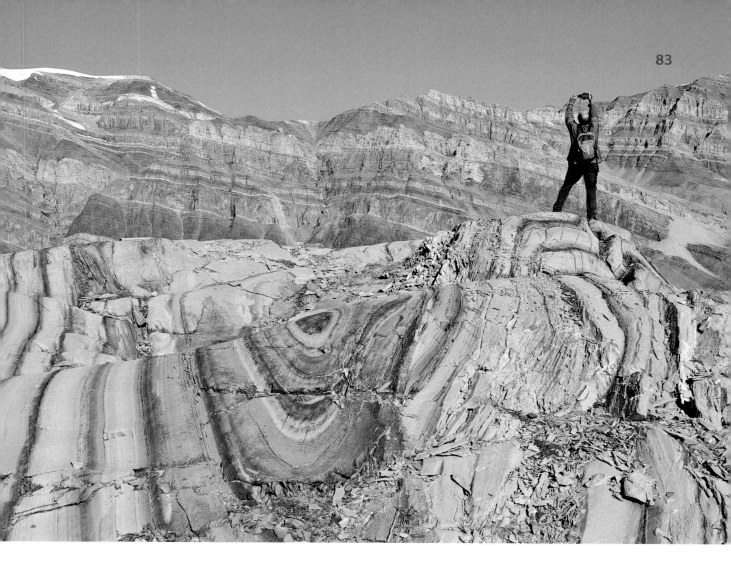

Comparing sizes by playing with perspective: Eastern Greenland is a paradise for geologists and photographers alike. | Nikon D700 • 48 mm • 1/400 s • f/10 • ISO 200

Top left: A picture of a waterfall. It's almost impossible to tell the size of the cascades.
Nikon D700 • 70 mm • 1/160 s • f/6,3 • ISO 200

Bottom left: A storytelling picture of the same waterfall shows that Salto Sapo in Venezuela is so large that people can actually walk behind it. | Nikon D700 • 70 mm • 1/125 s • f/5.6 • ISO 200

Everything Is Relative

10 Ninety Degrees More or Less
The Underrated Portrait Format

How many photos from your last trip were shot in landscape format? Maybe 95 percent, or 98? Holding the camera in landscape format is much more logical and comfortable, and it corresponds to our natural perception (our eyes are next to each other, not on top of one another). In many cases the landscape format seems like the best option, and in many cases it is. But some subjects and pictures would greatly benefit from a change of format. It may seem like it's more trouble and less comfortable to hold the camera in the portrait format, but the advantages outweigh the risks, not just with portraits. All it takes is the courage to turn your camera 90 degrees.

The first encounter with portrait format is often one of necessity: the subject simply won't fit into a landscape-format image because the focal length is too long or because it's impossible to increase the subject-to-camera distance. In many cases, however, a serious problem comes along with this use of the portrait format, first and foremost with urban photography – namely, converging verticals resulting from perspective distortions. Apart from that, the portrait format is much too valuable to serve only as a stopgap measure for these circumstances.

In almost any case, the portrait format will produce a photo with a drastically different effect than a landscape-format photo of the same subject. This makes changing up your format a worthwhile exercise in order to explore and take advantage of the peculiarities of the portrait orientation.

While the landscape format usually emphasizes the effect of horizontal lines and structures, thereby expanding the width and stability of a photo, the portrait format lengthens vertical lines and adds drive to many photos. The latter is a more challenging format for our habits of perception, but because of this, it also commands greater attention.

In some instances, the portrait format has downright practical advantages. Distracting elements surrounding your subject in landscape format can be relatively easily disregarded by adopting a portrait format. Composing panoramas of landscapes from several portrait-format exposures gives you more room above and below your subject for an eventual crop than landscape-format pictures. And then there are also photos that only work in portrait format; they would lose their impact if shot in landscape format. Apart from portraits, this includes wide-angle photos whose immediate foreground plays a key role in the composition, for example.

On a mountain tour in Peru: Climbing Diablo Mudo, Cordillera Huayhuash.
Nikon D700 • 24 mm • 1/500 s • f/11 • ISO 200

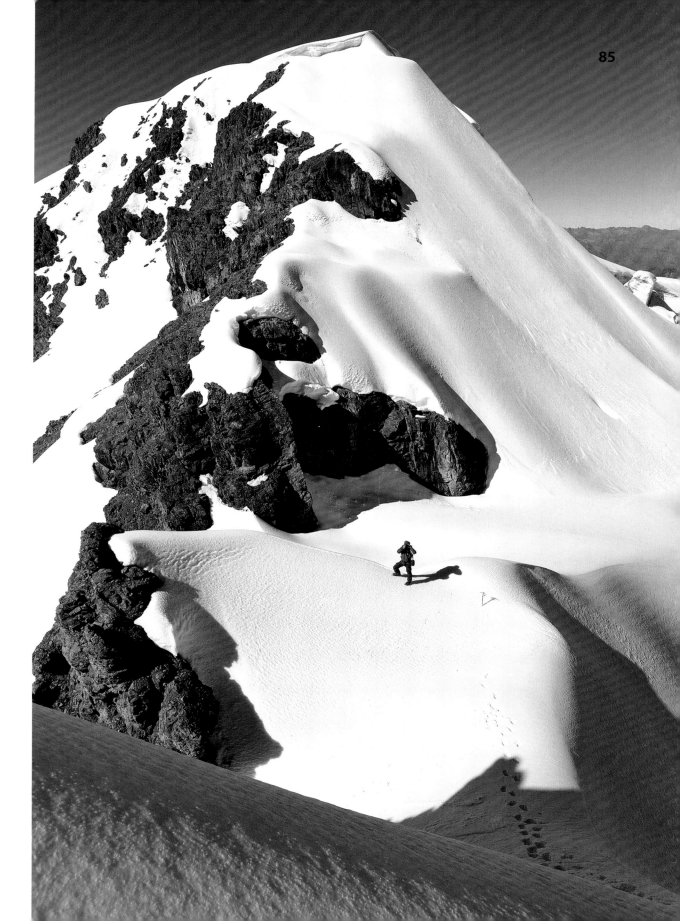

Sometimes you will instinctively recognize a specific photo or composition calling for the portrait format. In many cases, however, you'll approach the idea gradually, often after already having bagged a landscape-format version, as was the case with the pictures on this spread. The subject – the hands of a Tibetan monk linked behind his back and guiding a string of prayer beads through his fingers – had drawn my attention, and I first took some landscape-format shots. When I realized that the crop on the sides was far from being tight enough, I shifted to the portrait format.

One of the reasons that we don't use the portrait format as often and as naturally as we might surely has to do with the fact that most cameras seem to have been designed with the landscape format in mind. The larger, heavier, and more cumbersome a lens and camera combination is, the more difficult it is to rotate it and then stabilize it for a sharp photo. A vertical grip attachment that doubles as a battery pack can make it much easier to work with the camera in portrait format by providing greater stability, particularly when you're working with longer focal lengths. I have discovered that I am much more likely to at least try to shoot in portrait format when I have the grip attached to the camera – obviously, this particular accessory broadens my photographic opportunities.

Some of our reluctance to use the portrait format is probably also based on previous

A monk with prayer beads in Sera monastery, Tibet. The image below was the starting point for my final picture (opposite). | Opposite page: Nikon D700 • 170 mm • 1/640 s • f/4 • ISO 1600

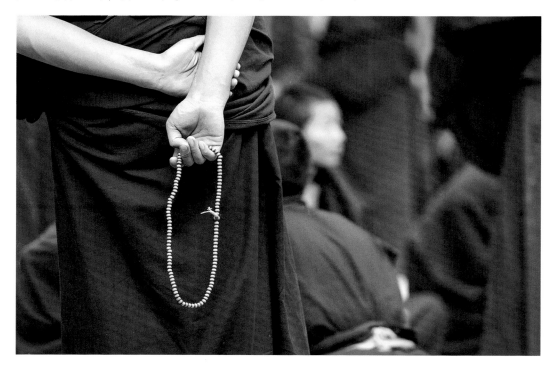

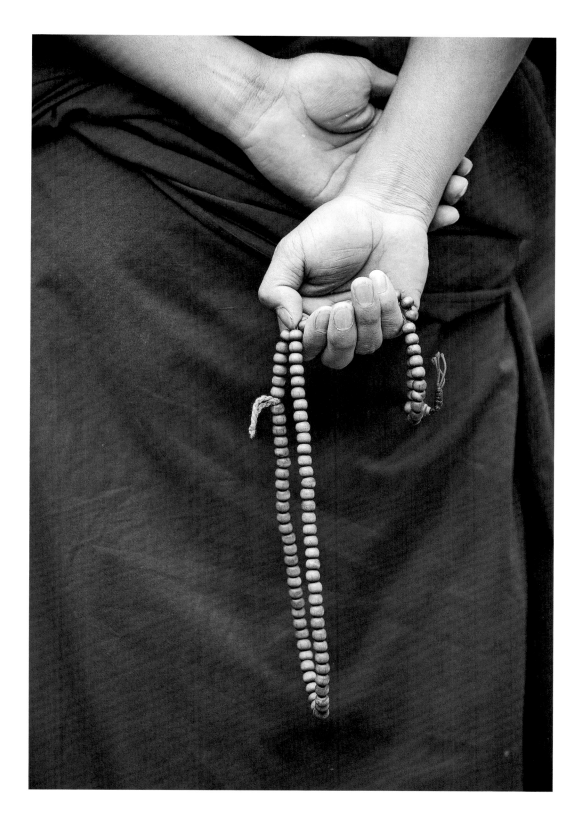

Ninety Degrees More or Less

Same subject, different effect: The picture above emphasizes the breadth of the landscape in Peru while the photo on the opposite page highlights the tension in the triangle created by the cairn, the lake, and the clouds. Top: Nikon D700 • 31 mm • 1/250 s • f/8 • ISO 400 • polarizer. Right: Nikon D700 • 38 mm • 1/1000 s • f/4 • ISO 400 • polarizer

experience. The more frequently the portrait format results in a successful image composition, the more likely we are to use it with fewer reservations. If you use a tripod regularly, you'd do well to purchase an L-bracket, which allows you to easily change between landscape and portrait orientation.

Despite all the encouragement for making use of the portrait format, however, there are some potentially undesirable consequences to keep in mind. Photographers who show their images in slide shows may want to stick with

the landscape format, as portrait-format photos are often difficult to integrate.

You also need to take caution when using the built-in flash for a portrait-format shot because the light will not be emitted from a point above the optical axis; instead, it will come from one side of the lens. Under certain circumstances this can result in an uneven distribution of light in your photo. External flash units, preferably with adjustable swivel heads, can prevent this problem, as they can be positioned away from the camera's flash mount.

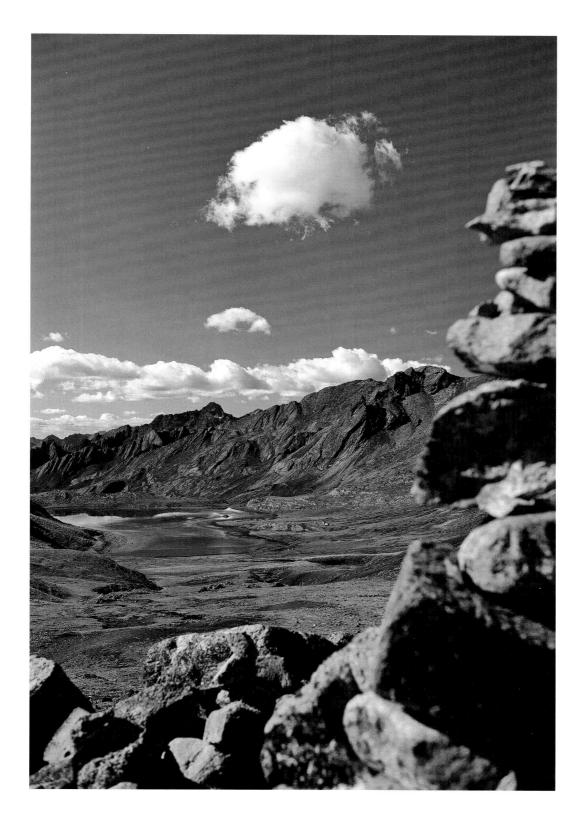

Ninety Degrees More or Less

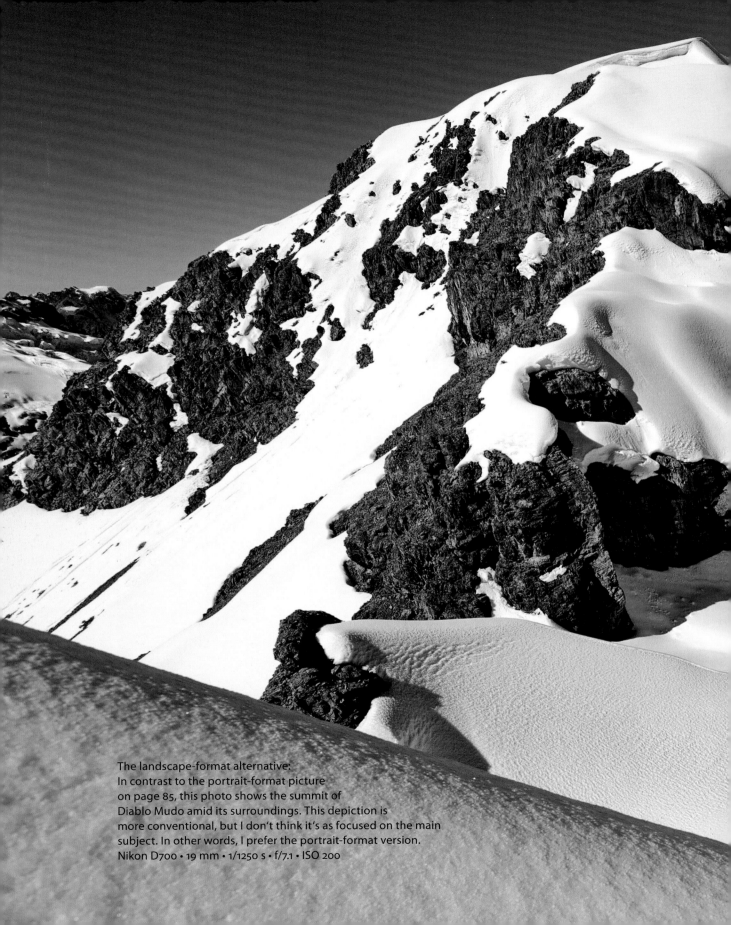

The landscape-format alternative:
In contrast to the portrait-format picture
on page 85, this photo shows the summit of
Diablo Mudo amid its surroundings. This depiction is
more conventional, but I don't think it's as focused on the main
subject. In other words, I prefer the portrait-format version.
Nikon D700 • 19 mm • 1/1250 s • f/7.1 • ISO 200

11 Less Is More

On Photographic Minimalism

In the words of French writer Antoine de Saint-Exupèry, "Perfection is achieved not when there is nothing more to add, but when there is nothing left to take away." Put differently: Most pictures are showing too much. Two clear-cut statements (the latter from photographer Andreas Feininger), one distinct message: Less is more. This applies as much to travel photography as it does to any other genre. The more distinct the composition, the less elements distract from the main subject, which in turn makes the photo more convincing.

Usually, it can only mean good things for a photo if its idea and main subject are obviously recognizable.

Minimalism, in the sense of focusing only on what's absolutely essential, is a means to an end for all types of photography. It implies maintaining a certain level of consistency with your compositions, selecting the image area carefully, waiting for the decisive moment, and tidying up the photo as much as possible.

It's up to you, as the photographer, to choose who, what, and how much from which perspective is revealed in your photos. Consider which element you want to have the main role in your photo and design your picture so that this very element actually plays the leading part rather than anything else. Ask yourself while looking in the viewfinder or at the camera display with a critical eye whether your composition holds up. Is there anything (besides what's absolutely necessary) that is distracting from the main subject? If there is, adjust your position to remove the distracting elements from your picture.

This might mean moving closer to your subject, or you might opt for a longer focal length or a wider aperture to isolate your subject from its surroundings.

The realm of minimalistic photography and abstract photography is rich with possibilities that are as diverse as they are fascinating. Photography of this genre may involve emphasizing details; concentrating on a composition that is convincing because of its simplicity; searching for a detail representative of a larger whole; documenting small variations that disrupt familiar patterns; or depicting structures, lines, colors, and shapes.

There are no limits when it comes to minimalist subjects and playful ways to capture them in an image. Try it! These subjects often present themselves unexpectedly along the way; you just have to develop a sense for what to look for. Fortunately, it's mostly a matter of practice, and it's equally enthralling and inspiring.

An African reduction: Even though only a small portion of the animal is visible here, every viewer recognizes the shape, color, and skin texture of an elephant. | Nikon D300 • 285 mm • 1/160 s • f/8 • ISO 200

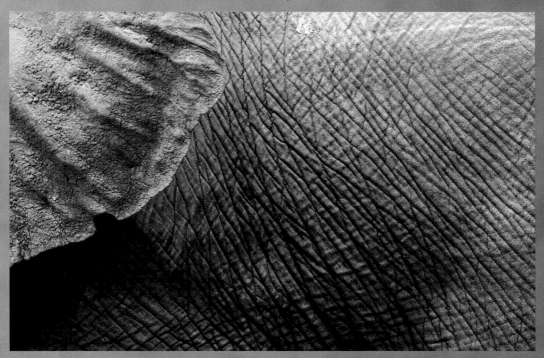

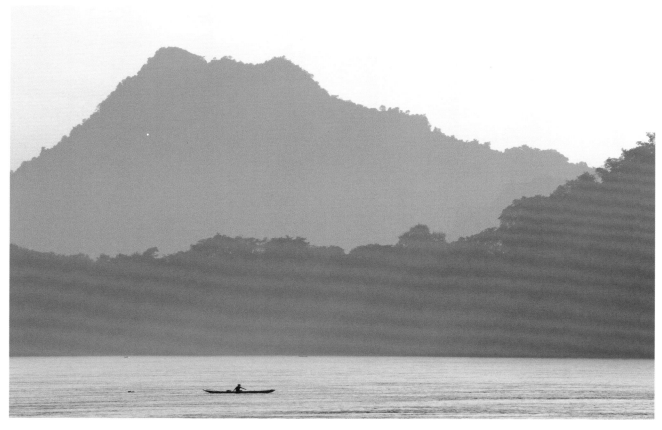

Evening at Mekong river near Luang Prabang, Laos. | Nikon D300 • 300 mm • 1/500 s • f/11 • ISO 320

Lizard tracks in the desert sand of Tunisia. | Nikon D70 • 36 mm • 1/200 s • f/10 • ISO unrecorded

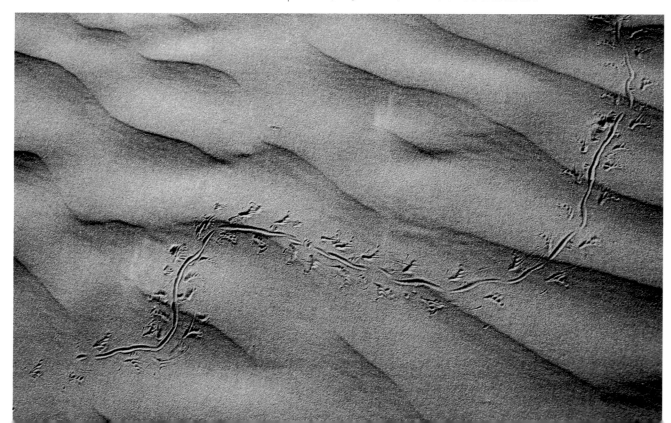

The colors and shapes of the desert as well as the interplay of light and shadow on the sand make this setting an inexhaustible reservoir of subjects. I walked around carefully before I finally settled on this portrait-format composition of a dune in Erg Ubari, Libya. | Nikon D700 • 70 mm • 1/250 s • f/8 • ISO 200

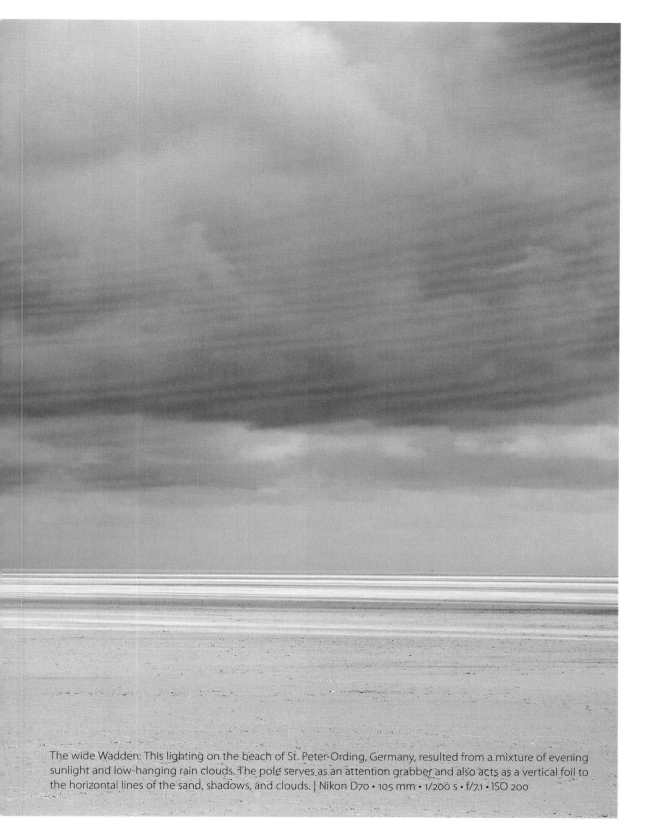

The wide Wadden: This lighting on the beach of St. Peter-Ording, Germany, resulted from a mixture of evening sunlight and low-hanging rain clouds. The pole serves as an attention grabber and also acts as a vertical foil to the horizontal lines of the sand, shadows, and clouds. | Nikon D70 • 105 mm • 1/200 s • f/7.1 • ISO 200

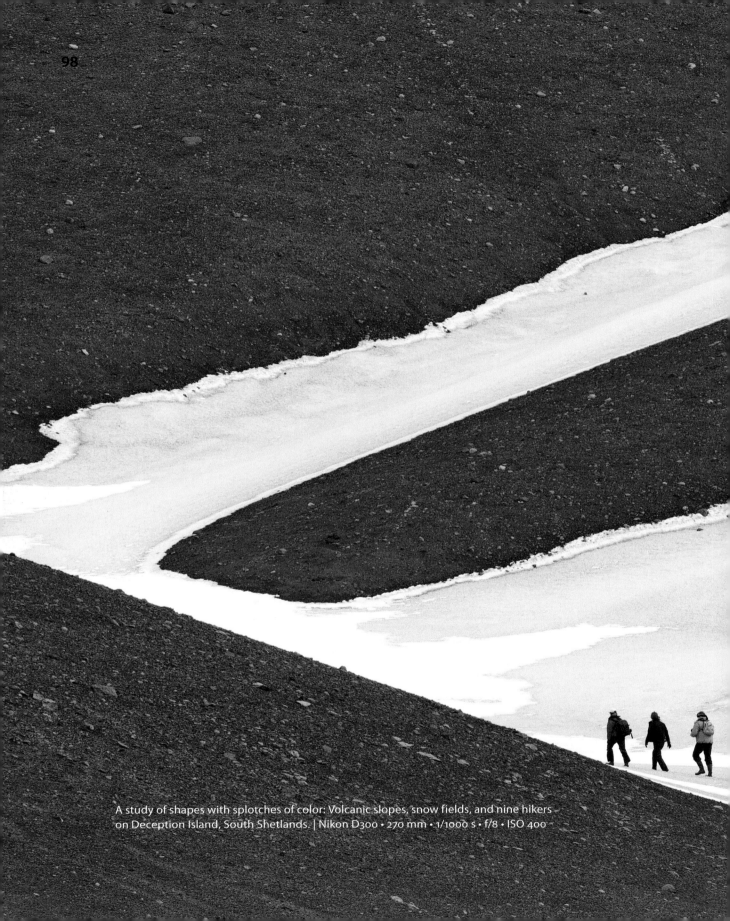

A study of shapes with splotches of color: Volcanic slopes, snow fields, and nine hikers on Deception Island, South Shetlands. | Nikon D300 • 270 mm • 1/1000 s • f/8 • ISO 400

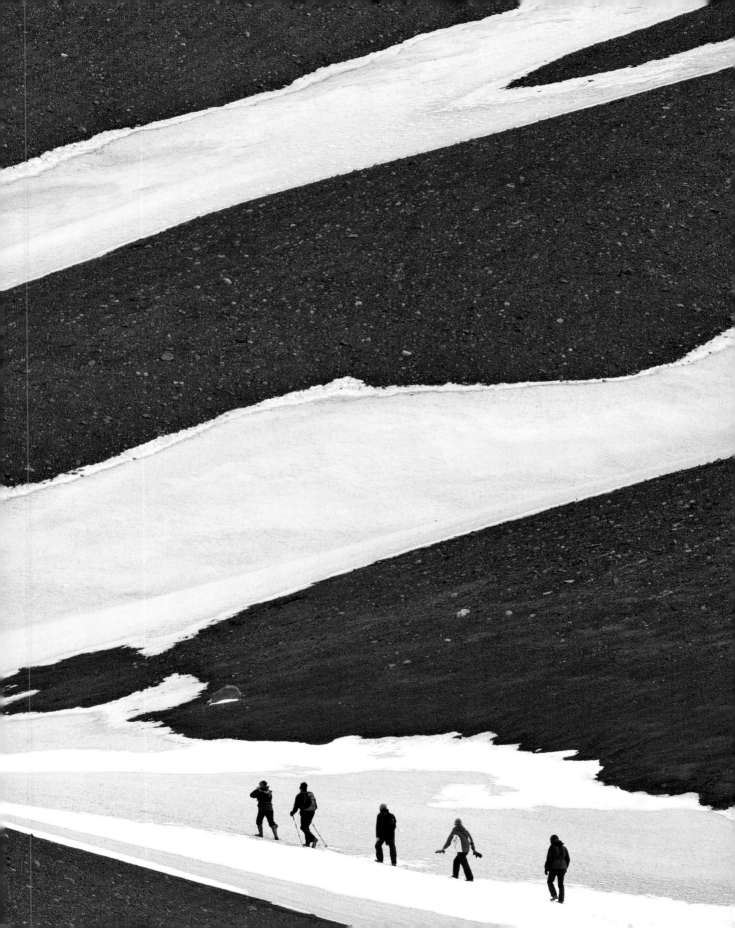

12 Opening Up

About Photographing People

Anyone who isn't blessed with boundless self-confidence and a natural gift of gab will find it difficult to take pictures of strangers at first. I am fairly shy, but I don't think much of pictures of people taken from far away with a big telephoto lens. All too often such pictures fail to establish a connection between the viewer and the subject, a bond depending on the documented person being able to decide how much or little to reveal about him or herself.

Now what? The only way to get around this issue is stepping out of your comfort zone and, again and again, bringing yourself to ask the stranger if you may take his or her picture. Create some sort of interpersonal contact with an inquiring look, a smile, a friendly gesture towards your camera, or simply with words. It's always helpful to learn a few phrases of the local language before traveling in a foreign country; ideally, "May I take a photo of you, please?" should be one of them. Making this effort shows that you respect the person, that you have made yourself familiar with the local culture, and that you are ready to do something for a photo. In rare cases, when circumstances demand it, you might have to take a picture first and then ask afterwards. But do respect someone's wish if they decline to be photographed with words, a facial expression, or a gesture. Basically, the rule of thumb, "Do unto others as you would have them do unto you," is a good one to follow when taking pictures, and not only with portraits.

The Treasury Guard: A uniformed desert policeman in the rock-cut city of Petra, Jordan.
Nikon D700 • 105 mm • 1/60 s • f/4.5 • ISO 250 • flash

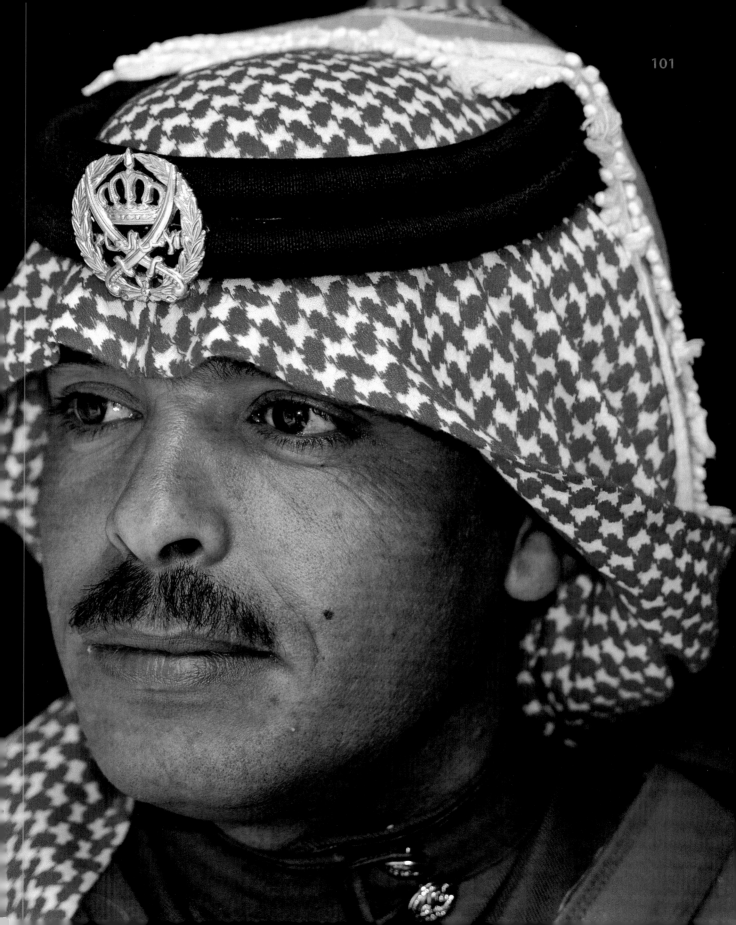

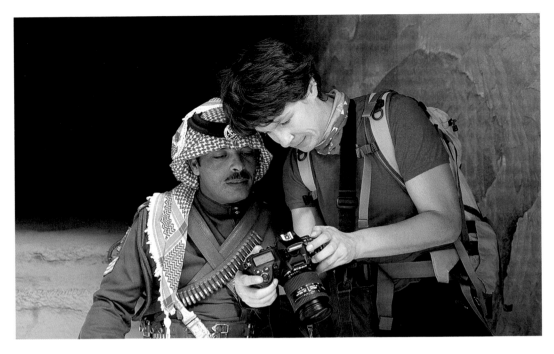

Emotional reactions to photos: Skeptical curiosity in Jordan (above; photo by Jörg Ehrlich) and open fascination in Bhutan (below).

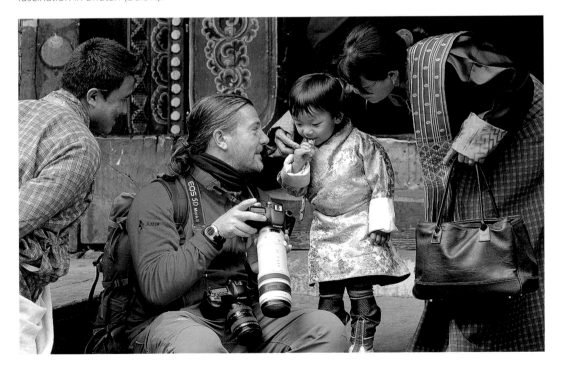

Chapter 12

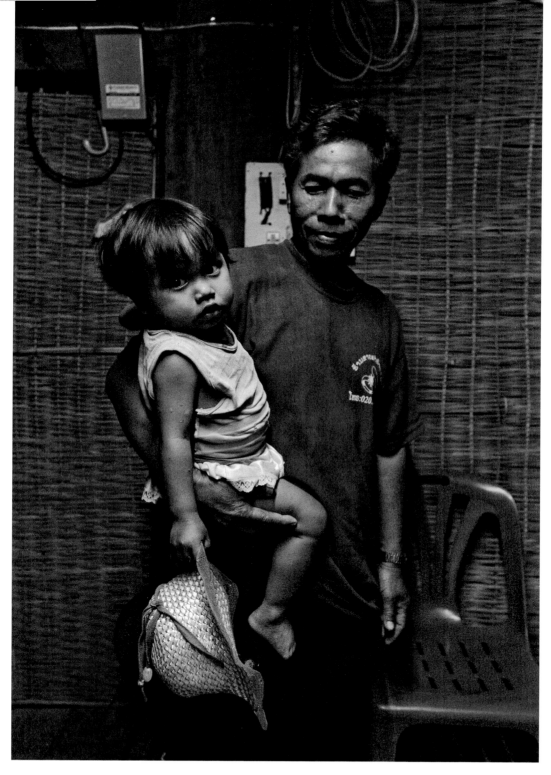

Double portrait at night in a small village close to the Mekong river, Laos.
Nikon D700 • 26 mm • 1/100 s • f/5 • ISO 6400

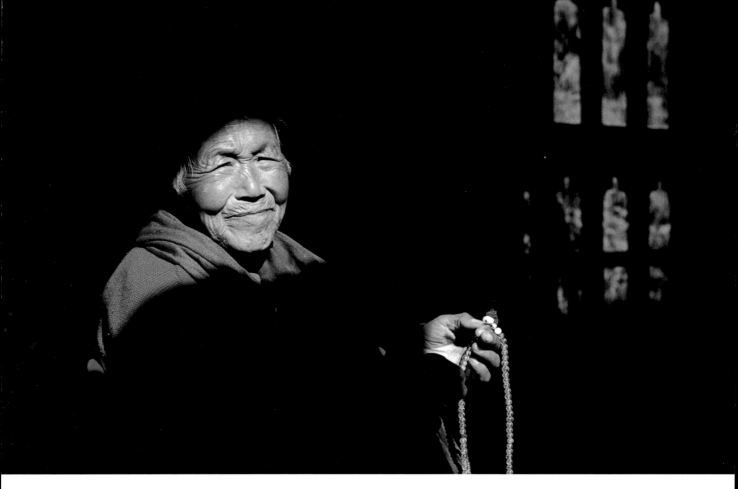

Bhutanese woman in a monastery in the capital city of Thimphu. This photo was the first in a series that I took, and it turned out to be the best. | Nikon D700 • 70 mm • 1/200 s • f/7.1 • ISO 400

The very least you should do in every case is allow some time. Time to get to know the person you'd like to photograph a bit. Time for the subject to become more comfortable with the presence of you and your camera. The time that you invest in a picture almost always pays off in the pictures you produce.

If you are traveling with a (local) guide, you can certainly ask his or her help to establish contact with others. In many cases, this method will allow you to learn more about the people you'd like to photograph than you'd be able to find out on your own. Photographers who would like to remember or be able

to reproduce details from such conversations should have a pen and a notebook handy, even if it's only to write down the names of people correctly (or have the people write down their names themselves). Showing people your picture of them on your camera display can also open doors. But don't be surprised if you're suddenly surrounded by a group of people and the next thing you know is that you have a long list of portraits to take…

If you have the opportunity to supply the person whose portrait you took with a small token of thanks in the form of a printout or an e-mail attachment of your (compressed)

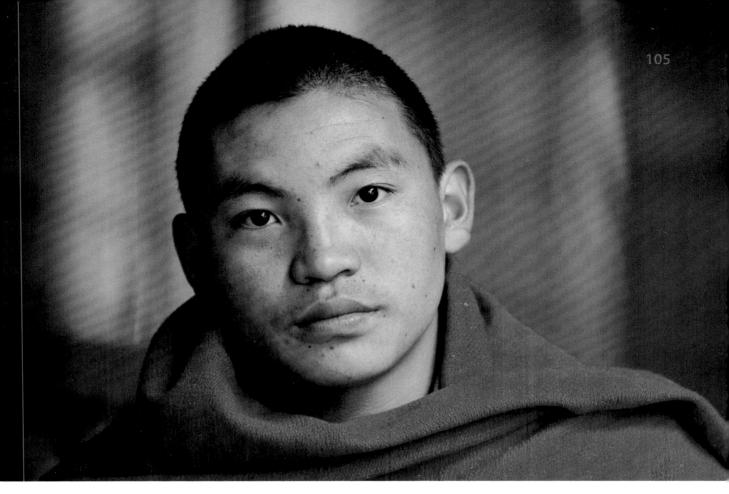

A young monk in Paro Dzong, Bhutan. The wide aperture isolates the subject from a colorful background, which subtly accents the photo. | Nikon D300 • 150 mm • 1/60 s • f/2.8 • ISO 1250

image file, you should definitely take it. In many countries, a picture that you provide may be a person's only picture of him or herself. And if you've told someone that you would send a photo, then you should absolutely make good on that promise.

I met the Bhutanese woman who's sitting half in the sun, half in the shade and holding her prayer beads, in a monastery in the capital city Thimphu. I first spotted her as I walked across the monastery courtyard, and though it cost me quite an effort, I stood waiting for a while making sure she had seen me and my camera before she finally looked directly at me.

I offered a friendly greeting – a respectful nod is understood in most places – and tried to find out with a smile and a vague gesture toward my camera if she was game for a photo. She was, and I got my picture. I subsequently took a series of other photos, but none of them turned out as well as the first one. She was quite amused while reviewing the photos I'd taken, and my local guide was able to bring her a print of the best picture later.

The subject of sports works wonders when trying to spark conversation with people of all ages; it seems to be a common topic of interest the world over. In Paro Dzong in Bhutan, I

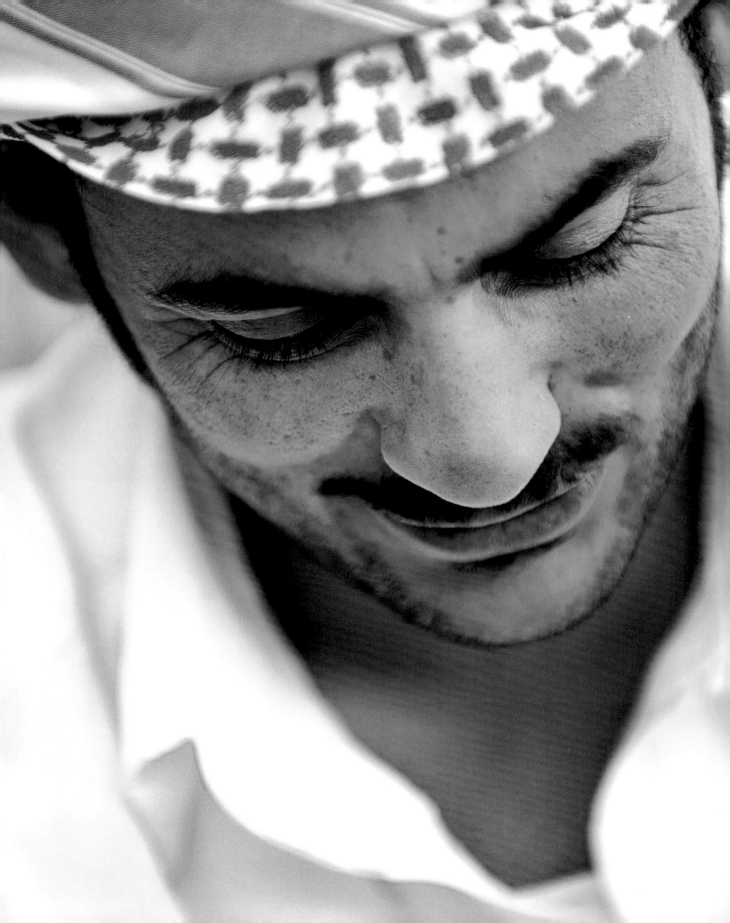

spotted a young monk whom I wanted to photograph and I politely asked in English whether I might do so. He assented and wanted to know, "Where do you come from?" "Germany," I replied. "Aaaaaaah, Germany," said the monk, "Michael Ballack!" The ice was broken. (Michael Ballack is a famous retired German soccer player.)

Acquainting yourself with and learning a little about the culture, traditions, and practices of your destination before you leave on your trip is not only helpful, it's essential. Doing so will help you avoid getting into uncomfortable situations, and will also help you understand the things that you see, experience, and photograph. Furthermore, in doing this sort of preparation, you may learn about special occasions or events that will coincide with your travels, such as a festival specific to a particular region. Local holidays and festivities are wonderful opportunities for taking pictures because they enable you to interact with genuine traditions in action, as opposed to artificial displays put on for tourists. Your research may also inform you about any traditional crafts practiced in an area or how regional delicacies are prepared. Collecting this kind of background information in advance helps you pick up on details while you're traveling, and you will likely pay closer attention to the little things that might otherwise go unnoticed by a less informed eye.

In addition, photographing people engaged in their everyday activities has other advantages. In contrast to staged photos, in which subjects often appear uncomfortable, portraits of people in action tend to be more relaxed, dynamic, and authentic. Following this path creates an entirely different kind of portrait, the environmental portrait, which shows your subject in his or her normal surroundings performing his or her usual tasks. This type of portrait reveals more about the person depicted and his or her living conditions than a traditional, close-cropped headshot.

Give multiple variations a try. If one picture is not enough, you might be able to create a little story out of two pictures. For example, the baker in Jerash, Jordan, shown on the following spread, baked flatbread for an entire restaurant outdoors underneath a wooden roof using a single oven. I had watched him working for a while, and long after all the others had disappeared to lunch, I perched myself on a little wall and began to photograph him at his artful craft. He became interested in me and my camera and started tossing the dough. In that particular moment he appeared to take as much joy in his work as I do in photographing. (By the way, it was the best flatbread of the entire trip, and I am determined to visit that baker again the next time I'm in Jordan.)

You can see that it took me several photos to arrive at the final composition, at the perfect moment with the bread dough flying high in the air (shown on page 109). My advice would be to always take several pictures, for more than one reason. Sometimes the person closes his or her eyes at the exact moment of

Revealing laugh lines: Including your subject's eyes in a portrait is good advice, but it isn't a must. Here, it's not difficult to spot out Salim's waggishness anyway. | Nikon D700 • 190 mm • 1/250 s • f/2.8 • ISO 500

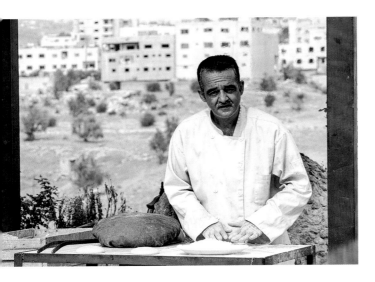

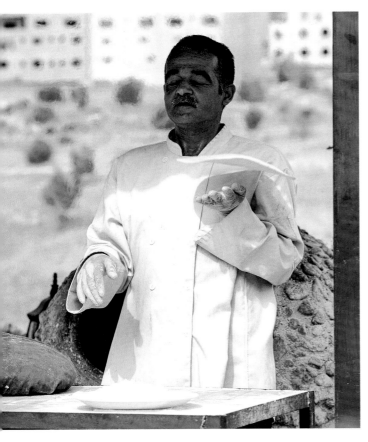

the exposure; sometimes he or she will look away; sometimes it's hard to capture the decisive moment of a movement with the first try; and so on. Also, many people tend to become more relaxed once the first few photos have been made, so it's a good idea to keep on photographing when they are getting more and more at ease with you and your camera.

If you flip through the pictures in this chapter, you'll notice that very few were shot in broad sunlight. Harsh light, such as what's available for the better part of the day when it's sunny, not only forces subjects to squint when being photographed, it also creates a large brightness contrast in photos. These can be hard to master and more often than not result in overblown highlights and crushed blacks, both of which don't exhibit any actual visual information.

In such cases it often helps to ask your subject to move into the shade or half shade – under a roof or a veranda, into the entrance of a house, or into the shadow of a tree with dense foliage (if the tree's leaves aren't dense enough, the small gaps result in an interplay between light and shadow that can produce

Open-air bakery in Jerash, Jordan. Not much time passed after the first photo before the baker started to twirl his flatbread in the air, much to the delight of the photographer. | Nikon D700 • 116 mm • 1/320 s • f/9 • ISO 400

The maestro of flying bread: The photo on the opposite page is more illustrative, but the one to the left brings me to laughter regularly. It also makes me think about the attitude with which we approach our work. | Nikon D700 • 120 mm • 1/640 s • f/6.3 • ISO 400

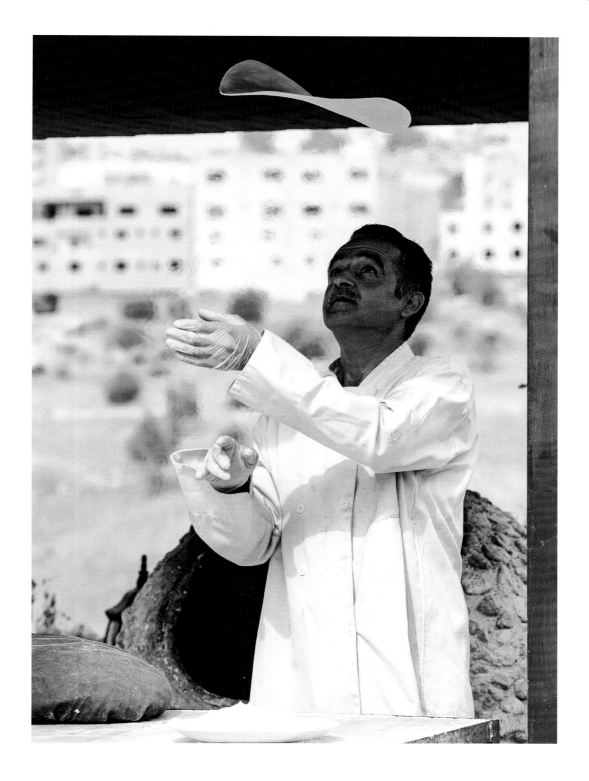

Opening Up

unattractive blotchy results in a picture). If you look around, you're likely to discover that almost every location has viable possibilities.

Alternatively, you can use fill flash or a reflector to reduce high contrast caused by harsh light (see the following chapter "Fill Flash", starting on page 112), but in general it's enough to avoid the direct light of the sun. The morning and evening hours are also an option. At these times of the day the sunlight comes from a lower angle, and the altered color temperature produces warmness as well as a flattering light that tends to benefit portraits.

Overcast skies are often well suited for portraiture because the soft light offers even and diffuse illumination. Using fill flash under overcast skies can produce an attractive, small reflection of light in your subject's eyes and add some intensity to the foreground colors. If you do use flash, watch out for reflective surfaces as they tend to either give away the use of flash or blow out.

It is often desirable to create portraits with a smooth, even blur in the background if you don't plan on showing much or any of your subject's surroundings. You can achieve this effect by choosing a larger aperture or by using the longest focal length possible (or combining both, of course). In addition, the greater the distance between your subject and its background, the better.

Since people tend to stand directly against a wall when you ask them to position themselves near one, you may want to encourage your subject to take a step or two away from it if you don't want the wall's details to be too clear in your photo (and also to avoid a hard shadow if you're using a flash). Or simply establish a shot from the outset that features a homogenous background that is far away. If you are working with a fast enough lens, you can use a wide enough aperture that should allow you to isolate your subject from its surroundings (make sure that the depth of field is sufficient, though). This effort is also aided by taking a few steps backward and using a longer focal length.

For most of the portraits I shoot while traveling, I use focal lengths between 70 mm and 300 mm; that said, I'm also using an f/4 500 mm lens as a portrait lens every now and then. Wide-angle portraits that show people and their surroundings are typically taken with a focal length between 17 mm and 35 mm.

One more thing that you should keep in mind when taking portraits is the fact that people move. Since I've been frustrated with clipped off ear lobes, locks of hair, and fingers more times than I care to think about, I try to always opt for a slightly looser crop when shooting portraits now. You can always bring the crop in tighter during post-processing.

A classic portrait from the Orinoco delta, Venezuela. Nothing takes away from the facial expression and personality of this young Warao girl. | Nikon D700 • 60 mm • 1/200 s • f/2.8 • ISO 800

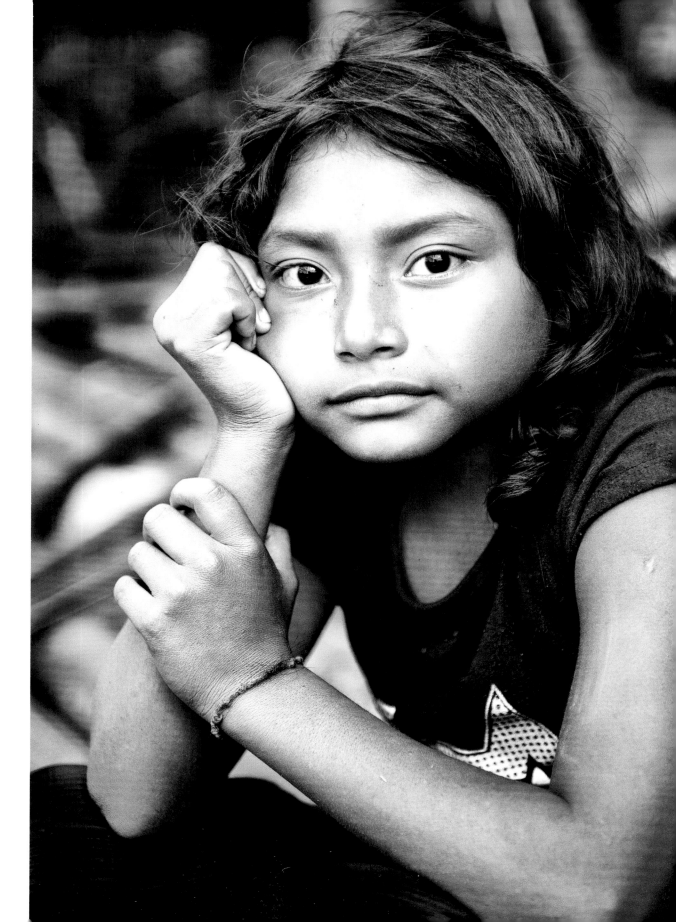

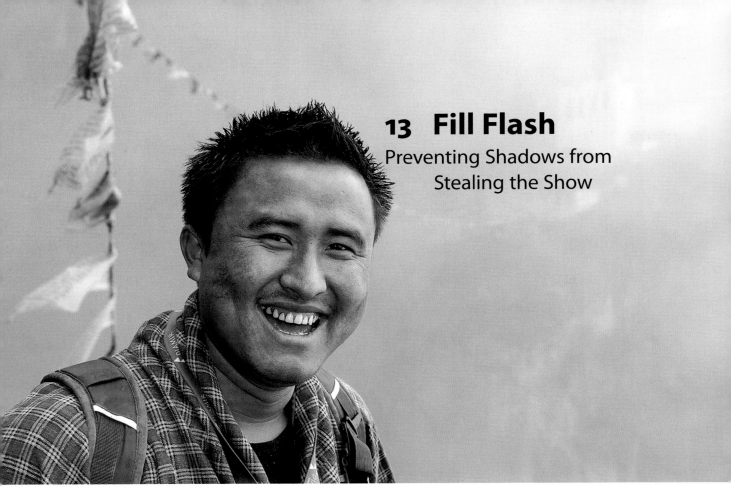

13 Fill Flash
Preventing Shadows from Stealing the Show

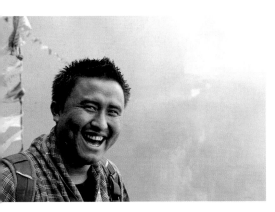

I used fill flash for the topmost image to make sure our Bhutanese guide's face was adequately illuminated. The difference between the two images is not dramatic, but it is perceptible. | Nikon D700 • 50 mm 1/250 s • f/7.1 • ISO 500

Fill flash is an antidote for obscured foregrounds, unwanted silhouettes, harsh shadows, and drab colors resulting from overcast skies. It's best used when the viewer can't even tell it's there.

The most likely scenario in which you'll opt for using fill flash – not only when traveling – is when you need to reduce the contrast of your scene. A portrait with a backlit subject is a classic example. If you expose your image based on the subject's face, which is obscured in shadow, you run the risk of overexposing the background; if you base your exposure metering on the background, however, your subject's face will be much too dark. The fill flash helps to give the subject's face better color, more detail, and a proper exposure by reducing the range of brightness values in the image without significantly affecting the exposure of the background.

The usefulness of fill flash extends beyond just this application, though. It can reduce harsh shadows produced by full sun-

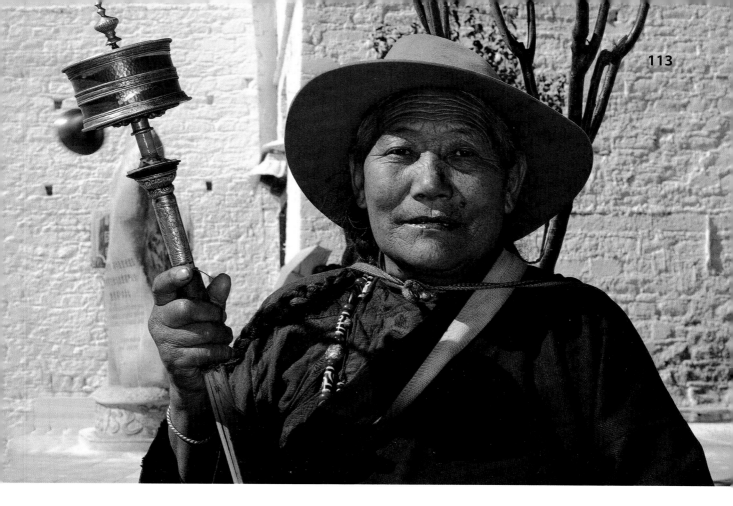

light and it can revive the colors of objects in the foreground that would otherwise look dull under an overcast sky. Fill flash can create a desirable small reflection in the eyes of your subject, which makes them appear more vivid. In all of these examples, the flash is used only for supplemental light, not as the main light source. The natural lighting conditions remain unchanged. This is what makes photos shot with the use of fill flash appealing; the subject isn't lit by a harsh light, but instead is gently illuminated. The use of fill-flash should not be all too apparent in an image but should add inconspicuously to its quality.

If you plan on using fill flash, you'll need either a built-in flash unit or an external one. External flashes offer a better range, are much more versatile, and can provide softer light because of a larger flash area. However, the built-in flash is better than nothing, and in many cases it will serve your needs just fine. There are times when an opportunity for a photo will come and go before you

Bright daylight made it difficult to take a portrait of this Tibetan woman in front of the Potala Palace in Lhasa. The flash took care of the harsh shadows and produced a small, pleasant reflection in her eyes (top image). Nikon D300 • 54 mm • 1/320 • f/9 • ISO 400

Fill Flash

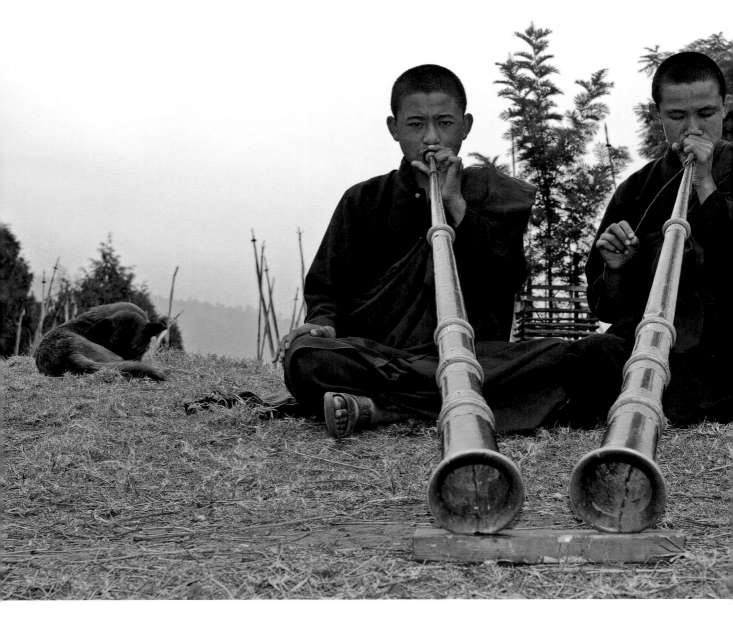

can pull out your external flash, mount it to your camera, and set it up. Unfortunately, not all digital SLRs come equipped with a built-in flash.

Regardless of what type of flash you use, its success depends on its restraint, which the photographer has to impose on it. I got the best results using a combination of program mode (P) and iTTL (with Canon: eTTL), espe-

cially when I need to work fast or when the lighting conditions change quickly. Set the flash to iTTL/eTTL with a permanent correction of about −0.7 stops for a normal picture. The correction prevents the foreground from being too bright. These settings are usually prepro-grammed on my cameras so that all I need to do is pop up the built-in flash to have fill light-ing at hand.

A dark foreground in front of a bright sky: Scenes like this are a classic example of when fill flash comes in handy. The output of the camera's internal flash was more than enough to brighten up the faces and vestments of these two monks practicing on a monastery meadow in Bhutan. | Nikon D700 • 70 mm • 1/250 s • f/11 • ISO 800

Unfortunately, there may be situations when using fill lighting in program mode will put limits on your creativity. When using automatic exposure (P mode) without fill flash, you can use the program shift function to adjust the aperture and shutter speed combinations to your needs. If you're using flash, however, this function will be limited. In P mode, your camera tries to produce a properly exposed image and avoid potential errors introduced by the photographer. That's why it will stop down automatically to prevent the fastest possible flash sync speed from being exceeded.

So you might end up with an aperture of f/16, even though you wouldn't have used such a small aperture opening otherwise. (Some camera models allow you to set the longest possible flash sync speed individually.) In this picture of two Bhutanese monks, the automatic exposure selected an aperture of f/11. I would have preferred to use a larger aperture to isolate the two protagonists a bit from the background, but since I had no way of telling if they were going to stop in a moment, I opted to be safe rather

than sorry. I'd rather have a photo with an aperture of f/11 than miss the moment entirely.

If you have more time at your disposal, you can also program the settings yourself using the manual mode (M) to select the shutter speed and aperture, though you may end up with some failed exposures while you're still striving to figure out the appropriate combinations of shutter speed and aperture. You can also use the aperture priority and shutter priority modes in conjunction with fill flash. Since it's possible to make serious and frustrating exposure errors by doing this, however, you should definitely familiarize yourself with this process before your trip.

With compact cameras, you can mitigate the flash's output with flash exposure compensation. In my experience a correction of about −0.7 stop is still a good starting point. This is really just a reference point, though. Depending on the intensity of light and the distance between the subject and the camera, you may need to increase the flash output. I've occasionally bumped up the output of a DSLR built-in flash by a full three stops for the purpose of creating fill lighting when standing at a distance of several meters from my subject in blazing sunlight.

Be careful when using a built-in flash in combination with a large (wide-angle) lens or a lens hood. Because built-in flashes are positioned so close to the optical axis, you can end up with unattractive shadows in your images.

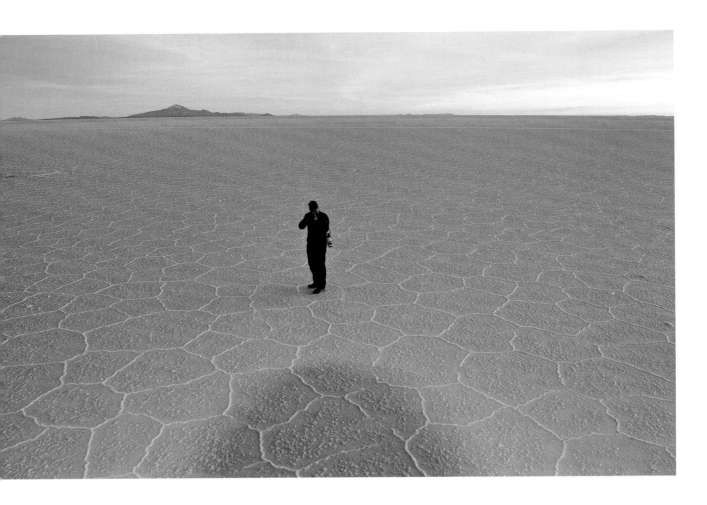

In these cases you can try removing the lens hood or increasing the focal length a touch. Even increasing the focal length just a few millimeters is often enough to eliminate the shadows when shooting in the wide-angle range.

When that doesn't solve your problem and you don't have an external flash unit on hand, your only remaining option is to ameliorate or remove the treacherous half-circle when editing the photo later.

Top: Using a built-in flash with a large lens can produce distracting shadows.
Nikon D700 • 24 mm • 1/250 s • f/10 • ISO 800

Top right: I used fill flash to photograph this woman selling jam on Moorea, French Polynesia. The extra light helped brighten up some of the darker areas. | Nikon D700 • 38 mm • 1/60 s • f/4 • ISO 400

Bottom right: Fill flash isn't limited to SLRs. I photographed these men on Isla del Sol (Bolivia) with a compact camera. They were waiting for a parade to begin. | Nikon P7100 • 55 mm • 1/100 s • f/3.5 • ISO 140

Fill Flash

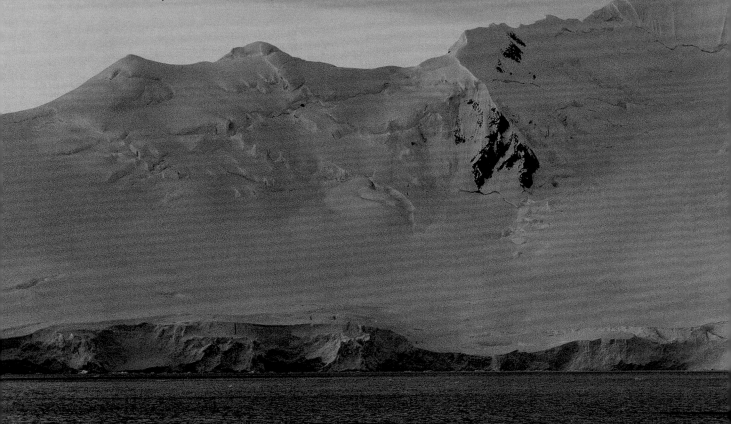

14 In the Best Light

Early Mornings and Late Evenings

It's quite simple: without light, there is no photo, and that doesn't just apply in a technical sense. The quantity and, above all, the quality of light determines whether a photo exists, is good, or is extraordinary. There's a reason photography literally means "painting with light." When you're creating your images, the light is at least as important as the concept and technology behind your shot. The lighting conditions of a specific location at a specific time affect the colors and clarity of your subject, in addition to what appears illuminated and what appears in shadows. In short, light plays an essential role in the look and feel of a photo and the mood that an image conveys.

Early risers and night owls often encounter rich lighting conditions. It's for good reason that nature photographers swear by the moments just after sunrise and just before sunset as the best time of day to work ("two hours after sunrise and two hours before sunset"). They rave about the soft, flattering light and the warm colors that cameras tend to depict more intensely than the human eye, which is regulated by the brain.

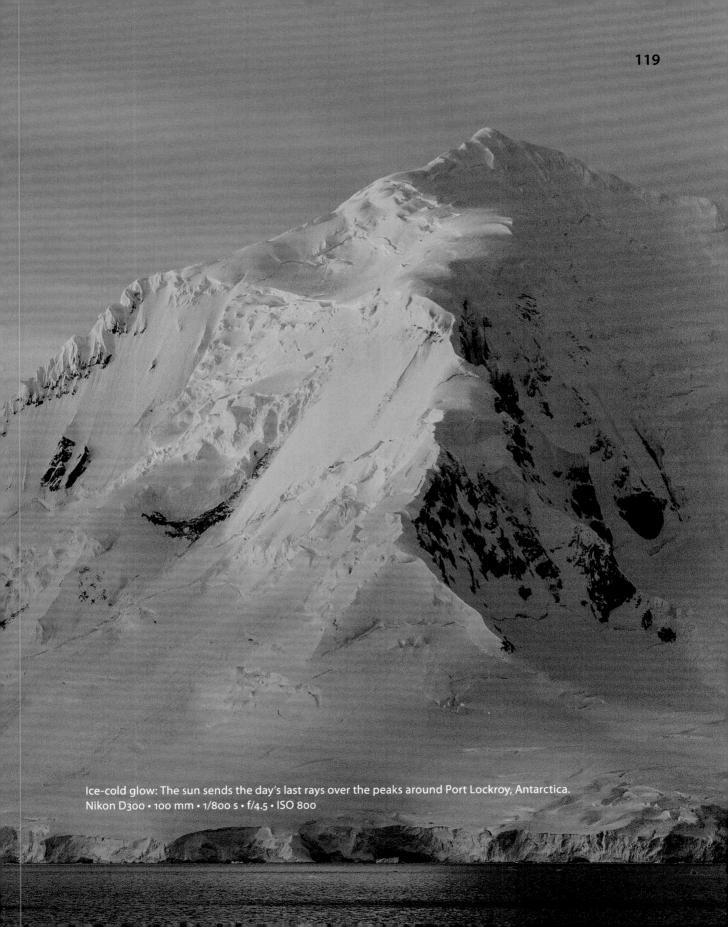

Ice-cold glow: The sun sends the day's last rays over the peaks around Port Lockroy, Antarctica.
Nikon D300 • 100 mm • 1/800 s • f/4.5 • ISO 800

The three Buddhas and the light: An evening detail shot from Vientiane, the capital of Laos. | Nikon D300 • 105 mm • 1/800 s • f/14 • ISO 250

Contrasts are not as extreme in the early morning and late evening as they are during the middle of the day. The warmer mood of light improves the look of most subjects. Mornings often offer up mist or fog, creating unusual lighting conditions, while many evenings provide an attractive play of colors and clouds. And don't forget about the "blue hour," that brief moment of transformation when it's no longer day but also not quite night that engenders such rich and evocative pictures.

The enchanted light of morning generally appears before sunrise, which is why it is useful to be on location before the sun climbs up over the horizon. Similarly, it's often beneficial to stay out a while after sunset – you might end up capturing a slight reflection in the clouds or on mountain peaks.

An ability and readiness to wait for the light is a key virtue for photographers, whether traveling or not, especially in the realm of nature photography. This patience often reveals itself in the photos. Pictures featuring exceptional lighting conditions may arise from coincidence, but in most cases, they are the result of watchful waiting. Once the right moment is at hand, however, speedy action is required. Light changes by the minute, if not by the second, especially during the hours of the early morning and late evening. The two

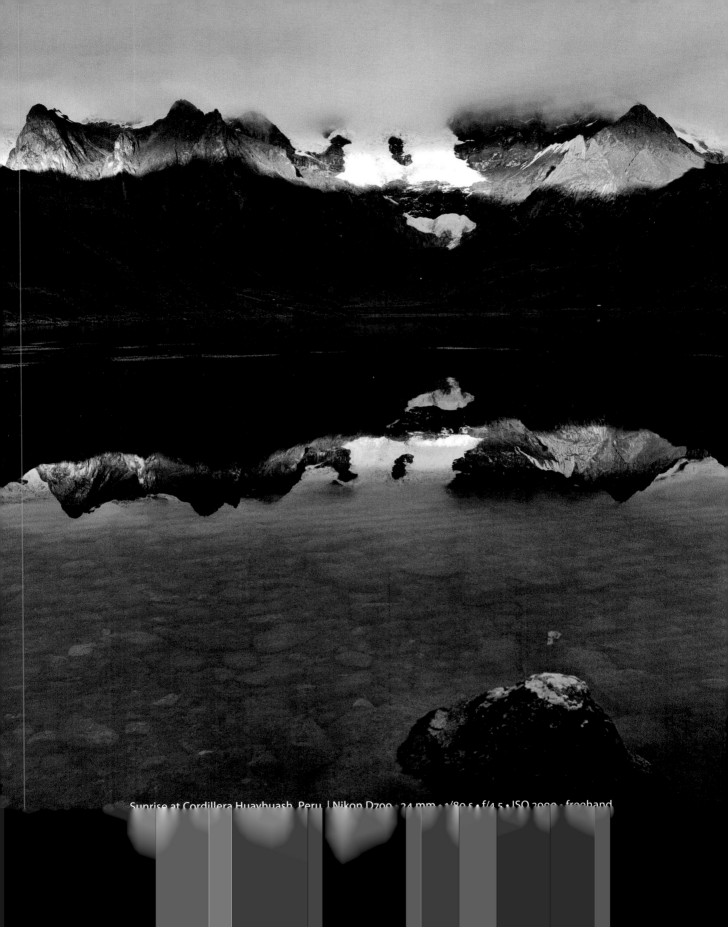

Sunrise at Cordillera Huayhuash, Peru | Nikon D700 · 24 mm · 1/80 s · f/4.5 · ISO 2000 · freehand

pictures of the Teufelsschloss (Devil's Castle, page 127), a prominent rock formation in eastern Greenland, were taken within eleven minutes of each other. The light goes away just as quickly as it comes.

If you are given the opportunity to photograph during the morning or evening hours, it's a chance you should grab. When traveling, however, you don't always have the ability to determine where you want to be at a specific time to take advantage of a particular quality of light. And on top of that challenge, the weather might not cooperate. (Taking pictures under adverse weather conditions is covered in the chapter "There Is No Such Thing as Bad Weather," starting on page 132.) If you have the time to wait for the lighting to improve in a particular location, it's worth it. A tiny bit of

patience can make a huge difference. And if you have the opportunity, you can also revisit a particular site when the light is better and try again.

Often you'll be forced to make do with the ambient lighting conditions, though. The good news is that exciting, appealing images can be created around the clock. You should take pictures whenever you can and want to, and try to make the best of whatever conditions are at hand. Train yourself to spot lighting that is not only beautiful but also unusual in some way. Unconventional lighting poses a challenge for photographers, but it often produces better results than you might first expect. On a cold, rainy morning that you've more or less written off for photography purposes, a sudden bluish-white morning fog starts to rise up from

The early photographer gets the light: A beautiful morning on the Busanga Plains, Zambia.
Nikon D300 • 375 mm • 1/1000 s • f/5.6 • ISO 400

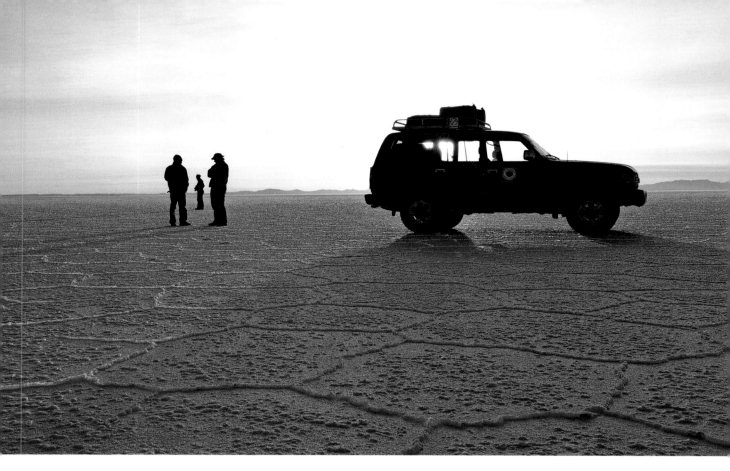

A play of shadows on Salar de Uyuni, Bolivia – just after sunrise on the largest salt flat in the world.
Nikon D700 • 35 mm • 1/640 s • f/13 • ISO 800

the river – not particularly attractive lighting, but a beautiful atmosphere where the blue conveys the coldness of the morning. During thunderstorms, rain showers, or changes in the weather, lighting conditions can change so frequently that it's worth paying close attention to what's going on in case you find yourself in the middle of something glorious.

Harsh midday light is a challenge. Unfortunately, soon after sunrise the light often already has the same qualities as that of the noon hour, so you need to learn how to adapt. It's important to know that midday light often leads to black shadows and white highlights because cameras are less adept at perceiving

light and shadow than human eyes. While we can still detect detail in bright and dark areas, the camera has significantly fewer brightness levels at its disposal. This limitation can be put to good use, however. When striking forms are combined with high-contrast lighting, it's often possible to include attractive silhouettes in your images.

If you need to take a portrait during broad daylight, it's better not to attempt your shot in open sunlight. If you move to the shade, the subject won't have to squint his or her eyes as much and the contrast will be more manageable. You can also use indirect lighting by making use of sunlight reflected off a wall. Keep in

In the Best Light

A nighttime stroll through the historic quarter of Chengdu, China. The city's youngsters sit in cafés or walk through streets that are decorated with lanterns. | Nikon D700 • 24 mm • 1/60 s • f/4 • ISO 6400 • freehand

Easter Island icons: Here the famous stone figures, the Moai, are photographed in four different lighting conditions. In the first image, the sun is hiding behind a cloud; in the second image, it's pouring rain. You can only try to make the best of it and, for example…

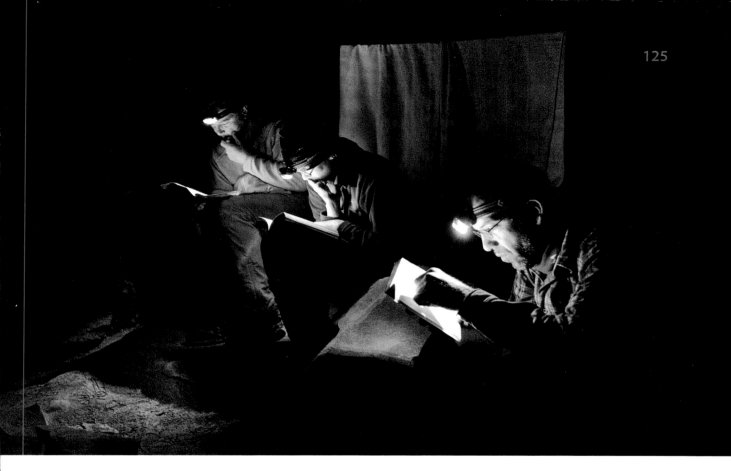

Evening reading hour on a trekking tour of Auyán-tepui, Venezuela. The headlamps and pages are blown out but that doesn't detract from the picture's feel. | Nikon D700 • 35 mm • 1/20 s • f/2.8 • ISO 6400 • freehand

…make use of the silhouette to depict the characteristic shape of the statue when the light is poor. Or you can wait for better weather. Maybe the sun will come out again (and the polarizer will go on your lens).

Bright background + dark foreground = silhouette: This equation doesn't apply only to eastern Greenland. If you brighten up the foreground with a flash, you'll lose the emphasis on the graphical outline of the foreground subjects. | Nikon D700 • 105 mm • 1/400 s • f/10 • ISO 2000

mind, however, that light reflected off colored surfaces can produce color casts in pictures.

As an alternative during the daylight hours, you can focus on details that are located in the shade or that allow themselves to be shaded. Dark interiors can benefit from a calculated accent of incoming daylight. Overcast skies are practical for detail photographs in which specific characteristics of your subject need to be accentuated, and also for portraits in diffuse, even light. Light striking your subject from the side emphasizes structure and texture, while backlighting emphasizes shape and outline.

You can even create exciting pictures in pitch-black darkness with artificial light sources. Such photographs almost always necessitate the use of a tripod or at least a steady perch for your camera, as well as a cable or remote trigger (or the self-timer if you're in pinch), since even at high ISO settings the lack of ambient light may make it impossible to take sharp pictures otherwise.

Opposite page: Waiting for the light – eleven minutes separate these two photos of the Teufelsschloss (Devil's Castle) in eastern Greenland. | Top: Nikon D700 • 29 mm • 1/250 s • f/5.6 • ISO 500. Bottom: Nikon D700 • 24 mm • 1250 s • f/8 • ISO 400

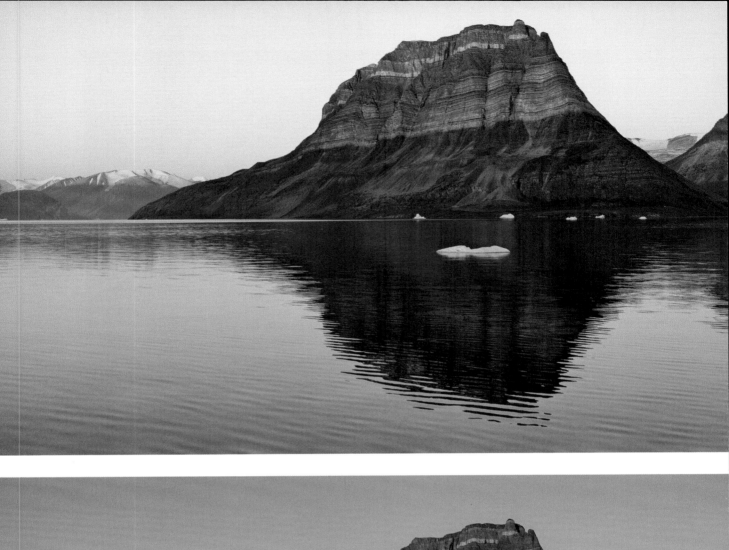
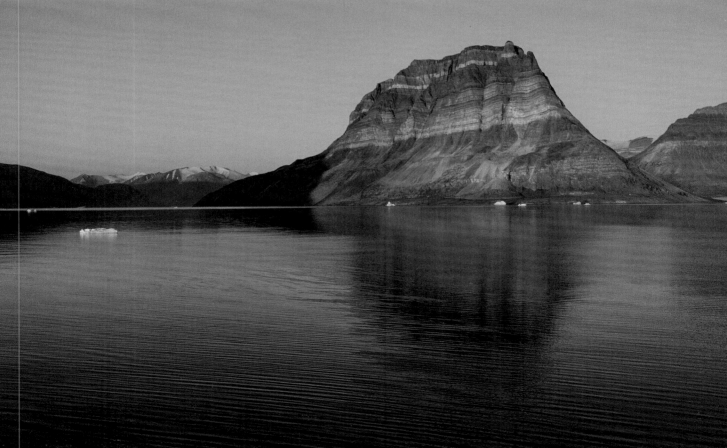

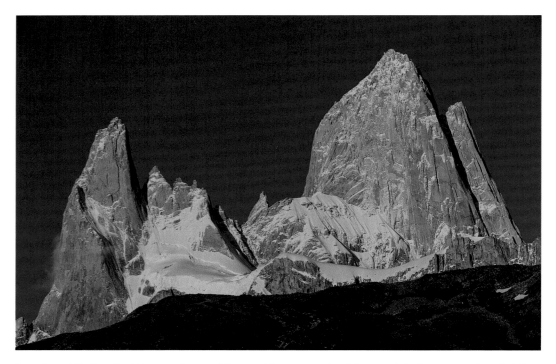

Four times Fitz Roy: On this spread, one of the most famous peaks of Patagonia is shown in various lighting conditions. | Top (time of exposure 6:11 a.m.): Nikon D700 • 115 mm • 1/500 s • f/11 • ISO 200. Bottom (8:46 a.m.): Nikon D700 • 70 mm • 1/500 s • f/11 • ISO 400.

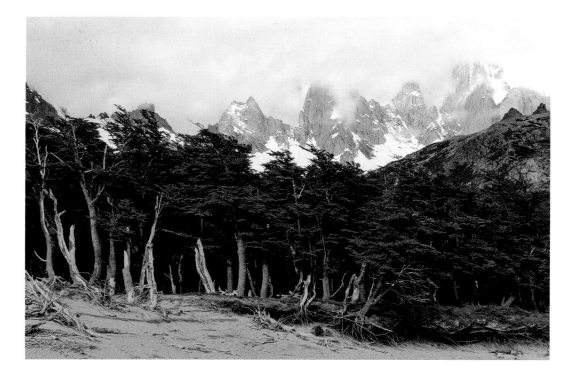

Chapter 14

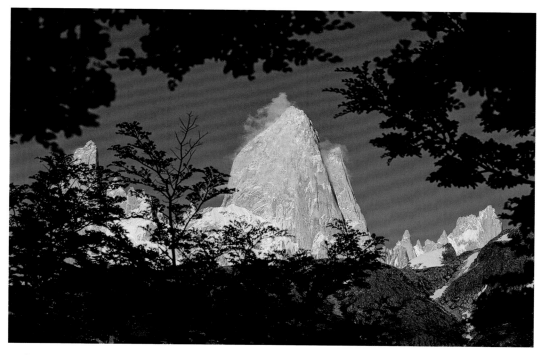

It often pays off to revisit the same place at a different time of the day to get different, and maybe better, light. | Top (time of exposure 6:42 a.m.): Nikon D700 • 85 mm • 1/640 s • f/11 • ISO 200. Bottom (this photo was taken in the afternoon on the day before at 5:04 p.m.): Nikon D700 • 27 mm • 1/500 s • f/11 • ISO 200

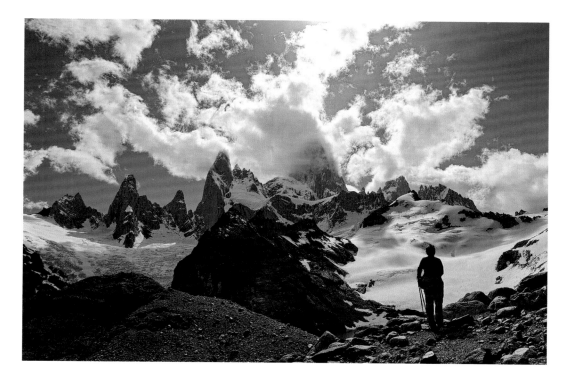

In the Best Light

The reward for getting up very early: The first rays of sunlight touch the Fitz Roy massif, Patagonia | Nikon D700 • 86 mm • 1/80 s • f/11 • ISO 200

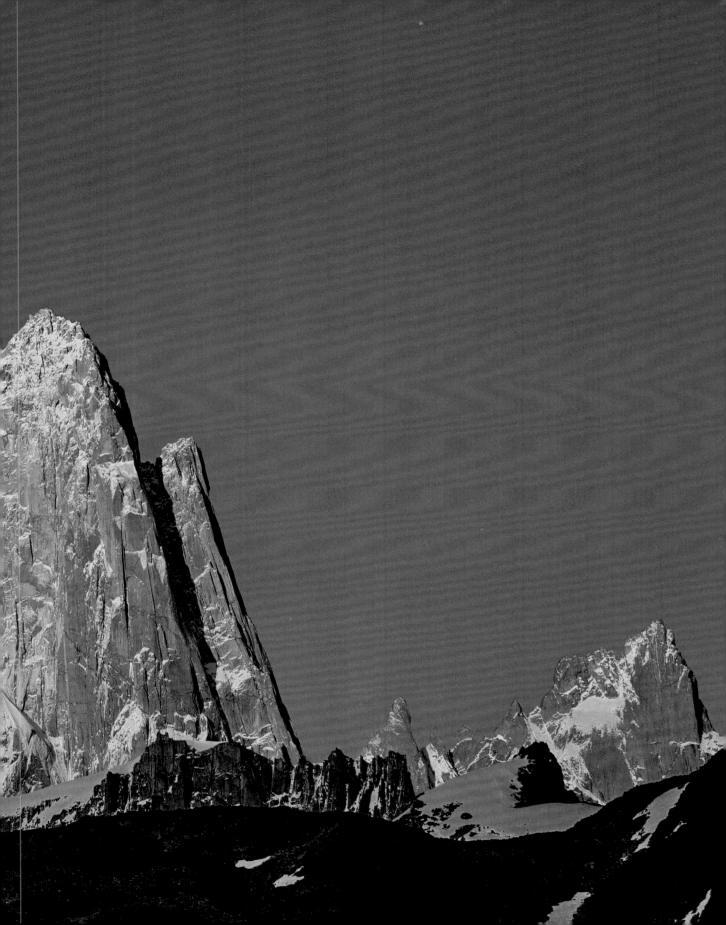

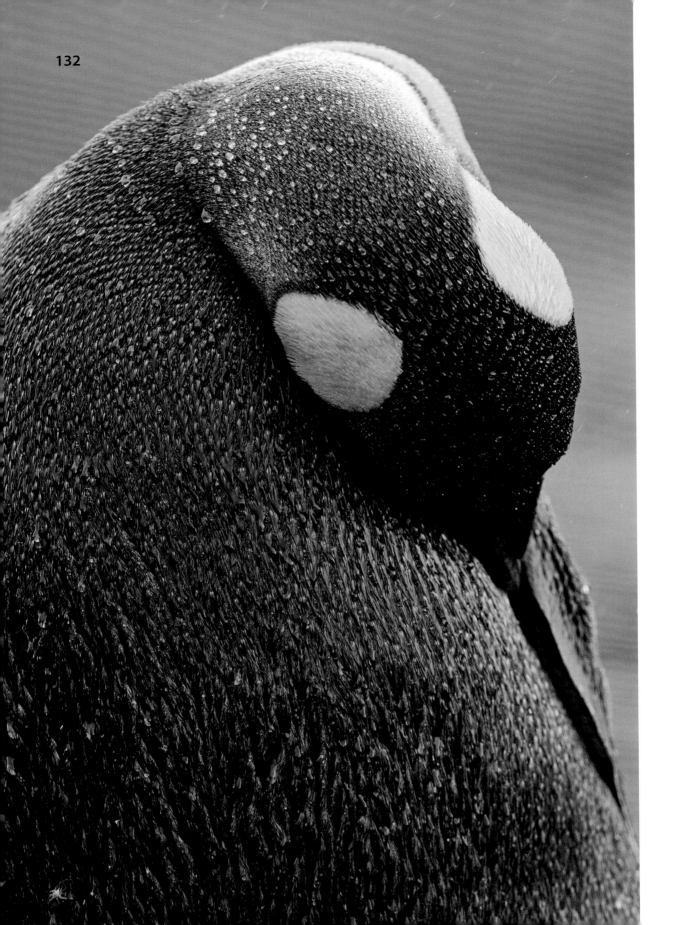

15 There's No Such Thing as Bad Weather

It's Just Rain, Fog, Snow, Storms…

"It would have been such a nice day for shooting if only the weather had cooperated." Who isn't familiar with this complaint? When we travel, we're often met with rain and fog instead of sunshine, or ice and snowfall instead of pleasant temperatures, or stormy winds instead of a gentle breeze. But what we call bad weather doesn't have to put an end to photography. As is so often the case, you get what you make of a situation.

Initially, "bad weather" just means that you need to prepare yourself for the conditions at hand, which implies protecting yourself and your gear appropriately (see the chapter "Better Safe Than Sorry", page 196). It also means you'll need to look for photographic opportunities amid the prevailing weather. There were fairly typical weather conditions when I took the picture of a King penguin on the island of South Georgia (opposite) – four seasons represented within a single hour. Rain, sleet, and wind gusts all appeared. It's partly because of their oiled plumage that King penguins can withstand harsh weather. In the photo of the sleeping animal whose feathers are covered in raindrops, I intended to reveal exactly this.

Often when we think of traveling and the photos we produce on holiday, we automatically think of sunshine and pleasant conditions. And while it is frustrating when it rains throughout an entire vacation, we don't have much control over the weather. It's worth thinking about the photos you can create with the weather you have rather than the photos you could have taken with the weather you don't have. Bad weather is often synonymous with dramatic or exceptional lighting, so the opportunities are many.

When the weather is gray and foggy and the sky is thick with low-hanging clouds of a single color, it can be difficult to produce breathtaking landscape photos with a wide-angle lens. The nuances of color that the human eye can naturally perceive even in gray light are lost on the camera's sensor. Raindrops add to the veil of gray, further limiting visibility. Pictures shot under these circumstances often lack the color intensity and contrast you would hope for. But these conditions also allow you to create nearly monochrome landscape photos that have their own charm. In any case, you'll need to contend with the broad brightness

Slumbering in the rain: A portrait of a sleeping King penguin in South Georgia.
Nikon D700 • 400 mm • 1/400 s • f/6.3 • ISO 1600

The vivid hiker: The rain parka red provides a welcome splash of color in an otherwise dreary picture in the rain and fog on the summit plateau of the Auyán-tepui, Venezuela. | Nikon D700 • 17 mm • 1/200 s • f/7.1 • ISO 400

contrast between the sky and the landscape, as these photos from Venezuela show. The contrast here would have been tough to manage without a graduated ND filter or some subsequent post-processing. One solution to this problem is to push the sky out of your photo entirely, if your subject lends itself to this treatment – many pictures turn out well without a horizon line at all. If you want to integrate a person as a point of reference for the propor-

tions within your image, or to serve as an initial eye-catcher, colorful clothing fares best in dull conditions. Red and yellow tones in particular can be real attention grabbers.

For photographing details at close range, these gray conditions can actually prove useful. The gentle, diffuse light highlights subtleties and, as long as you leave the sky out of the picture, contrast is much easier to manage than with bright, harsh sunlight. If you're work-

Dark foreground, blown out background: Another photo from Auyán-tepui, Venezuela. The bizarre rock formations stand out from the sky, which lacks any detail. | Nikon D700 • 17 mm • 1/250 s • f/14 • ISO 1000

ing close to your subject, raindrops and snow-flakes in the air as well as fog or clouds pose less of a problem, and your images will have a greater clarity compared to a landscape image, for example. You can also use fill flash (see page 112) to revive some colors at close range. Using flash in these circumstances requires some caution, however. Falling raindrops and snowflakes may reflect the flash and show up as white specks in your photo. This effect can be put to creative use, but it can also cause distractions.

Fascinating cloudscapes such as those that emerge during thunderstorms, and that are also quite common in regular April weather or in late summer, serve as a subject in their own right. Documentary exposures of thunder-heads rolling in are just as feasible as studies of abstract shapes and colors or long-exposure captures that show the movement of clouds.

There's No Such Thing as Bad Weather

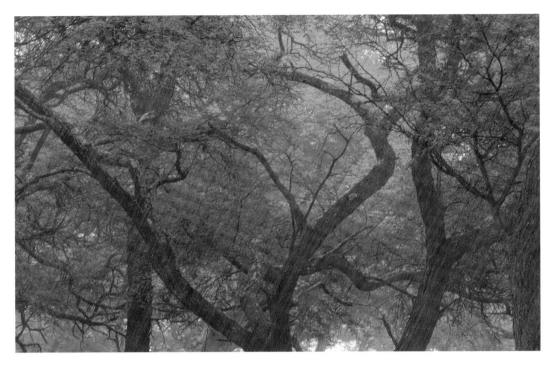

Natural hatching made in Zimbabwe: The raindrops streaked across the image area during the relatively lengthy exposure time of 1/25 second to create a curtain of individual threads. This effect works especially well in front of the dark background of trees. | Nikon D300 • 190 mm • 1/25 s • f/16 • ISO 500

Dramatic lighting often emerges in the first moments when the sun breaks through the clouds after a downpour. Patience is a virtue here. Find yourself and your gear a bit of shelter from the elements, and with some luck the weather will reward you with stunning light, clear air, and intense colors.

Treat rain, snow, wind, and waves in the same way that you would treat other moving objects. A fast shutter speed freezes raindrops, snowflakes, swaying branches, sea foam, and clothes and flags blowing in the breeze, and slower shutter speeds make their movements visible. The photo above of a downpour in Hwange National Park, Zimbabwe, was taken using a shutter speed of 1/25 second, causing

the individual raindrops to streak across the entire image area. In contrast, I used a fast shutter speed of 1/200 second to freeze the snowflakes in place in the photo from Antarctica (opposite page).

Fog can also produce fascinating pictures. In most instances, a camera's autofocus won't be able to settle on an object if the object is shrouded in fog. To get around this you can focus on a substitute object in roughly the same distance or you can rely on manual focusing. Similarly, an exposure metering system is often just as confused in fog as it is in snow landscapes, and tends to underexpose photos in these conditions. A look at the histogram can tell you if you need to use exposure com-

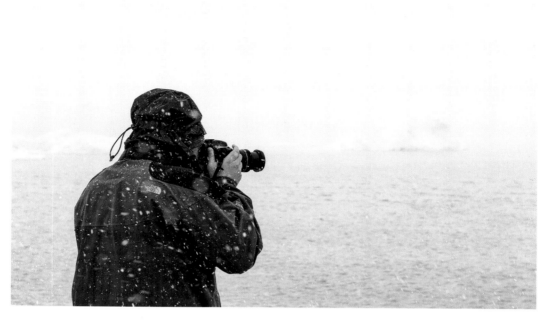

Photographing snowfall: In this image shot with a shutter speed of 1/200 second, the single flakes are visible – not perfectly sharp, but clear enough to be recognizable. This photograph was taken en route to the Antarctic Peninsula. | Nikon D300 • 105 mm • 1/200 s • f/7.1 • ISO 500

pensation – an allowance of one-third to a whole stop is not uncommon.

You can also turn bad weather into an interesting subject by documenting it indirectly. Rather than showing the weather conditions themselves, show their consequences: colorful umbrellas, people with white clouds of breath in front of their faces, puddles, reflections on wet asphalt, raindrops trickling down a window pane, wave crests torn apart by the wind, a rainbow spanning the desert, trees enveloped by snow… This list could easily go on; in the end, it's your creativity that determines the photographic implementation.

If, despite all of your precautions, your camera gets wet while taking pictures in bad weather, dry it as soon as possible, and once you get back to your lodging or car, remove it from your equipment bag (which is likely no longer dry as well). You should also be cautious when moving quickly from a cold to a warm environment, since condensation can materialize on and inside your camera. You might consider not bringing your camera indoors between two outings into the cold. Alternatively, you can set your camera in a plastic bag and clasp it shut as tightly as possible. When you bring it into the warm room the moisture will condense on the bag rather than the camera. Then some gradual warming becomes the task of the hour for both the photographer and his or her equipment.

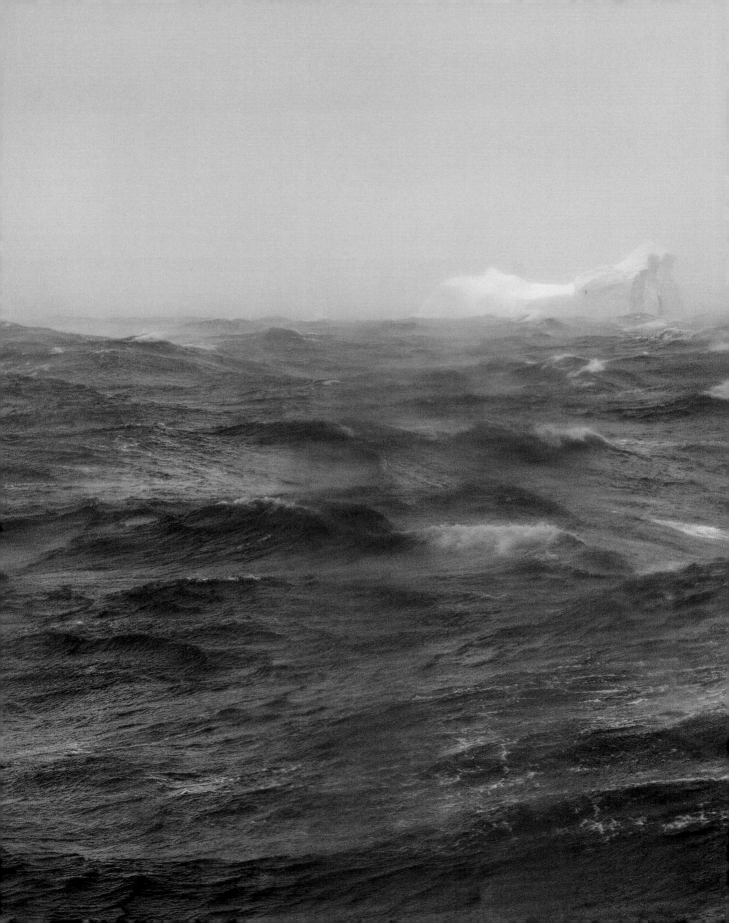

The Southern Ocean, seen through a porthole: Floating iceberg and high waves on the way to South Georgia. | Nikon D700 • 70 mm • 1/800 s • f/10 • ISO 800

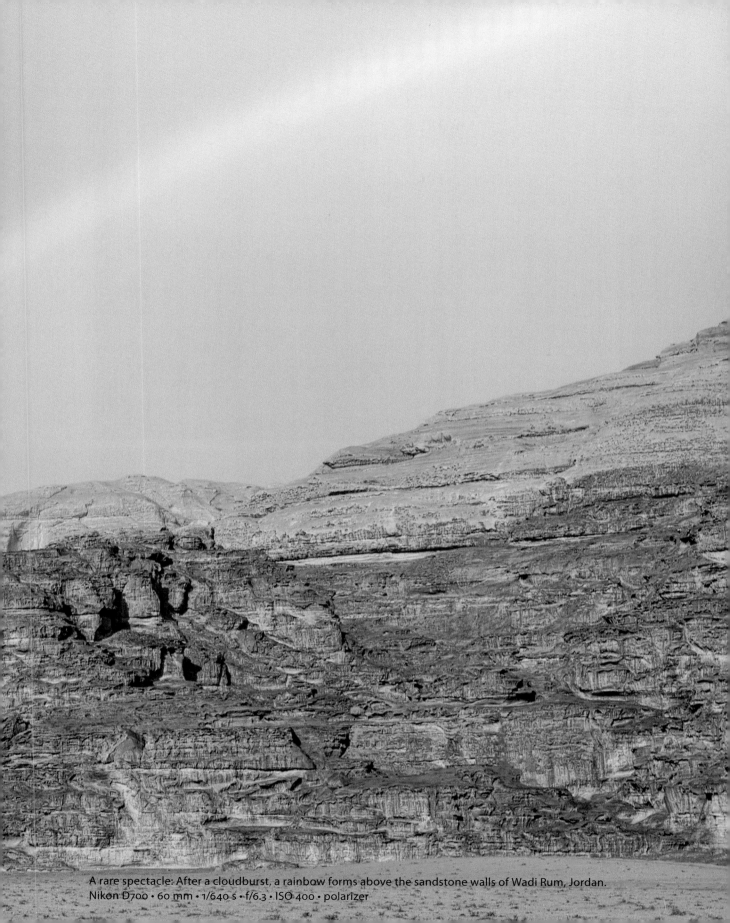

A rare spectacle: After a cloudburst, a rainbow forms above the sandstone walls of Wadi Rum, Jordan.
Nikon D700 · 60 mm · 1/640 s · f/6.3 · ISO 400 · polarizer

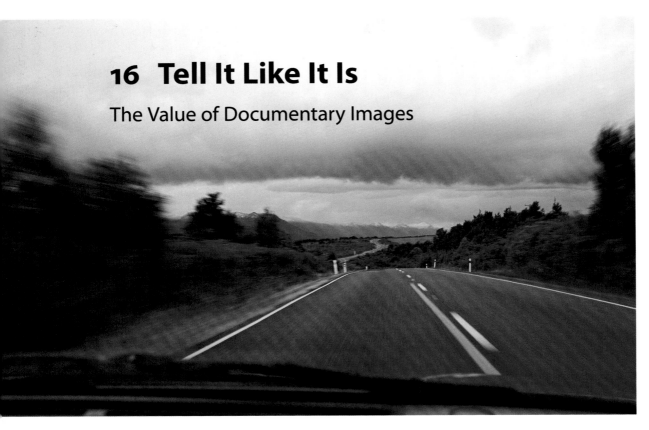

16 Tell It Like It Is

The Value of Documentary Images

In a rush to Milford Sound, New Zealand. The weather report forecasted sunshine for the coming day. We drove late into the night to be there as early as possible. | Nikon D70 • 36 mm • 1/20 s • f/3.8 • ISO 200

A picture of the salt deposits on the tires of the jeep. A picture of the ice crystals that cover the entire tent after a cold night. A silly self-portrait in front of a famous attraction. A peek into the cooking pot after the longest leg of the trek. The wind meter on the bridge of a cruise ship. A comical sign somewhere in the world. All interesting subjects, but the composition of the images is anything but perfect because each was shot quickly before the moment passed. Maybe the horizon is slanted, or one side of the subject is truncated and a random arm is accidentally included. "Just a snapshot," you might be tempted to say dismissively.

Yes, snapshots. Many photographic souvenirs are not choice quality. They simply docu-

ment what was. And really, there's nothing wrong with snapshots; the opposite is actually true. It's definitely worthwhile to document the circumstances of your journey and to capture special moments, people, feelings, and experiences, even if the resulting images don't quite meet your photographic standards (or those of others).

Documentary exposures serve a different purpose. They might replace or supplement your travel journal, serve as an aid to your memory, or document routes to retrace later. And they capture moments that seem meaningful at the time. Sometimes this meaningfulness doesn't expand beyond that particular moment, but sometimes it retains its importance for

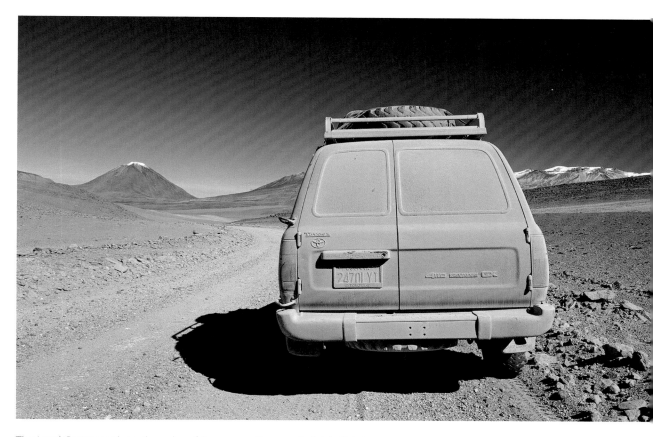

The Land Cruiser took on the color of its surroundings on Bolivia's Altiplano.
Nikon D700 • 29 mm • 1/400 • f/10 • ISO 400 • polarizer

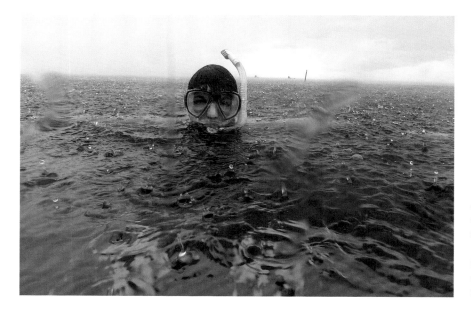

A tropical downpour surprised me when snorkeling off Tahiti. Photo by Jörg Ehrlich. Panasonic TZ10 • 25 mm • 1/200 s • f/4 • ISO 80 • underwater housing

Tell It Like It Is

years to come. For all of these reasons, those quick and anything-but-perfect snapshots have value – documentary value, but more importantly, emotional value.

As a photographer, you should come to appreciate this type of photo and its qualities. Only then will you actually take such pictures, and not kick yourself later for not taking a picture of something that piqued your interest for a passing moment.

This doesn't mean, however, that you should randomly snap away without putting any thought into documentary exposures. Firing shots without any measure of consideration produces snapshots that are devoid of meaning, idea, charm, or a connection to the moment of their creation.

In other words, thinking through the composition doesn't hurt, even if the resulting photo doesn't stack up to your standards

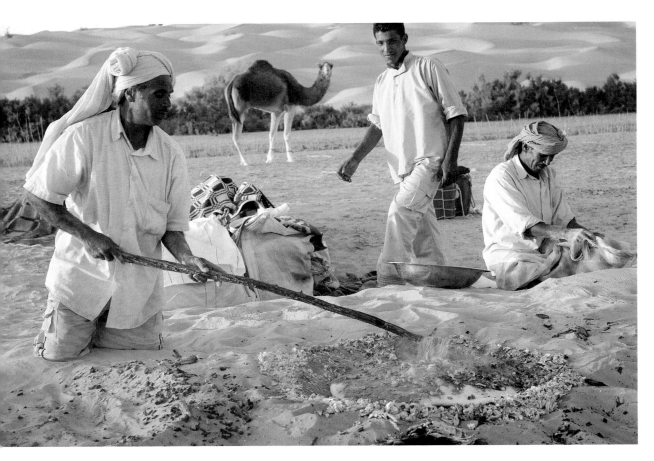

Baking in the Tunisian desert: The cook heaps glowing charcoal onto the flatbread in the sand. If I had taken greater care when composing the image, I wouldn't have clipped the head of the gentleman in the background. | Nikon D70 • 66 mm • 1/200 s • f/4.5 • ISO 200

Chapter 16

for your non-documentary images. Don't be too strict with yourself, but also remember that the more photos you produce, the more photos you will eventually need to examine, sort, evaluate, and potentially edit after you return home from your trip.

When the ego goes through the roof: Road sign in New Zealand. | Nikon D70 • 84 mm • 1/200 s • f/7.1 • ISO 200

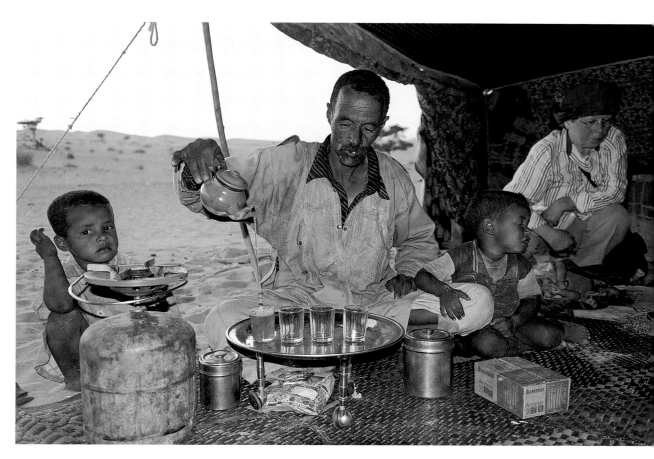

Mauretanian hospitality: Ahmed, shown here with two of his children and a visitor, prepares tea for guests he just met. We were able to send him and his family prints of this photo later. | Nikon D200 • 33 mm • 1/60 s • f/2.8 • ISO 100 • flash

Tell It Like It Is

17 The Small Traps

A Plea for Concentration

"And that little dark spot in the background of the photo, that's an extremely rare bird; there are only a few of them left in the world." Unfortunately, the animal that seemed so large and detailed to the excited photographer while looking through the viewfinder is the size of a pinhead in the actual picture. It's nothing but a splotch in the landscape. The picture still has value as a memento, but it's disappointing as a stand-alone photograph. What happened?

The more intently you focus on your main subject, the more likely you are to overlook other aspects of the scene (and not just parts of what is visible in your viewfinder). We often don't see what's there; we see what we're concentrating on. The more we concentrate on

A full-format shot of these flamingos wasn't possible so I opted for a more graphical composition instead. Below: Nikon D700 • 500 mm • 1/1000 s • f/10 • ISO 1600. Opposite: Nikon D300 • 285 mm • 1/400 s • f/10 • ISO 200

The Small Traps

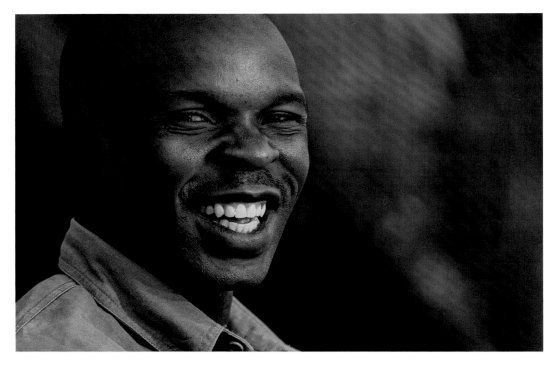

Luckson, our friendly guide in Zambia, really deserved a better positioning within the image area. But my zoom lens didn't have a shorter focal length, and I would have had to sacrifice the moment to change the lens. The solution would have been to use portrait format. | Nikon D300 • 300 mm • 1/800 s • f/4 • ISO 800

a single object, the easier it is to allow other objects and details to slip through the cracks.

We may not be aware of the actual size of our subject relative to its surroundings, or we may fail to notice distracting elements that appear at the border (especially if they're not visible in the viewfinder) or in the foreground of our images (e.g., grass, straw, or poles). We are oblivious to these distracting elements because we're focusing – literally and figuratively – on another subject, one that's far away.

The small traps that pop up in photography when we aren't paying attention include the infamous clipping off of a person or animal's body part. They include capturing a well-known attraction in the best lighting only to discover that a corner of it is missing in the final image. They include camera shake and times when the subject's movement leads to unwanted blur – in the latter case, the chosen shutter speed wasn't fast enough for the subject's movement.

Crossing the minimum focusing distance is also treacherous – for example, when you want to bring that beautiful rose in a regal garden as close as possible to your camera's sensor. The autofocus churns and churns with no success while the eager photographer gets even closer to the rose while failing to pick up that they're moving in the wrong direction (even though

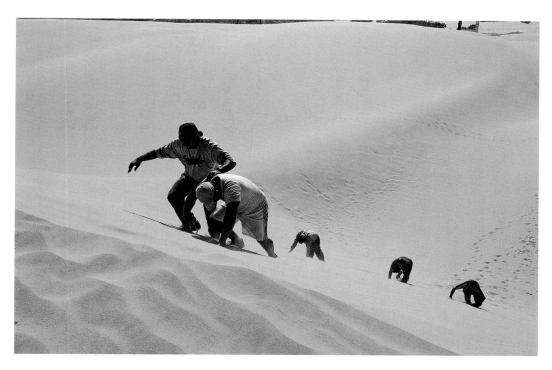

I overlooked the distracting elements along the upper edge of this photo from the dunes of Coro in Venezuela. This oversight is frustrating, but in this case, it can be quickly corrected afterwards with a crop.
Nikon D700 • 35 mm • 1/320 s • f/9 • ISO 200

the camera usually indicates this). The list of pitfalls goes on.

The bad news is that there are small traps that can cause significant problems at almost every step of the picture-taking process. The good news, however, is that you can prevent most of these problems by taking the proverbial step back to give yourself some distance from your work. This is true in an emotional sense, too, since every photographer at some point or another loses his or her head in the excitement of working with a particular subject and light.

The critical control of your image content, image composition, and technology is ulti-

mately a matter of concentration. Concentrate not only on your main subject, but also on the entire composition of your image and its technical parameters. Before you release the shutter, check again to make sure that your composition actually delivers what it promises.

Is the main subject large enough with respect to the rest of the image area, or does it appear large only because it's at the center of your attention at the moment? Are there any distracting elements between you and your subject that you haven't consciously processed? Is there a dramatic brightness contrast that the camera will accentuate much more than the human eye? This list could go on, but

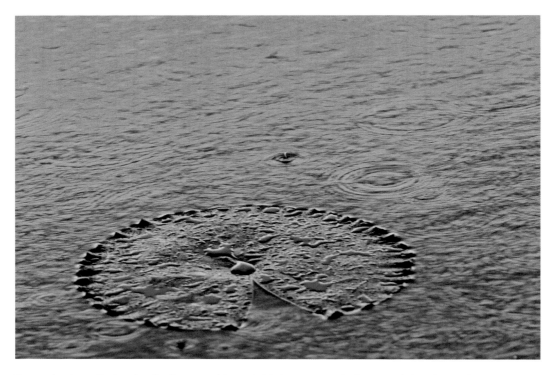

Down the drain: To this day, I'm frustrated that I didn't have a tripod when I took this photo after a thunderstorm in Botswana. Setting the lens on a guard railing wasn't enough to produce a sharp image.
Nikon D300 • 450 mm • 1/15 s • f/5.6 • ISO 800

with time and practice many of these checks will become second nature.

To return to the rare bird mentioned in the beginning, there are ways of dealing with the situation when you still wish to photograph a subject even though it's exceptionally far away. Since many camera models have such a high resolution nowadays, one option is to make use of a detail enlargement. This allows the subject to appear larger than it actually was. Another option is to make a virtue of photo-graphic necessity: A small red bird in a sea of green grass can make for an interesting subject if the composition works and the focus is well executed.

That's also more or less how I proceeded when photographing flamingos in Peru (images on pages 146/147), when I wouldn't have been able to take a full-format picture even with a 500 mm lens. The images I produced emphasize the graphic quality of the scene and reveal the animals' habitat.

Very curious: This Puffin came closer than the lens could focus.
Nikon D300 • 300 mm • 1/500 s • f/4.5 • ISO 400

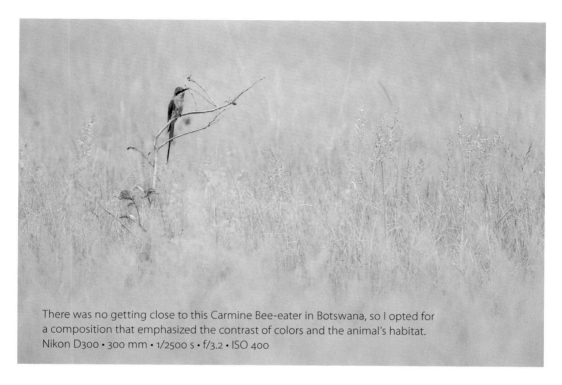

There was no getting close to this Carmine Bee-eater in Botswana, so I opted for a composition that emphasized the contrast of colors and the animal's habitat.
Nikon D300 • 300 mm • 1/2500 s • f/3.2 • ISO 400

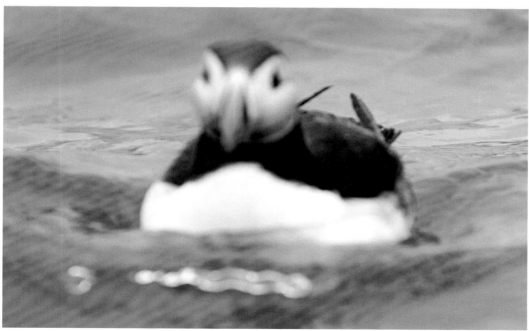

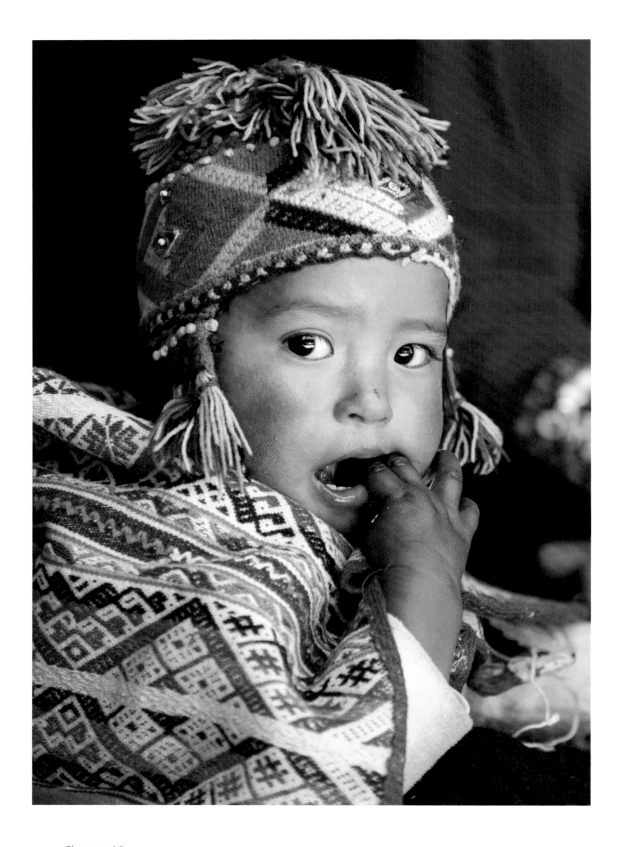

18 On To Something New

Seven Tips for More Variety

Nothing but chocolate, all day every day? Sounds enticing, but eventually it will all start to taste the same. With photography, we can run into a similar sort of problem: If you shoot from the same perspective, with the same focal length, and use the same concept for every image, you and your viewers will grow bored. Trying out new things is an effective way to break out of your old habits, both when you're on the road and in familiar climates. This chapter includes seven tips for trying something new – you're on your own for number eight and beyond.

Experiment with Depth of Field

Your favorite aperture is f/8? It might be time to step out and play the field. It's ultimately up to you, the photographer, to decide how much of your photo will appear in focus. Admittedly, there are certain situations in which the lens or even the camera makes this decision, but whenever a range of apertures is available to you, you should exploit the possibilities of the entire range. Consciously set out to work exclusively with a wide or narrow aperture for a while. Become familiar with the character-

istics of your lens. How far does the depth of field span at a specific focal length, camera-to-subject distance, and aperture? How does the depth of field change with the aperture, focal length, and camera-to-subject distance? How do the sharpness curves vary? How steep or gradual is the transition from focus to blur in the foreground and background?

While playing, feel free to break any of the common "rules". Do landscape photos necessarily need to be sharp from the front to the back? This is a common opinion for good reason, but it's not carved in stone. You can hide unattractive foregrounds, for example, with carefully applied blur. Should the focal point of a portrait always be on the subject's eyes? In principle, yes, but if you position the focal plane somewhere else, you may unveil a surprising new view of your subject. And there may even be times when you don't want anything to appear sharp in your photo.

Experimenting with depth of field is easier with cameras that have a relatively large sensor, such as most DSLRs, than it is with cameras that have small sensors, such as most compact cameras. Due to sensor size, the latter always have a relatively large depth of field under the

Halfway between skepticism and curiosity: An encounter in Peru.
Nikon D700 • 190 mm • 1/200 s • f/4 • ISO 1600

same conditions and settings, which is why you need to open the aperture up much wider than you do with larger-format sensors to reduce the depth of field.

Take a Walk with a Prime Lens

It's not for nothing that photographers occasionally head out in search of subjects with only a prime (fixed focal length) lens in hand. This deliberate limitation quickly turns out to be a creative challenge – who can say in advance exactly what images you can take with a 35 mm or 85 mm lens in Venice? If this sounds too risky to try on a vacation, then give it a try at home, where you'll have time and leisure. There's no need to spend an entire day with only one prime lens; sometimes even a stroll with a self-imposed focal length restriction can open your eyes to new subjects. Photographers who have a camera with interchangeable lenses will have an easier time with this, but even some

compact cameras can be set to a specific focal length. Then all that's left is to hold yourself to your setting.

A Small Series of Images

Pick a theme for your trip and create a series of images that represents that theme by searching out specific subjects when you are out and about. Strive to take pictures related to your theme every day or at least regularly. Let your interests determine your theme, and take pictures of whatever speaks to you. It doesn't matter whether your series is on New Zealand's streets, the hands of Bhutanese dart players, people in windows, or fruits and vegetables at the market. What's important here is the concentration on your fundamental idea. When you focus on a specific theme you see the world around you with different eyes and you are on the lookout for subjects that you might otherwise have overlooked.

This little series was the result of a walk through the weekly market in Paro, Bhutan. It reveals typical fruits and vegetables for the region, but it also functions as a study of colors and shapes.

A detail of two palm leaves, shot with a 135 mm prime lens on La Digue, Seychelles. | Nikon D70 • 200 mm • 1/640 s • f/3.2 • ISO 200

Chili peppers (far left) are a staple of Bhutanese cuisine and they're featured in the national dish Ema Datshi (chilies with cheese).

Playing with Shadows

As children, probably most of us used to play with their shadows. There's no reason to stop when we're grown up, especially when taking photographs. Where there's light, there's a shadow – a bit cliché, perhaps, but it's a fundamental fact of photography.

Don't paint with light alone, make sure to include its twin too. Sometimes a light area takes on its weight from its juxtaposition with a shadow. Whether you include the object that casts the shadow or just the shadow itself is up to you. Set out in search of light's dark side. You'll be amazed at what's lurking in the shade…

Go Back to Square One

It's not uncommon for photographers to want to try out a new piece of equipment before really understanding how to use it. But we may fail trying and end up being frustrated, as good results are obtained only by chance and it's impossible to know what you did that was right or wrong. In these cases, it's helpful to revisit the theoretical basics again. You might turn to books for help, but you can also ask a well-versed friend, pose a question in an online photography forum, or visit a photography workshop. Don't be shy. Address the problem head-on when you realize you have one. The solution is often not as complicated as you fear.

Facing page: Sunset after a heavy thunderstorm, Botswana. | Nikon D300 • 420 mm • 1/250 s • f/5.6 • ISO 800

Bottom: Reflections in western Iceland. | Nikon D700 • 24 mm • 1/320 s • f/9 • ISO 400

Reflections

From very concrete to confusingly abstract, reflections are multifaceted subjects. Whether seen in a shop window, car mirror, puddle, or pair of sunglasses, reflections add at least one additional layer to a picture. They lend themselves to everything from self-portraits to studies of color. A calm, balanced composition with an emphasis on symmetry (e.g., the Antarctica picture on page 36) is just as fitting as any number of more dynamic and extreme image designs. It all depends on the photographer's intentions and playfulness.

If you don't want to appear in your own picture, you'll need to carefully consider where to position the camera to avoid capturing your reflection. Also keep in mind that using a flash can produce unattractive results when shooting reflective surfaces. It often helps to change the angle of the camera slightly to deal with this particular issue.

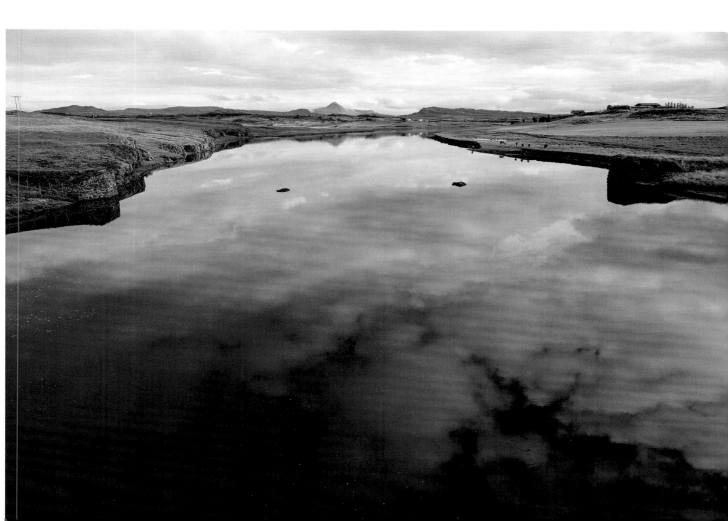

Top left: Hydrant on board an expedition cruise ship.
Nikon D700 • 110 mm • 1/1250 s • f/11 • ISO 400

Bottom left: Shadow cast by the sculpture The Chalice in Christchurch, New Zealand.
Nikon D70 • 18 mm • 1/160 s • f/18 • ISO 200

Below: Not exactly sharp – nighttime lights on a street in Chengdu, China.
Nikon D700 • 70 mm • 1/100 s • f/5 • ISO 6400

Dare Yourself to Have Creative Ideas

Creativity isn't your thing? That can change. Try something new, break from your regular routine, and stretch outside of your comfort zone a little. And when you take risks, try to stay relaxed. When taking a step into the unknown it's normal for things to not work out perfectly. Stick with your photography even if your images don't turn out the way you imagined; try again or try something a little different – the next time will go better.

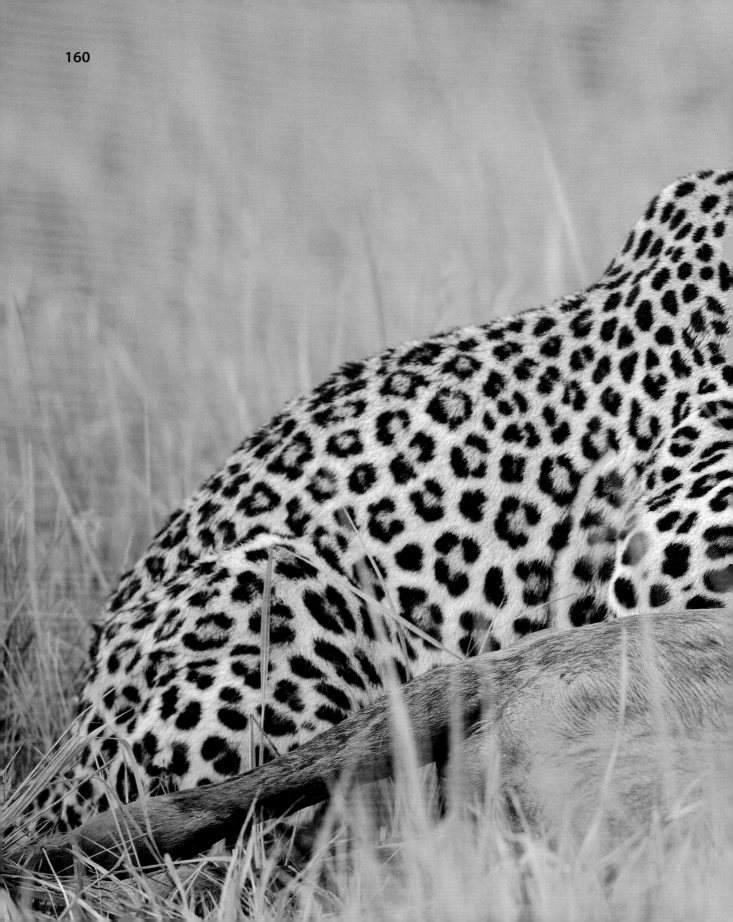

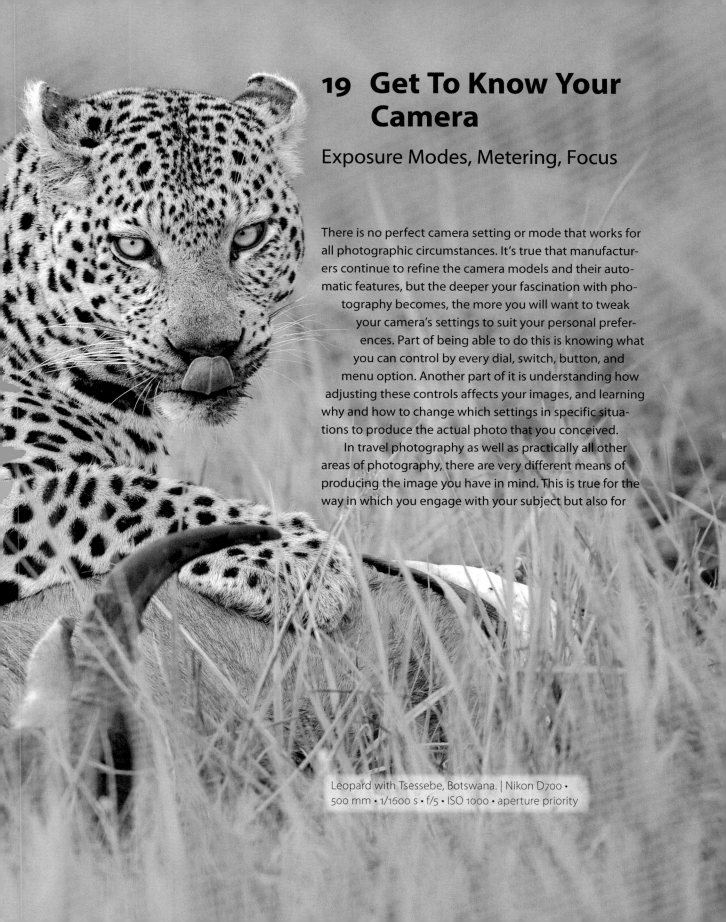

19 Get To Know Your Camera

Exposure Modes, Metering, Focus

There is no perfect camera setting or mode that works for all photographic circumstances. It's true that manufacturers continue to refine the camera models and their automatic features, but the deeper your fascination with photography becomes, the more you will want to tweak your camera's settings to suit your personal preferences. Part of being able to do this is knowing what you can control by every dial, switch, button, and menu option. Another part of it is understanding how adjusting these controls affects your images, and learning why and how to change which settings in specific situations to produce the actual photo that you conceived.

In travel photography as well as practically all other areas of photography, there are very different means of producing the image you have in mind. This is true for the way in which you engage with your subject but also for

Leopard with Tsessebe, Botswana. | Nikon D700 • 500 mm • 1/1600 s • f/5 • ISO 1000 • aperture priority

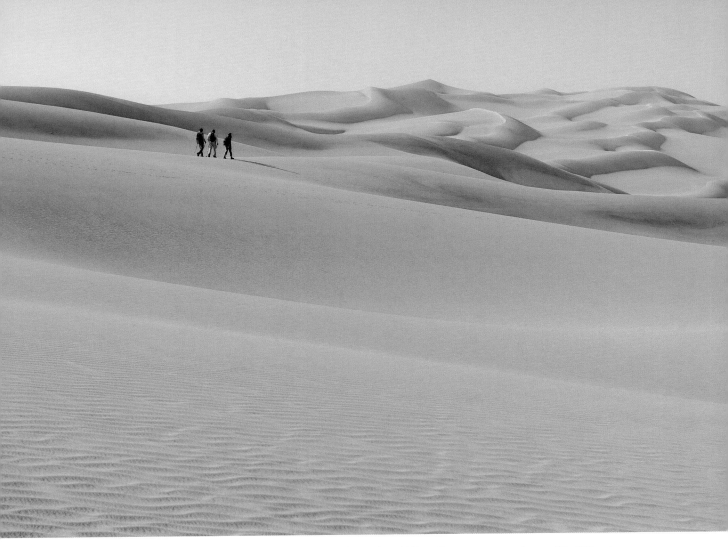

Small figures in a sea of dunes: Walking in Erg Ubari, Libya. | Nikon D700 • 70 mm • 1/250 s • f/8 • ISO 200 • program mode • polarizer

your technique and technology. Every photographer has different methods, different preferences, and different practiced procedures.

On the following pages I would like to share the settings I use for my own photography – this is my very personal style of using my camera as a tool for creating images. Most of the discussion centers on digital single-lens reflex cameras because I shoot almost all of my photos with them. This doesn't mean that you can't use a compact camera, a mirrorless system camera, or another type of camera to produce quality travel photos – quite the opposite, actually. Good pictures depend much more on the abilities of the photographer than the technical specifications of his or her camera.

Exposure Modes

In general, I think little of fully automatic exposure modes (with the exception of using simple compact cameras, perhaps), but I like the program mode (P). The main reason is that in P mode, as soon as you turn your camera on, you'll have a usable shutter speed–aperture combination at hand; you won't need to change or adjust anything if you're in a hurry. Additionally, you can use the program shift function to change the aperture or shutter speed to match your creative intentions. If a combination of 1/250 s and f/8 doesn't appeal to you for some reason – perhaps you were hoping to isolate your subject more than an aperture of f/8 would allow – you can swap your settings in fractions of a second for 1/1000 s and f/4. Furthermore, you can work with the exposure compensation and use fill flash in program mode. For all of these reasons, in many situations P mode is a powerful tool that can help you capture your desired image.

In those cases when you need to use a specific shutter speed or aperture, the two semi-automatic modes are the tools of choice. In the shutter priority or time value mode (S or Tv), the photographer sets the shutter speed and the camera automatically selects a complementary aperture. The settings remain

The wisdom of the desert: An old manuscript in a library in Chinguetti, Mauritania. | Nikon D200 • 82 mm • 1/100 s • f/5.6 • ISO 800 • program mode

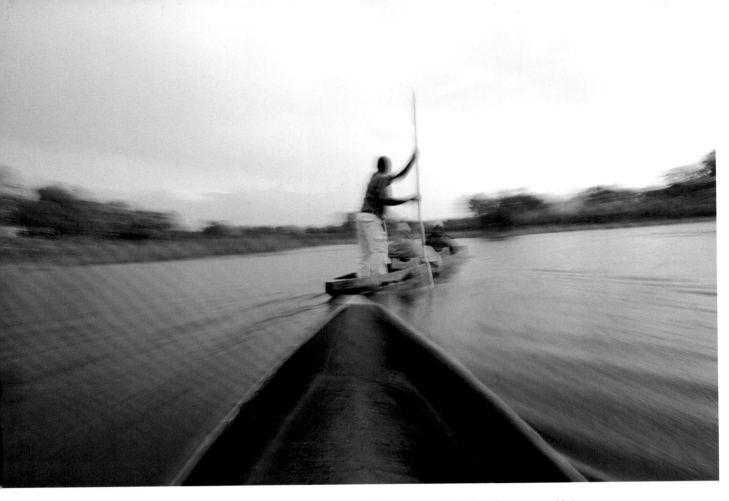

On the water in a dugout canoe in the Okavango Delta, Botswana. The slow shutter speed brings some energy into the picture. | Nikon D700 • 19 mm • 1/2 s • f/11 • ISO 200 • shutter priority

stored in the camera so you can pick up where you left off even after turning the camera off and back on.

Particularly fast shutter speeds are desirable in sports and wildlife photography, when motion blur and camera shake should be avoided, like when you're on safari using a long focal length and the lens is not stabilized. Slow shutter speeds are needed if you want to avoid freezing motion entirely to reveal something more dynamic instead, such as with long exposures of bodies of water, panned shots, or night exposures.

The counterpart to shutter priority is aperture priority or aperture value (A or Av). This setting is useful for situations when you would like to use a specific aperture setting to achieve a certain look-and-feel in your photo, particularly by making use of depth of field. In portraiture it serves to isolate the subject from his or her background with a wide aperture; in classic landscape exposures it's used to maximize the depth of field with a particularly small aperture. Of course, in virtually all other areas of (travel) photography the elaborate use of a certain depth of field – be it shallow or large –

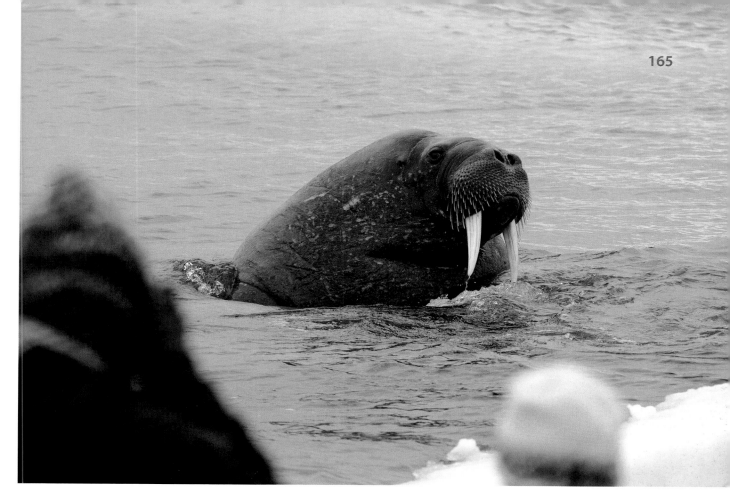

Coming up for air: A walrus off the coast of Nordaustlandet, Svalbard. | Nikon D300 • 600 mm • 1/800 s • f/8 • ISO 500 • shutter priority

can produce exciting and surprising results as well.

To me, the most important practical difference between the shutter and aperture priority modes and the program mode (which also allows you to select a specific aperture or shutter speed) is that when using aperture or shutter priority, your settings stay locked regardless of your subject and the lighting conditions, or if you have turned your camera off in between exposures. You can be sure that your settings will remain unchanged until you explicitly alter them.

However, this advantage can easily turn into a downside of the semi-automatic modes. For example, if the amount of ambient light diminishes dramatically because you moved into the shade, and you forget to alter the fixed aperture, the camera will lengthen the exposure time, possibly causing you to produce a blurred image due to camera shake. Or if you accidentally leave your shutter priority setting unchanged in the same situation, the camera will attempt to compensate by opening up the aperture as much as the lens allows. If the camera reaches the maximum aperture and can't

open it any farther, the shutter speed still won't change and you'll end up with images that are too dark.

One possible workaround to this situation is the automatic ISO function, implemented in most new cameras. With this mode, the camera can avoid exposure times that are too long by increasing the light sensitivity of the sensor (the ISO speed) within certain, partially definable limits. In some cases, the increased ISO speed will end up producing more noticeable image noise. In many cases, however, a small amount of noise will probably be preferable to a blurry photo.

A general tip is called for here in connection with all of the critical camera settings. From personal experience, this reminder can't be repeated often enough: anytime you alter the settings of your camera for a photo, you should always re-examine the settings to

A play of light and shadow in sandstone country: A visitor to as-Siq canyon, the famous entrance to the ancient Nabataean city of Petra, Jordan. | Nikon D70 • 105 mm • 1/200 s • f/8 • ISO 200 • program mode

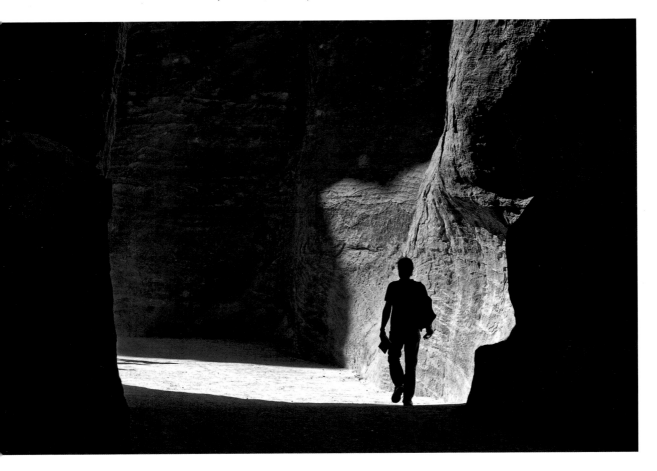

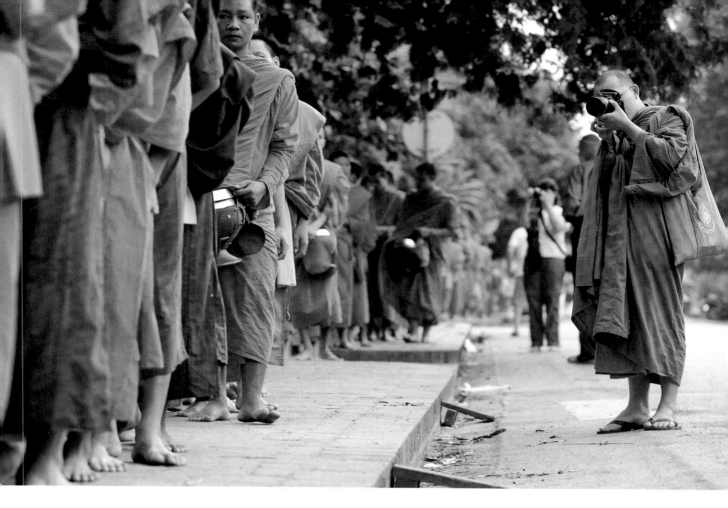

An out-of-line monk: He blended in with the mostly foreign onlookers during morning alms in Luang Prabang, Laos. | Nikon D300 • 175 mm • 1/80 s • f/4.5 • ISO 1000 • program mode

determine whether you can use them again for your next photo or whether you need to make adjustments. For example, a relatively large exposure compensation adjustment may be necessary for one photo, but may produce an unmerciful underexposure or overexposure for the next. The same goes for the exposure metering and autofocus methods. It's best to double-check, especially when the exciting distractions that are part of traveling can easily lead you to neglect the somewhat banal task of adjusting your camera settings.

Exposure Metering

Almost all the time, I entrust my exposure metering needs to the matrix metering mode, often also called multi-zone metering. In all but a few cases, I find that this mode produces results ranging from good to excellent. Using this mode – while examining the distribution of brightness values in the histogram and using the exposure compensation dial – covers most situations. Spot metering is a practical alternative in specific situations such as portraiture, for example, when the light in the background is

dramatically different from the light illuminating the main subject.

My previous reminder to double-check your settings prior to each shot also applies to exposure metering. You'll want to make sure that a setting isn't lingering from your last photo and that the metering mode selector switch hasn't been accidentally changed (as can happen if it gets snagged on the camera bag, for example). I've inadvertently used spot metering on more than a few occasions only to wonder about the confusing exposure before figuring out that the problem was actually located behind the camera, as is all too often the case.

Autofocus

With few exceptions, I keep the autofocus (AF) on my cameras set to Single AF (Nikon: AF-S; Canon: One Shot). In the vast majority of cases for static compositions, I select an individual AF point – either the central one, in which case I subsequently determine the exact image area while keeping the shutter button halfway down, or the AF point that is located where the main subject is. In general, pivoting the camera after the focus is locked is a faster process than using a switch or dial on the back of the camera to select a certain AF point. Doing so with a wide aperture, however, is not advisable – even a small shift can cause the focal plane to move away from where you intended it to be. In

these cases, it's best to manually select the AF field that corresponds to your main subject.

I opt for continuous autofocus (Nikon: AF-C; Canon: Servo-AF/AI Servo) when photographing a moving subject or when I am moving, such as in a car or on a boat. I only use manual focus when the autofocus doesn't establish the focus I want, as sometimes happens with fog, clouds, or darkness, as well as with macro exposures. Here again, don't forget to update your settings!

Do You Know Your Camera?

As tempting as it might be to bring your newest equipment with you on a trip, you are better off learning how to use your gear at home, especially if you don't shoot photos on a daily basis and tend to be more of a vacation photographer. The saying "practice makes perfect" may be cliché, but it's 100 percent true as far as photography goes. And the best place to start practicing is back home – before you take off for your once-in-a-lifetime journey. You will only be able to work confidently with your gear and remain composed in the heat of an exciting moment if you know your camera really well and have enough experience to know how to adjust its settings for certain situations and react to changing circumstances quickly.

Anyone who is completely comfortable with his or her camera will find no use for an owner's manual. However, someone who has

Skiers on the Zugspitze, Germany: The clouds confused the autofocus. I took care of the problem by first focusing on the people and then pivoting the camera. | Nikon D70 • 105 mm • 1/400 s • f/16 • ISO 200 • program mode

just purchased a new camera will be grateful to have one. If you need or want one, it's not at all unreasonable to bring your instruction manual on your trip as long as you're not obligated to pack exceptionally light. (You can also load the instructions onto a laptop, iPad, or smart phone, if that's an option.) It's frustrating to discover while on location that you can't figure out how to program an unusual or complex setting that is necessary to take a particular picture.

File Format

A simple question, a simple answer: use RAW. When it comes to determining which file format to use, you should make no compromises. As a photographer traveling or a traveler taking pictures, you likely won't have the opportunity to revisit sites later to recapture situations and moments (not to mention the fleeting mood of a scene). Why not get as much out of your camera as you possibly can?

Using the RAW format means that your camera will capture the maximum amount of visual data for each picture, leaving you the greatest flexibility when editing your pictures later. This includes adjusting the exposure and the white balance retroactively, among many other possible edits that you can also attempt with JPEGs or TIFFs, but with RAW you'll have significantly more wiggle room and you won't lose any of the original image data.

Admittedly, saving RAW image files requires more data storage space than saving JPEGs. You'll need to make plans for dealing with the increased volume of data at the various steps of your process: when collecting and saving your pictures and even when sifting through them and evaluating them. Chapter 23 on page 206 goes into more detail about the subject of safeguarding data.

Dos, don'ts, and flagpoles: Looking out of the window at the Chilean-Argentinian border while waiting for the bus. Photo by Ingrid Petrowitz. | Fuji S5Pro • 128 mm • 1/290 s • f/9 • ISO 320 • program mode

SALIDA DE EMERGENCIA

Fascinating confusion: The crew of the ship is reflected in a windowpane with the South Atlantic in the background. Photo by Ingrid Petrowitz. | Fuji S5Pro • 128 mm • 1/640 s • f/13 • ISO 500 • program mode

Shooting RAW also entails that after your trip (at the latest), you'll need to take up the task of editing your image files, which requires time and effort. If you want to avoid this process altogether you can use a RAW converter software to batch process many or all of your images into JPEGs in one go. You'll still retain your high-quality RAW data should you ever want to do a more thorough conversion later. Alternatively, many cameras allow saving RAW and JPEG versions of the same file in parallel. This, of course, increases the need for memory even more.

Many advanced compact cameras are capable of recording RAW files, but if your camera isn't, you may have to consider alternative options. (Not having the ability to shoot RAW would be reason enough for me to look for a different camera.) In this case, the goal is to find a camera setting that least compromises your pictures. Aside from choosing the highest possible resolution and the least amount of compression, you will also want to keep the camera's internal post-processing (sharpening, contrast, etc.) to a minimum. This will give

you the greatest flexibility to make corrections and adjustments and to develop your picture according to your personal preferences subsequently. Almost any digital photo can be sharpened, but it is significantly more difficult to reverse sharpening that has been overdone. The same is true for excessive contrast.

A note of caution: While the RAW format is highly capable, it can't work wonders. Pictures with significant exposure errors can't be rescued, regardless of whether they are in the RAW or JPEG format. The bottom picture shows a hopelessly overexposed image of a river in Peru's Manú National Park. Under the slightly hectic circumstances of the moment, I made three mistakes. First, while swapping back and

forth between two cameras in the dawn of the day, I forgot to change the ISO setting from 800 to something more appropriate. Second, I overlooked the fact that I was still shooting in aperture priority mode with a preset aperture of f/4. And third, I checked the histogram way too late.

The camera did what it could to create a properly exposed image, but it stood no chance, even with the fastest possible shutter speed of 1/8000 second. There was simply too much light. The result is a ruined photo, though you could find a certain artistic quality in it – at least if you don't know the story and assume the image turned out just the way the photographer intended.

There's no way to rescue this severely overexposed picture taken in Manú National Park in Peru. Even having a RAW file didn't help in postprocessing – the blown-out white areas don't retain any detail at all. Nikon D300 • 260 mm • 1/8000 s • f/4 • ISO 800 • aperture priority

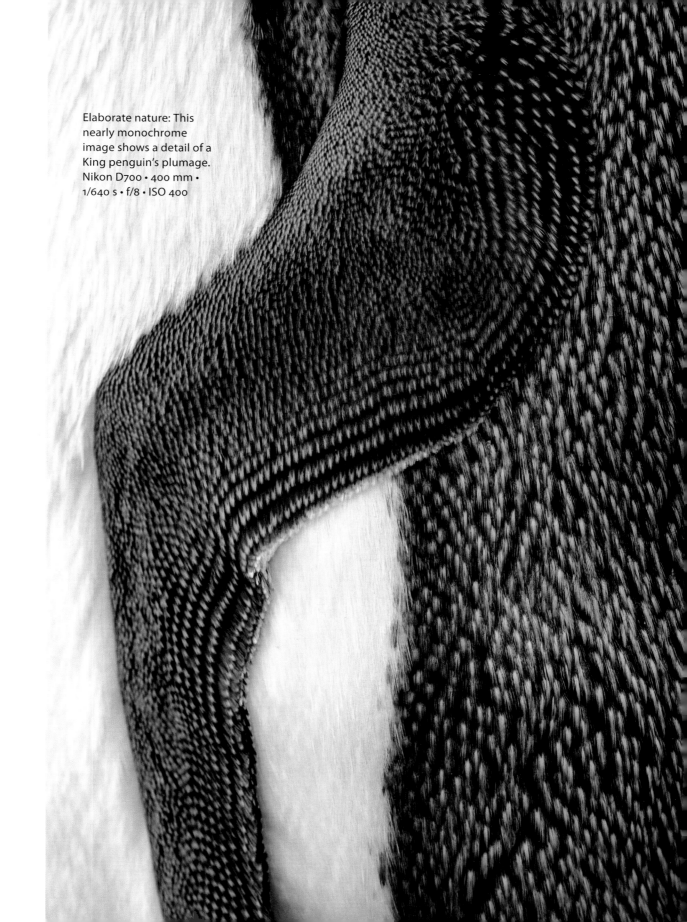

Elaborate nature: This nearly monochrome image shows a detail of a King penguin's plumage. Nikon D700 • 400 mm • 1/640 s • f/8 • ISO 400

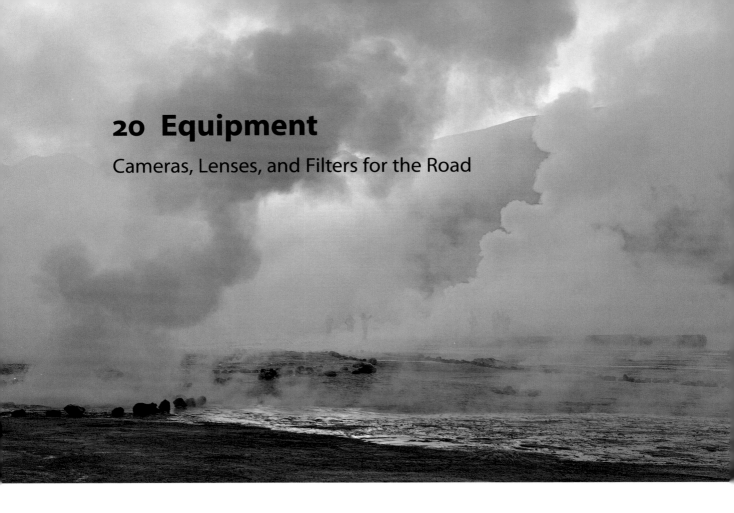

20 Equipment

Cameras, Lenses, and Filters for the Road

It's not easy to decide what photographic equipment to pack for a trip, regardless of whether you consider yourself a traveling photographer or a photographing traveler. The goal is to retain mobility and not be burdened by too much gear, but still have enough equipment to enjoy photographic freedom. Depending on the way you're traveling, your personal preferences, and your intentions as a photographer, everything from a cell phone to a large-format camera is conceivable, at least in theory.

In the vast majority of cases, the selection will be limited to digital single-lens reflex cameras or mirrorless system cameras and their lenses and digital compact cameras. It's impossible to give a general guideline because the prerequisites and intentions of every photographer are different. Cameras are like hiking boots: When packing for a really important trip, you may not want to take your most recently purchased gear, and instead opt for the equipment that you're familiar with. But really, this just means that you should get to know your gear well before using it on a trip.

Which camera(s) and which lens(es) you select is a personal decision and, unless you're purchasing an entirely new set of gear, will depend on the equipment that you have on hand. The type of travel you plan to embark on is a key factor. If you're headed out on a multi-day mountain trek, you're going take less photo equipment with you than you would on

Opposite: Steaming earth – the first rays of dawn at –12 °C at the Geyser El Tatio, Chile. | Nikon D700 • 70 mm • 1/250 s • f/8 • ISO 400

Bottom: Kiwis on the road – the back of a tour bus in New Zealand with vent holes shaped like kiwis (the national bird). | Nikon D70 • 84 mm • 1/100 s • f/5 • ISO 200

a relaxing holiday getaway in a hotel. If you're traveling by bicycle, your luggage restrictions are much more extreme than if you're touring a country in a rental car. Generally speaking, take as much as necessary and as little as possible.

It's important to note that the ideal camera, lens, or camera and lens combination for a specific country, region, or trip does not exist. All photographers have their own conception about the equipment they deem necessary. Questions about what type of lens to take to Namibia or what gear to bring on a two-month tour of New Zealand seem much less productive to me than other considerations like: What are your photographic priorities? What do you want to photograph when you're on the road? How much equipment can you carry? How much equipment do you want to carry?

A photographer's equipment should give him or her the chance to realize any ideas for pictures with as few limitations as possible. The camera(s) and lens(es) you bring along depend much more on your intentions and preferences as a photographer than on your travel destination. The gear that served you well on a general tour through Laos will also be well suited for a similar trip through Peru. You'll want to include the telephoto lens that was so useful on safari in Tanzania when setting off for a comparable trip to Zambia. If you plan on shooting portraits

while traveling, you might want to consider bringing a fast prime lens somewhere in the range of 85 mm to 135 mm. If you know you are primarily interested in landscapes, you likely won't want to do without a wide-angle or ultra-wide-angle lens. If macro photography is your priority, a macro lens should probably find its way into your equipment bag.

The following paragraphs describe the gear that I usually take with me while traveling, but that doesn't mean that it is also what will work for you; it's included here as a starting point for you. I predominantly use (fast) zoom lenses because I'm usually not willing to give up the flexibility afforded by zooms while traveling. Moreover, I appreciate the mechanical quality of an f/2.8 lens designed for daily use in a professional environment. Bringing along fixed-focal length lenses is not an option for most trips on account of space and weight limitations, but other photographers may want to include them.

My minimalist combination comprises a full-format digital SLR (currently a Nikon D700) and a standard zoom lens (f/2.8 24–70 mm). If I happen to be traveling somewhere with

Opposite page: A symphony of color and a photographer's dream – Antelope Canyon, USA. Photo by Jürgen Gulbins. | Canon EOS 20D • 31 mm • 30 s • f/14 • ISO 400 • tripod • cable release

Below: The largest salt flat in the world – daybreak at the Salar de Uyuni, Bolivia. The elevated camera position highlights the salt pattern. | Nikon D700 • 24 mm • 1/125 s • f/5.6 • ISO 1250

conditions that make changing the lens inadvisable (e.g., a sandy desert), or I'm in a position where I can't afford to lug around anything else, this range of focal lengths paired with the large maximum aperture allows me to realize many photographic ideas. I could also imagine using a zoom lens with a range between 24 mm and 120 mm or something comparable as an everyday lens.

The more universal set of gear, which I bring on most trips, includes an f/2.8 17–35 mm lens on one end and an f/2.8 70–200 mm lens on the other. I also usually have a second camera body as backup (currently a Nikon D300). The crop factor of the D300's smaller sensor means that the 70–200 mm lens is effectively a

105–300 mm lens with a continuous maximum aperture of f/2.8. This sort of photographic flexibility comes with a price tag in the form of added weight, though. The two cameras and three lenses add a good 11 pounds to the scale, without accessories.

If you are after a smaller or lighter setup (which usually means sacrificing lens speed and most often also a bit of image quality), but want to retain the focal range, you might consider an APS-C camera paired with an 18–200 mm lens or a full-format camera with a (relatively heavy) 28–300 mm zoom, complemented by a fast prime lens in the normal or wide-angle range. Zoom lenses should generally feature internal image stabilizers. There are

Photographing on African safaris often calls for long focal lengths. I rested my lens on the roof of our safari vehicle for this shot taken in Amboseli National Park, Kenya. | Nikon D300 • 600 mm • 1/500 s • f/5.6 • ISO 200

limitations to this assortment, of course, and you'll have to decide for yourself what compromises you're willing to make. Another alternative would be to use a mirrorless system camera with interchangeable lenses of your desired lengths.

Avoiding gaps in focal lengths isn't a must. If focal lengths in the normal range aren't your priority, then you can combine a 17–35 mm zoom or a fast 24 mm prime with a 70–200 mm zoom and ignore the range that isn't covered. This decision should be informed by where and how you're traveling and what and how you're

photographing. You can pretty easily get by on "zooming with your feet" for city adventures, and it may not be necessary to have a proper zoom lens with you. But if you find yourself in a situation where you can't adjust your position, such as in a safari jeep or on a boat, zoom lenses are more or less indispensable.

Special situations often require special equipment. If I'm photographing wildlife, for example, then I use an f/4 200–400 mm and an f/4 500 mm lens. These long telephoto lenses allow for amazing photographic possibilities, but their weight and size limit their "travelabil-

Handy, practical, inconspicuous: Compact cameras are a sensible addition to DLSRs. This photo was taken in the Okavango delta, Botswana. Photo by Jörg Ehrlich. | Canon EOS 7D • 240 mm • 1/1000 s • f/5 • ISO 1250

Equipment

ity". Lighter and less expensive alternatives include slower lenses with focal-length ranges between 70 mm and 150 mm on the low end and 300 mm and 500 mm on the high end.

A teleconverter is one relatively cost-effective and lightweight solution to elongate the focal lengths you already have. They are available at different levels of magnification – commonly, 1.4x, 1.7x, and 2.0x. This increase in length usually comes with a decrease in lens speed. Nikon's 1.4x TC-14E II amounts to a loss of one stop, the 1.7x model a loss of 1.5 stops, and the 2.0x model a loss of two stops. Nature photographers often find that the increase offered by a 1.4x converter when paired with a long, fast prime lens is a good solution. This setup results in a noticeable increase in focal length, and the loss of lens speed and image quality isn't significant. A 1.4x converter turns an f/4 500 mm lens into an f/5.6 700 mm lens – impressive for a small accessory that weighs around seven ounces.

Not all teleconverters are compatible with all lenses. Before buying one you should check to make sure it actually fits on the lens you intend to use it with. Additionally, if you attach a teleconverter to a relatively slow lens, the autofocus may stop working properly or even at all because there won't be enough light to support the focusing system. Manual focus is the only way to go in this situation.

Sometimes, I include compact cameras in my travel setup; when I do, they supplement my DSLR. When selecting a compact model, I tend to look for something with high image quality and a practical range of focal lengths. On the short end, anything longer than 28 mm doesn't work for me, and 24 mm is better yet

(based on a 35 mm film equivalent). Even though the difference is only four millimeters, it accounts for a lot in the wide-angle world. On the long end, 105 mm or 120 mm generally does the trick. It's also important to me that a compact camera can be manually programmed and that it can save images in the RAW file format. If it offers relatively fast optics on top of all this, then all the better. Many modern compacts also include a useful macro mode.

Next I'll go into accessories, but only those that are directly related to cameras and lenses. You can find more in the chapters "Steady Now" (on tripods, page 186), "Better Safe than Sorry" (on protecting equipment, page 196), and "Safeguarding Data" (on protecting image files while traveling, page 206).

In my opinion, the most useful accessory for every lens is a lens hood. It prevents unattractive light reflections (flares) and physically protects the lens and its front optical element from scratches. My lens hoods are always on, unlike my lens caps. The same goes for UV or clear filters for protecting the front lens. When transporting my gear, however, I push the lens hood back over the lens in reverse position and reattach the lens cap. This works as well with the costly and voluminous but indispensable lens hoods for super-telephoto lenses. Additionally, lens hoods often allow you to work in the rain with less trouble – the hood protects your front optical element from getting wet.

A polarization filter (polarizer) is often useful for landscape photos, as it can produce clearer, more saturated colors and minimize reflections. A polarizer's effect on a photo is stronger than it appears in the viewfinder, so

A play of colors in Laguna Colorada, Peru: The above photo was shot without a polarizer; for the one below I used a polarizer at its maximum effect. | Nikon D300 • 75 mm • 12/250 s • f/8 (above), f/6.3 (below) • ISO 400

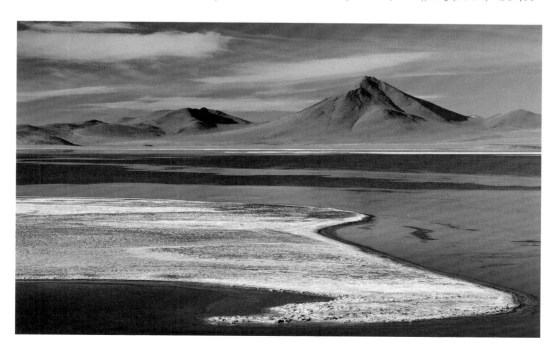

make sure to familiarize yourself with it before using it at its maximum strength. Polarizers can also eat up to two stops of light, so it's advisable to remove the filter when you don't need it. One last word of warning: when using polarizers in tandem with wide-angle lenses, the sky can often take on an uneven color cast.

If you decide to purchase a polarizer, go for a high-quality one. The same can be said for anything that you attach to the front of your lens. You'll often see photographers shell out lots of money for lenses and cameras but then skimp when it comes to filters. This is too bad because an inferior filter can have negative effects on images, regardless of how formidable the optical system behind it is. In a technical sense, every picture can only be as good as the weakest component involved in the entire exposure process.

You can generally be sure that a filter is high quality if it has multiple coatings and is produced by a trusted brand manufacturer. These characteristics come with added cost,

of course. There are many manufacturers; I use screw-on polarizers from B+W and Singh-Ray. I generally bring two 77 mm polarizers with me so that I don't have to constantly move one from lens to lens (and have a spare in case I happen to lose or damage a filter). One polarizer goes on my f/2.8 24–70 mm lens, the other goes on either a wide-angle or a telephoto zoom lens. If you have lenses with different-sized filter threads, you might decide to purchase a filter for each diameter (or lens). This is a practical but expensive solution. Filter adapters (step-down rings) are less expensive and allow you to use a filter with a larger diameter on a lens with a smaller one. You can't use an adapter with a lens hood, however.

Occasionally I'll use a neutral density (ND) filter or, more often, a graduated ND filter to experiment with long exposure times or to reduce the range of brightness values in an image. I recommend the use of rectangular graduated ND filters that can be slid into special holders attached to the lens. Lee and Singh-Ray offer such options. Going this route allows you to precisely position the transition point between the non-darkened and the darkened area. Employing a tripod isn't essential, but it is recommended. If you're using long exposure times with an ND filter – to capture the flow of moving water, for example – there's no getting around using a tripod.

Playing with color, shape, and light: Detail of a passenger ferry in Patagonia, Chile.
Leica D-LUX 6 • 37 mm • 1/160 s • f/2.8 • ISO 80

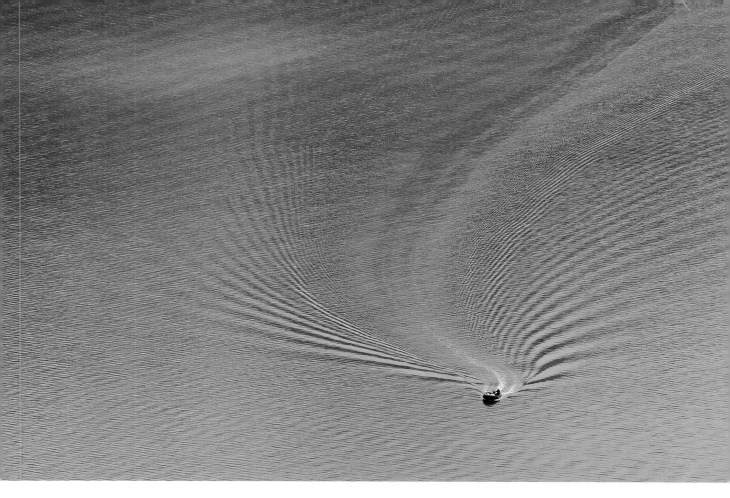

Swinging across Arctic waters: Rubber dinghy in Tinayrebukta, Spitsbergen.
Nikon D300 • 230 mm • 1/250 s • f/8 • ISO 400

If you intend to shoot macro photographs, you can bring a specialized macro lens with you, or you can opt to make do with relatively lightweight tools, such as close-up lenses and extension tubes, to enlarge details from exposures made with normal or telephoto lenses. A close-up lens is screwed onto the front of the lens, like a filter, and functions just like reading glasses or a magnifying glass. The strength of a close-up lens is measured in diopters. The stronger the lens, the closer you can approach your subject. Your camera's exposure metering will work, as will the autofocus, though possibly with certain limitations, and there will

be no significant loss of light. Upmarket, corrected close-up lenses (achromatic lenses) can be found in a variety of filter thread diameters and strengths depending on which lens (or rather, which range of focal lengths) you'd like to modify. The 250D close-up lens from Canon is rated at +4 diopters for the range of focal lengths between 50 mm and 135 mm; the 500D model at +2 diopters for use with focal lengths between 70 mm and 300 mm. Close-up lenses become more powerful with longer focal lengths and they can be used to good effect with telephoto and zoom lenses. When using this type of lens, it's a good idea to stop down

Colorful: Beach finds in Kong Oscar Fjord, Greenland. | Nikon D700 • 70 mm • 1/160 s • f/6.3 • ISO 800 • Canon 500D close-up lens (+2 diopters)

a few steps, primarily to counteract a loss of sharpness in the image corners. In the picture of pebbles from Greenland (top), I should have stopped down to f/8 or f/11 for the sake of the sharpness near the image border.

Extension tubes that go between the camera and the lens are an alternative to close-up lenses. They don't contain any opti-cal elements and are practically hollow; their purpose is to increase the distance between the lens and the sensor plane. This reduces the minimum focusing distance, allowing you to approach your subject closer and to grab a larger depiction of it. In addition to being available at different lengths, tubes can also be coupled together to alter the exten-

Sculptural artwork made by nature: A look into the marble caves of Lago General Carrera, Chile.
Nikon D700 • 50 mm • 1/800 s • f/9 • ISO 2000

sion length. Automatic extension tubes are preferable to the less-expensive manual ones because they relay the autofocus and exposure settings between the camera and the lens. With adequate light and a fast enough lens, the autofocus should work fine.

In contrast to close-up lenses, extension tubes are more effective with shorter focal lengths. You have to take a loss of light into consideration with extension tubes, and "normal" exposures are just as difficult to take with extension tubes as with close-up lenses: the lens can no longer focus at infinity.

21 Steady Now

The Need for Stability: Tripods & More

It's for good reason that landscape photographers swear by tripods: a tripod forces the photographer to work with a certain degree of focus and deliberation, which can only be a good thing as far as image composition goes. Anyone who wants to experiment with long exposure times, perhaps at twilight or nighttime or simply for creative reasons, won't be able to get very far without one. Finding the right tripod is comparable to finding the right lens, the right photo backpack, or the right camera bag: it all depends on your priorities. No one tripod will meet all of your needs, but you can probably find a satisfactory compromise.

Carrying a tripod only makes sense if you're actually going to use it; otherwise it's just dead weight. This is the central dilemma for travel photographers, which often enough results in the decision to do without one on the next excursion. The ideal travel tripod is light, stable, and doesn't take up much space when packed away. Unfortunately, this desirable combination tends to be expensive. If you don't have tight luggage constraints – perhaps you're traveling in a rental car – finding a tripod that will meet your needs is much easier.

Fiery spectacle: Nighttime view
of the Halema'uma'u crater in
the caldera of Kilauea, Hawaii
Volcanoes National Park (USA).
Nikon D700 • 82 mm • 3 s • f/2.8 •
ISO 400

All Good Things Come In Threes

All of the general rules about photo equipment also apply to the classic tripod: as light and compact as possible, but as stable as necessary. Better to err on the side of sturdiness than not, since a wobbly tripod is useless. I've long wanted a compact and, above all, light tripod, but in the end I always fall back on my old carbon tripod (Gitzo 1348), which weighs close to five pounds without a head and measures a bulky 24 inches. When using the appropriate tripod head, though, it holds up my f/4 500 mm lens without a whimper.

Carrying around such a long lens while traveling is more of an exception than a rule if you're not on a safari or something similar (see page 192 for beanbags and such), but a travel tripod should be sturdy enough to support the camera mount, the camera itself along with a vertical grip, and, depending on your lenses, a 200 or 300 mm lens without any problems.

Here's a quick rundown on what gear might weigh: A Nikon D700 with a vertical grip and an f/2.8 70–200 mm zoom lens weighs in at around six and half pounds. Add in a ball mount, an L-bracket, and some additional weight for accessories and we're close to nine pounds. A tripod with a maximum weight rating of 11 pounds wouldn't collapse under the weight of this setup, but its vibration dampening capacities might well be at their limit. With this gear, a tripod rated for 15–18 pounds (and the corresponding improved dampening) would be better. You're better off taking the recommended weight capacities provided by the tripod manufacturer with a grain of salt; it's better to have a bit more tripod than you need.

On one hand, the more segments a tripod has in its legs, the smaller its size when collapsed. On the other hand, tripods with fewer segments tend to be more stable because they have fewer connections and sturdier legs. You'll generally have to choose between tripods that have three or four segments. I personally opt for models with fewer segments and accept the added size as a compromise.

A center column may seem advantageous, but it often causes instability, especially when you're using longer focal lengths. If you're not using it, you're better off retracting it or removing it entirely. The latter goes for when

you want to position your camera close to the ground.

One critical factor when selecting a tripod is the height at which you generally shoot. If you often set your camera at eye level, you'll be grateful to have a tripod that allows you to work without having to be bent over all the time. Having significant height as an option can also help out when you're working on unlevel ground because the added length of the legs can make it easier for you to compensate for the unevenness. If you don't need the full length of the legs, you're better off using the thicker segments near the top of the tripod, since they are structurally more solid than the slimmer segments near the bottom. The lower ones should be used only when necessary.

The material out of which your tripod is made – aluminum, basalt, or carbon – will depend on how important it is for you to have a lightweight tripod and how much money you can or want to spend. Carbon tripods are the most expensive but they also tend to be the lightest. Aluminum tripods aren't all that light but they are relatively inexpensive. Basalt tripods come in somewhere in between in terms of both weight and price. Anyone using an aluminum tripod in winter may want to cover the topmost part of the metal legs with duct tape, neoprene, or aftermarket sleeves, which will prevent the metal from getting all too cold and will keep your fingers from sticking to it. Some nature photographers swear by wooden tripods on account of their vibration dampening, but these aren't very practical for travel photography since they tend to be bulky and weigh a lot.

Use Your Head

One could write an entire book about tripod heads and the right choice for travel photography. In practice, most travel photographers have to decide between a ball head and a 3-way pan-and-tilt head. These are the most popular varieties. Ball heads are practical and swift to set up while pan heads allow for more fine-tuning and a greater degree of precision. Again, your selection will depend largely on your intentions and preferences. Travel photographers who are interested in architectural photography may want to consider the pan head

variety, but in general, if you have a medium-sized ball head, you'll be prepared for almost any situation.

You also want your tripod head to be as small as possible, but as large as necessary – a heavy super-telephoto prime lens poses different requirements for a tripod and its mount than a normal zoom with a significantly lighter weight. A compact travel tripod with a ball head that has a 40 mm diameter is often a good choice. Larger heads such as the BH-55 from Really Right Stuff can manage my f/4 500 mm lens without trouble. When making a purchase, test the head to see if a relatively heavy camera-lens combination causes the mount to shift at all. This can be a particularly aggravating problem when you've spent a while getting your composition just right only to have your camera slide down unexpectedly.

It's ideal if a tripod head includes a specific base designed for panoramas that is separate from the actual ball and allows for smooth horizontal panning. Additionally, I find a friction setting invaluable. It prevents the camera-lens combination from tipping to one side when you release the ball head, which is particularly critical when you've entrusted your tripod with heavy equipment.

If you plan on photographing at all in the colder regions of the world, make sure you can operate your tripod and mount while wearing gloves or mittens; large, nonslip screws and levers are best. With a little bit of practice, and if the controls differ from one another in size and positioning, you should be able to adjust your tripod head in the dark without any trouble (or without explicitly having to look at what you're doing).

A photographer's back will be thankful if his or her tripod is tall enough. Raudfjorden, Spitsbergen.
Nikon D700 • 110 mm • 1/250 s • f/8 • ISO 400

Quick Release Systems

Anyone who shoots with a tripod regularly is familiar with the advantages of a quick release system. If you wanted to, you could mount your camera directly on the tripod or head with the traditional screw every time and then remove it afterward, but quick-release systems take less time and make the process much easier. To have this flexibility an appropriate system must be installed on the tripod head, and your cameras and lenses need to be fitted with the requisite counterparts. In most cases, these counterparts consist of plates or rails that slide into a jig mounted atop the tripod head.

There are a variety of quick release systems on the market. The dovetail plates built to the Arca-Swiss standard are widely popular. Some plates are designed for specific camera models while others are designed as an alternate mount for longer telephoto lenses. Super telephoto lenses in particular should be attached directly to the tripod instead of mounting the camera. With this setup, the lighter camera body hangs from the much heavier lens rather than the other way round. This puts less strain on the lens mount and makes the camera-lens combination much easier to handle because of its more pivotal position.

One special accessory worth mentioning is the L-bracket, which positions a second dovetail rail on the left side of the camera in addition to the one below the camera. This allows photographers to rotate the camera-lens combination to the portrait format without needing to adjust the tripod head itself. Anyone who likes shooting in portrait format should at least consider using an L-bracket.

En route to the next photo target with a full load: That's me on the move on Spitsbergen. Photo by Jörg Ehrlich. | Canon EOS 7D • 160 mm • 1/200 s • f/5 • ISO 100

In theory, all Arca-Swiss compatible camera and lens plates have a standard fit, and most do indeed, but you should exercise caution when using quick-release clamps on your tripod head. Double-check that the clamp and the camera or lens plate really fit together and that when the clamp is closed, the camera is securely fastened. With the classic screw clo-

sures (which I prefer, in part because they're easier to operate while wearing gloves) this problem doesn't come up. One more thing: quick-release-system plates often require a hex key to tighten or remove them from a camera – this key belongs in your equipment bag!

One Leg, Or a Bean Bag, Is Often Enough

Tripods are the standard when it comes to camera stands, but they aren't practical for every situation, often on account of their weight or size. In these cases, you might want to look for alternatives, and there are quite a few. Anything that provides stability is worthy, and inventiveness can go a long way here.

First on the list is the tripod's smaller brother, the monopod. It may not look like a proper camera stand, but it has its place. It can help to stabilize longer focal lengths, even if it can't replace a tripod. Transferring some of the weight of a super-telephoto lens to a

monopod so you no longer have to support the entire camera-lens pair yourself provides immediate relief, and not only for sports photographers. A monopod is also useful in many travel photography situations, such as when there's not enough space for a tripod on an inflatable raft. Using one will require a bit of practice. Either a smaller ball head or a simple two-way pan head works as the mount. Here the goal is less about being able to have ultimate control and more about ease of use.

Yet another alternative to a tripod is a beanbag. It is extremely helpful if you want to shoot from the window of your car or the roof of a jeep, for example (if necessary, a small pillow will do as well). Ideally you would travel to your destination with the bag empty and then fill it up with rice, beans, corn, or lentils once you arrive. I've even used sand when nothing else suitable was on hand. A photo beanbag should be large enough so that you can easily rest your lens and/or camera on it, and it

Patagonian light show: Just before sunrise near Torres del
Paine, Chile. | Leica D-LUX 6 • 50 mm • 1/250 s • f/2.8 • ISO 160

193

should also have a string attached to it so you can pull it back into your vehicle if you should happen to drop it overboard.

Anything else that might serve as support for a camera or lens is fair game while traveling: a backpack, a wall, a bundled-up jacket, a chair, a table, a bench, the ground… Many (sturdy) photography backpacks or camera cases can be jerry-rigged to support your camera if no proper stand is handy – here the ingenuity of the photographer is in demand.

Working with a makeshift camera stand is obviously not as easy as working with a proper tripod, but again, it's better than nothing. When doing so, however, don't forget to make use of a remote shutter release. This little helper can prevent camera shake and belongs in your equipment bag even if you're doing without a tripod. If needed, the camera's self-timer can also prove useful for this purpose.

Detail of Hraunfossar, Iceland: The waterfall got its name from the water appearing to jump directly out of the lava ("hraun" in Icelandic). | Nikon D700 • 135 mm • 1/200 s • f/7.1 • ISO 200

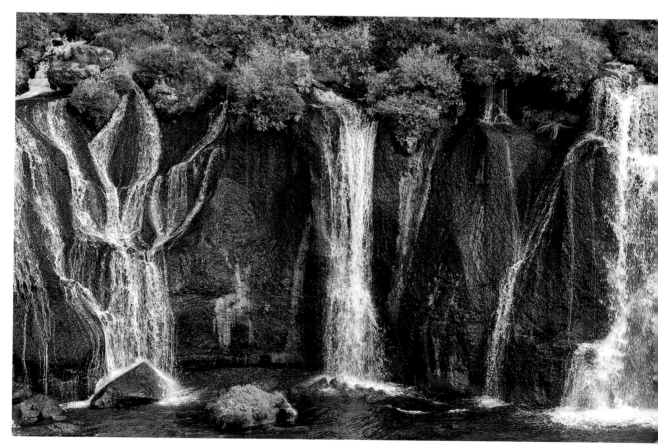

Benefits and Limitations of Image Stabilizers

Many modern lenses and cameras offer image stabilization of some kind. The fundamental method of operation of these systems is always the same: Movable optical elements in the lens or a flexibly mounted sensor in the camera counteract the photographer's movements, which cause camera shake during long exposure times. (Note that several compact cameras pretend to offer something loosely related to these systems, but in reality, they only hike the ISO values to inadvisable levels if the exposure time goes above a certain limit. The best-case scenario produces half-sharp images with distracting noise. For this reason, keep an eye out for misleading marketing terms such as "digital image stabilization.")

Proper optical stabilizers produce good to excellent results, based on my experience. They aren't a cure-all, however, and they do have their limits. To begin with, every photographer shakes differently. Through extensive practice and controlled breathing, one photographer may be able to produce sharp handheld photos with relatively long exposure times, while another has to rely on mechanical stabilization for practically every exposure on account of his or her trembling. If a camera manufacturer were to claim that one of its stabilized lenses allows you to shoot freehand with exposure times that are two, three, or four times longer than you could without stabilization, I would neither believe the claim nor doubt it. But I would want to try it myself to test it out with different equipment, under different circumstances, and with different exposure times to know just when I could produce sharp images handheld.

With the development of high-resolution DSLRs, the old rules of thumb about the maximum advisable exposure time for shooting sharp images by hand – such as, "one over the focal length" – have turned out to be only partially applicable. The more megapixels that get crammed into a photo, the greater the requirements for sharpness. And that means that thinking of the reciprocal of the focal length as a personal limit isn't as practical as opting for a shorter exposure window.

Furthermore, the best anti-shake system won't help at all if the subject is moving. Motion blur is different from camera shake. In the former case, the photographer doesn't instigate an exposure's blur. When a subject is moving, its movement is the central feature of an exposure, and the only way to deal with it is by adjusting the shutter speed. If you use a fast shutter speed, you freeze the motion in place. A slower shutter speed allows the motion to blur, or you can pan along with the motion to capture the subject sharply in front of a swiped background.

It's also important to know that there are different ways of proceeding when you use a stabilized lens or a camera with stabilizer in

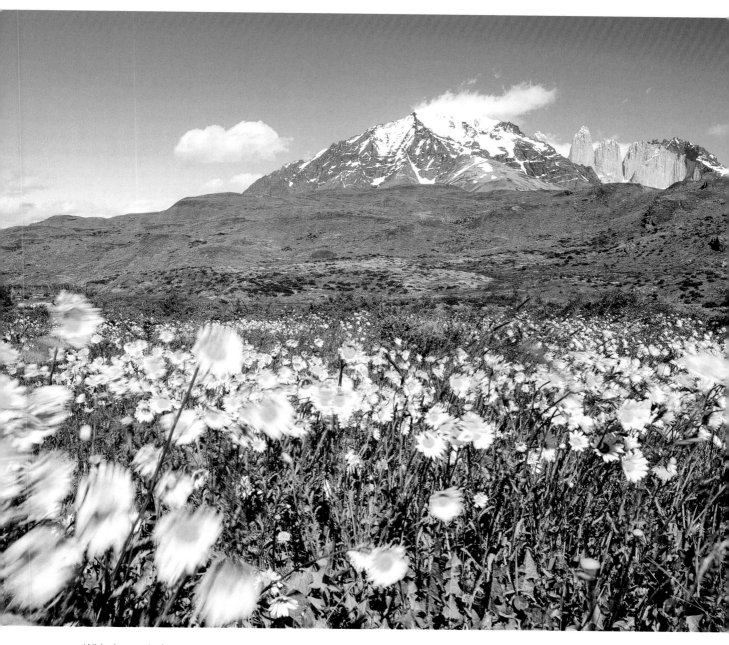

With these windswept marguerites in Torres del Paine National Park, Chile, even the sturdiest tripod would not have been of any help because the subject was moving. | Nikon D700 • 24 mm • 1/50 s • f/22 • ISO 200

combination with a tripod. Some models suggest that you disable the stabilization while others have a special tripod mode. You'll have to dip into the owner's manual to find out what to do for sure – ideally before you travel anywhere.

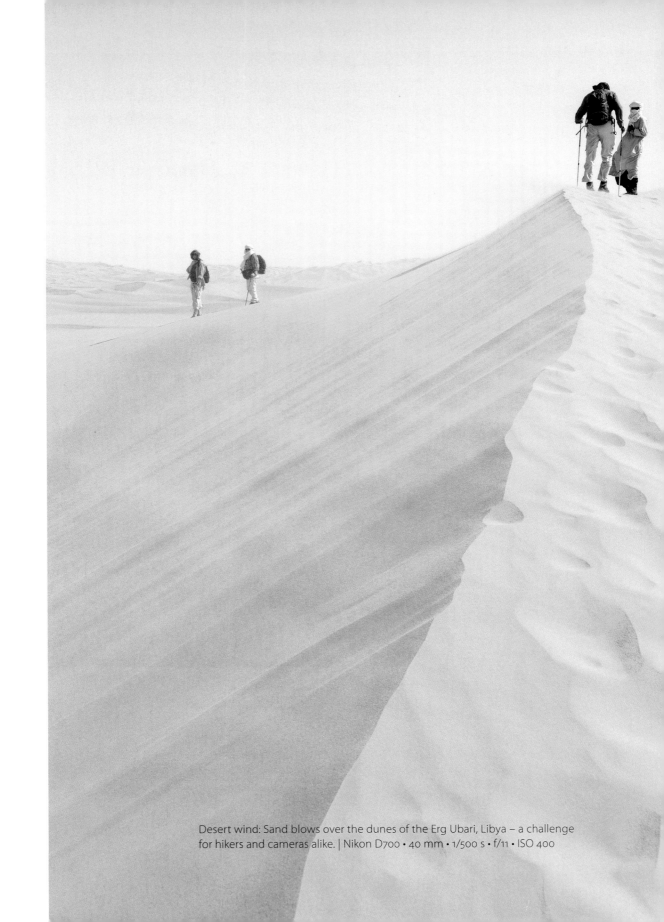

Desert wind: Sand blows over the dunes of the Erg Ubari, Libya – a challenge for hikers and cameras alike. | Nikon D700 • 40 mm • 1/500 s • f/11 • ISO 400

22 Better Safe Than Sorry

Transporting and Protecting Photographic Equipment

As little as possible, as much as necessary, and above all, what you really need: the same general rules that apply when selecting your photography equipment for traveling apply when transporting and protecting your gear. Choosing a photo case or backpack is just as personal a matter as deciding whether to store your camera away after each shot or carry it around in your hand. Asking around about the best rain shield (and if you even need one) will produce as many different responses as asking about a favorite lens. This chapter describes various possibilities based on my personal experience, so that you can have a slightly easier time deciding on a practical solution for your equipment and your travels.

Bag, Backpack, Holster, Hand

Anyone who wants to bring more than a compact camera quickly comes to appreciate the question of how to transport gear. Whether you decide on a photo backpack or a case depends on the amount of gear you're traveling with, the location to which you're traveling, and the kind of travels you do. It's also important to think about how often you need to quickly reach for a camera or a lens.

With this in mind, a shoulder bag, such as the classic reporter bag, can't be beat; and fortunately, they are available in designs that don't scream out, "I'm a photo bag!" They are practical for short urban trips with a limited amount of equipment, but if the bag becomes too heavy or large, it quickly loses its advantages. When purchasing a bag you should also make sure that all of your equipment fits comfortably, since while you're on the go, you often need to fit one or two other small items in it.

A backpack is often a more practical solution while traveling, if for no other reason than it divides the weight over both shoulders and can often accommodate additional objects such as a raincoat, water bottle, and travel guide. A photo backpack should combine a reasonably good level of comfort with an easily accessible and practical division of interior compartments for your camera and lenses, as well as additional space for all the other necessities. Larger backpacks should come equipped with a hip belt that provides stability and comfort in addition to transferring a significant amount of the weight. The overall padding as well as that for the individual compartments should be practical but not excessive; this isn't a bag that you're going to be throwing around carelessly.

It may seem that having countless individual compartments and exterior pockets would be desirable for storing accessories, but in reality, I've found that it's more convenient to have a few decent-sized compartments that

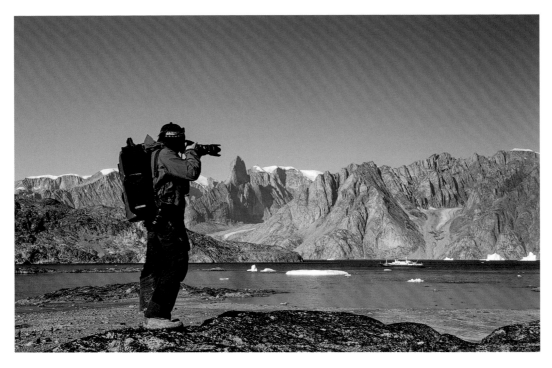

On a photo tour of Greenland: That's me with both cameras on hand and my 500 mm lens in a waterproof backpack. Photo by Michael Lohmann. | Canon EOS 1D Mk IV • 130 mm • 1/800 s • f/8 • ISO 250

can accommodate typical odds and ends such as batteries, memory cards, filters, cables, and power cords.

One of my favorite photo backpacks has three removable secondary compartments in addition to the main one; these smaller pockets can easily hold a 100 mm-wide standard graduated ND filter in its case.

If you're planning on taking a tripod with you and you don't want to hold it in your hands at all times, then a tripod holder will be of special interest to you. And if you'd like to use your photo bag as carry-on luggage while traveling by plane, you will want to factor in the airlines' size limitations when deciding what to purchase.

If you don't want to buy a backpack specifically designed for camera gear, then you can equip a standard hiking backpack with a camera insert. This is particularly practical if carrying comfort is critical – for example, if you're going on a long hiking trip. And the less a camera equipment bag looks like a camera equipment bag, the better off you are in terms of the risk of theft.

A holster case is yet another option that can be especially useful if you're traveling with a single DSLR and a general-use lens, a combination that is common for trekking or hiking tours. You can sling this type of bag over your shoulder or attach it to your belt or hiking bag and you'll have easy access to your camera,

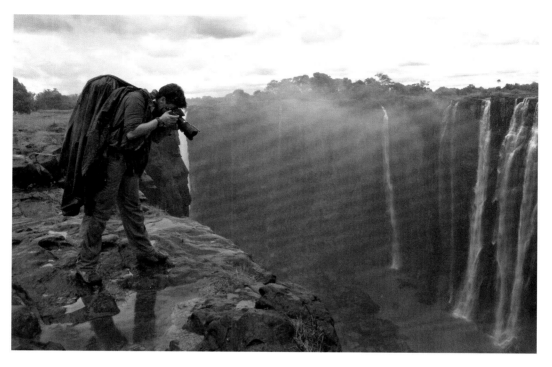

The backpack hides under the poncho while the camera has to rough it out in the spray of Victoria Falls, Zimbabwe. Photo by Jörg Ehrlich. | Canon PowerShot S80 • 28 mm • 1/1000 s • f/6.3 • ISO unrecorded

which still benefits from some protection. If you have more equipment, however, holster cases are less useful. With that said, you could store a camera with a wide-angle or standard lens in the holster and keep an additional telephoto zoom lens in your regular backpack, pulling it out as needed and then returning it for safekeeping. (Many holsters allow for a side-mounted lens case for just this purpose. If you are simply storing your lens in your general backpack, you don't necessarily need a special lens case. If you're adequately careful, wrapping your lens with a neoprene cloth will provide sufficient protection.)

By now I'm sure that there is no such thing as the perfect photo backpack that serves all purposes or the consummate photo case that is the right choice for every situation. Photographers have to settle for some sort of compromise; the main thing is to make sure it's not a bad compromise.

Eventually, the futile search for the perfect photo bag has led me to carry my camera in hand or wear it around my neck most of the time. If you tend to carry your camera on a strap over your shoulder, I recommend hanging it with the lens facing your body, which may seem odd at first glance but is more stable in my experience. It's also best to hold heavy telephoto lenses in your hand so that the lens mount isn't under an inordinate amount of stress.

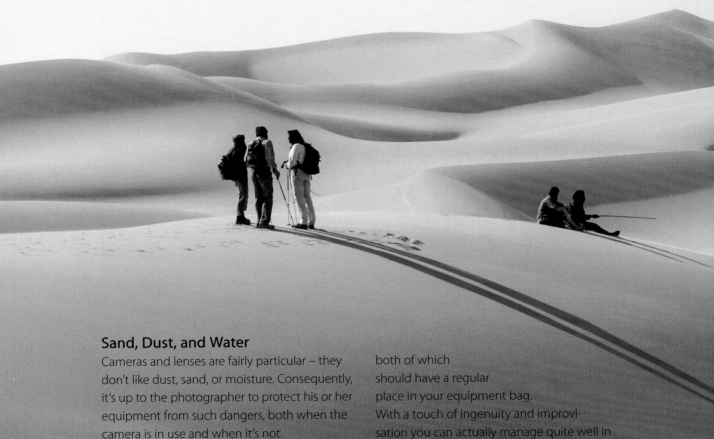

Sand, Dust, and Water

Cameras and lenses are fairly particular – they don't like dust, sand, or moisture. Consequently, it's up to the photographer to protect his or her equipment from such dangers, both when the camera is in use and when it's not.

When it comes to protection from water, a trusty umbrella is valuable when taking pictures; there are even tripod mounts that can hold it so you can work with your hands free. In strong wind, though, you'll need to come up with another solution. Rain shields made of transparent plastic material that cover your camera and lens barely hinder your ability to manipulate your camera. In a pinch, you can also do pretty well with a do-it-yourself solution using a plastic bag and some cable ties, both of which should have a regular place in your equipment bag.

With a touch of ingenuity and improvisation you can actually manage quite well in the rain. Even a neoprene lens cloth can serve as protection from the weather. Packets of silica gel help to absorb moisture in your photo bag; they can be dried out and reused. A few packets fit into even the smallest equipment bags.

A rain cover for your entire photo bag won't make it completely waterproof, but it's better than nothing. A large, robust garbage bag is also effective during a rain shower if you put it over your entire photo bag. In more challenging circumstances or continued torrential

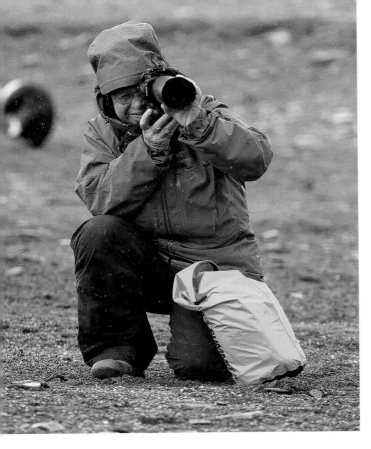

A practical solution for inclement weather such as here in South Georgia: After the shot, the camera went back into its waterproof dry bag. | Nikon D700 • 360 mm • 1/1000 s • f/7.1 • ISO 1600

rain, a robust, waterproof dry bag with a roll closure or a waterproof zipper is your best bet. These bags are pretty easy to use as long as you've chosen a model that's large enough – put your camera bag (or camera) in and then roll the top closed. Dry bags are relatively easy on your budget and fairly sturdy if you don't choose the ultra-lightweight versions.

When you really wish to pack your equipment in a waterproof or dustproof bag but also need to retain fairly easy access, you don't have many options. There are a few waterproof photo bags or expedition-grade plastic cases available. I've had good experiences with König Photobags, which use tough semi-truck tarps

as a base material and feature stable, padded, and adjustable compartments. Lowepro and Sagebrush Dry, a small manufacturer in Alaska that specializes in gear for water sports and fishing, also offer waterproof photo backpacks.

The question of whether to use an underwater case in severe weather conditions often comes up. Underwater housings for DSLRs are bulky, heavy, and expensive. They're really only designed for divers and snorkelers who can get the most out of such high-tech gear. The relatively affordable and easy-to-handle plastic housings for compact cameras, in contrast, prove worthwhile even in sandy environments. If you're considering taking your camera swimming or snorkeling or planning a desert trip, these are worth looking into.

If your equipment does get wet, dry it off as soon as possible. After carefully absorbing all of the moisture present on the outside of the camera and lens, leave some time for the interior elements to dry out. If your camera gets really wet (and perhaps even stops working), take the battery and memory card out, save your image files, and don't try to turn your camera back on immediately. Doing so can cause damage to the interior electronics if moisture has worked its way in that far. Give your gear some time to dry out, ideally over night, and then try to power it up again in a dry place. Cameras often recover surprisingly well after contact with rainwater, even if they give out at first.

Saltwater is a much more serious problem. If your camera's exterior gets splashed with saltwater, clean it as soon as possible to prevent the abrasive salt from settling. If your camera gets doused in saltwater, there is often

Only recommended with underwater housing rated for diving: This picture of a coral reef with Damselfish and a Purple Tang was shot at a depth of about five meters in the Red Sea, Egypt. | Canon Ixus 750 • 37 mm • 1/160 s • f/2.8 • ISO unrecorded • underwater housing

no way to save it, so take special precautions when shooting near saltwater.

Everything about water also goes for dust and sand. The particles find their way into the smallest openings and settle unmercifully on everything. To prevent this from causing damage, store your camera and lenses in a dust-proof or dust resistant case. You also need to protect your camera while it's in your hands. You might, for example, wrap a towel around it or fashion a "camera shield" out of a pillowcase.

In deserts, at the beach, or in any location where fine sand is prevalent, you should take care not to set your camera case or backpack on the ground, especially if it's windy. The wind blows strongest at ground level, and that's also where it carries the most sand particles. If you attempt to shoot on the ground (trying to get a low angle), you'll feel properly sand-blasted afterward.

It should go without saying that it's a good idea to perform some regular cleaning maintenance on your cameras and lenses with a bellows and a brush. Stubborn dirt on the front lens element can be treated with a LensPen, which is a type of fine eraser. You can use cotton swabs with a cleaning solution (a mixture of isopropyl and rubbing alcohols) to clean filters. I generally don't attempt to clean the sensor while traveling because it's difficult to find a

dust-free environment. The camera's automatic sensor cleaning process usually does the trick, even if I have to run it several times in a row.

When you hear scraping and crunching indicating that the dust and sand have settled, the only recourse is to conduct a thorough cleaning when you get home. I leave this up to professionals who disassemble and clean the camera and lens. This is not an inexpensive process, but it costs less than a new camera or lens.

Cameras and lenses aren't the only pieces of gear you'll want to protect; memory cards also appreciate some protection from the elements. My CF and SD cards are sorted and stored in a memory card case that can hold up to 10 cards in transparent compartments and can be folded for transport. This saves me from having to fiddle with dozens of cases, and I'm able to keep the full and empty cards separated.

Safe, Safer, Insured?

I don't believe that a photographer behaves any less carefully with his or her equipment as soon as it's insured; at least, that hasn't been the case for me. But knowing that damage to my cameras, lenses, and accessories won't send me into a financial disaster has made me a bit more relaxed while traveling. And I do believe that this sort of peace of mind benefits one's photography and creativity. Insuring your equipment helps to remove some of your worries without making you careless.

For someone like me who is frequently on the road in different parts of the world, it's prac-

tical to have photo insurance that covers misfortunes at home as well as abroad. If you don't require worldwide coverage, many policies allow you to limit their territorial scope.

It's also critically important to me that an insurance policy covers damages or accidents regardless of how they occur. Whether resulting from the carelessness of the photographer (e.g., you drop your equipment or leave it somewhere) or theft from a locked car or open tent, the insurance should have you covered without any ifs or buts.

Since each insurance company writes contracts differently and offers different types of coverage in its policies, it's important to read the fine print and compare coverage with regard to both price and the services offered. This isn't fun, but it's the only way to find out exactly what you're paying for. For example, you'll want to know who is considered liable if you check-in insured gear with an airline and it gets stolen while in the airline's possession. Since airlines offer only meager compensation for the loss or damage of baggage (unless you have upped the standard insurance rate with them), you may end up getting stuck with the bill if your insurance company doesn't cover this type of thing.

Whether you decide to insure all of your gear at a specific total value or insure each item individually will depend on a few factors. If you itemize your insured gear, you can easily include or exclude pieces as wanted (which affects your premium), but setting up and maintaining such a policy requires a bit more work.

Some insurance companies use the retail price of equipment as the sum insured. For

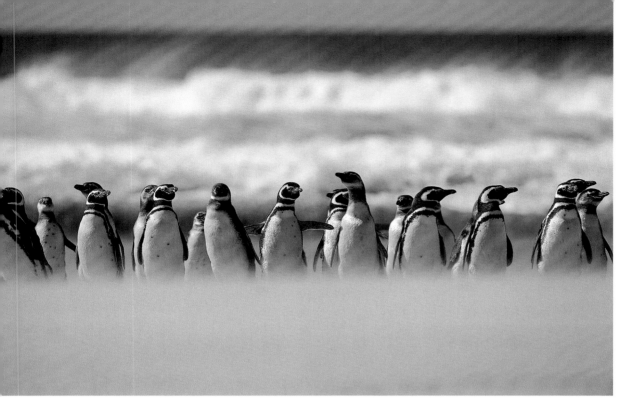

Sand-blasting for free: The blurred lines hiding the penguins' feet are caused by sand blowing about on the ground. I was lying in the middle of it. | Nikon D700 • 400 mm • 1/2500 s • f/5.6 • ISO 200

someone like me who often purchases (expensive) lenses secondhand, this isn't ideal because it can drive up the premiums. I have accordingly opted for a policy that allows me to set the sum insured for each individual piece of equipment depending on the purchase price or the value I attach to the item. The price for the item if I were to purchase it new is the upper limit.

STOP Worrying

One more thought on safeguarding your belongings: Cameras, lenses, tripods, filters – all of these things are replaceable, even if losing them is painful. There's no insurance for lost pictures, however. This is one more reason that data backup while traveling (and everywhere else) should be given special attention (see the following chapter "Safeguarding Data" on page 206).

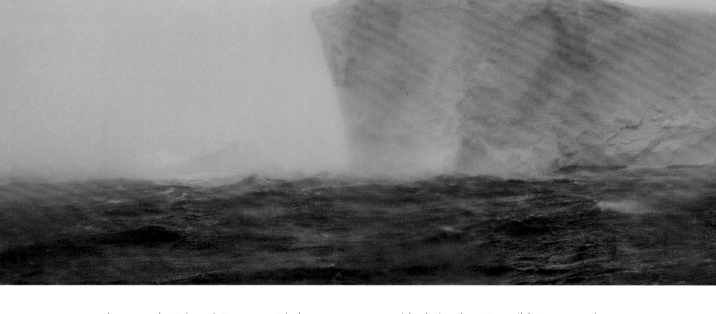

23 Safeguarding Data
Image Backup While Traveling

Anyone who takes pictures on a trip has a vested interest in bringing those photos home with them. The good news is that backing up data is neither terribly complicated nor exorbitantly expensive. The somewhat less good news is that backing up data requires a bit of discipline.

How you back up your images while traveling is one question. The much more important matter, however, is that you're backing up your images at all, and not just while traveling. As is the case with all types of security systems, the magic word is redundancy. In the realm of digital photography, this basically means that the security of your data increases with each existing copy.

It's obviously not possible to set up the same data security measures while on the road as you might have in place at home, but it's imperative to save at least one copy of your files while traveling. There are photographers who neglect to do this. Some find the process too inconvenient, others lack the necessary equipment, and others just don't see the importance of the matter. But the lesson learned when you don't back up your files can be a painful one, especially if it involves the loss of data.

As mentioned, one copy is a must, two copies is better, and three is better yet. At the same time, there's no need to go overboard, since backing up data on the go should be

Sailing the Southern Ocean: Iceberg and waves near South Georgia.
Nikon D700 • 34 mm • 1/800 s • f/10 • ISO 800

207

practical; otherwise, it will face the same fate as the bulky, heavy tripod: chronic neglect. This isn't of any use.

My own recipe for backing up files looks like this: I leave my images on the memory cards for as long as possible. Memory cards are a robust medium and unless I need to refill the card for lack of other memory, the photos stay saved there. This is one reason it makes sense to bring an ample supply of memory cards with you on the road.

I also copy the files to at least one, better yet two external 2.5-inch hard drives using a netbook and a USB card reader on a more or less daily basis. I take this opportunity to perform an initial sifting of the photos (more on that later). This allows me to spot any technical problems with a camera or lens that I didn't notice when I was taking the pictures. Whenever possible, I store the two copies in separate places; one hard drive gets stashed in my main bag, for example, and the other stays more or less permanently with me.

Since card readers can malfunction – for example, if the little pins in the CF card slot bend or break – you might consider bringing a second one along (ideally with its cable). As an alternative, digital cameras can usually be directly connected to a computer (via a cable, which obviously only works if you have it on you, or via a wireless connection). This method depletes your camera's battery, however, and the data transfer usually takes longer than with a card reader.

Try to develop a routine for your backup process to prevent mistakes and avoid redundant efforts as much as possible. You might, for example, always set the cards that have not

High noon: Light and shade pattern on the floor of Wadi Rum Visitor Center, Jordan.
Nikon D700 • 48 mm • 1/400 s • f/10 • ISO 640

been read to the left of your computer and the ones that have already been copied to the right. Or you might set one group with the top side facing up and the other group facing down. Or, or, or… the main thing is to not get confused, and to establish a reliable routine.

As far as hard drives go, I opt for tried and tested solid models that feature a rubber casing. This not only helps them survive the challenges of sand, dust, and moisture a bit better than their unarmored cousins, but it also prevents them from sliding off tables. Drives with a

capacity of 500 to 750 GB have served me well, even when I've backed up the photos taken by travel companions in addition to my own.

In the future, it's possible that compact solid state disks (SSDs) will develop into viable alternatives to traditional hard drives. Their biggest advantage is that they have no moving parts, which makes them mechanically more robust. As of now, however, portable SSDs are too expensive for average users, but it's probably only a matter of time before that changes.

USB flash drives are a possibility for smaller amounts of data. If you go this route, look for models with fast writing speed because otherwise data transfer with them can quickly turn into a real test of patience.

The centerpiece of a backup system should be a compact notebook or netbook computer, which allows you to not only save images, but also view, organize, edit, and send pictures when needed. Apart from that, of course, it's useful for many other tasks as well. I use an Apple Macbook Air, specifically the smallest model available (for space and weight reasons) with the maximum RAM (for speed reasons).

The process that I've described up until now only makes sense when you have regular access to electricity. When you're visiting locations where that's not the case, such as the Sahara, for example, portable photo storage devices with integrated card readers are a good option. Ideally these devices operate with standard, readily available batteries, and with a single click they copy your data onto their internal hard drive. Unfortunately, these devices appear to have fallen out of fashion. There are only a few models available on the market and they usually have proprietary batteries, which dramatically limits their usefulness.

I don't think much of saving images onto CDs or DVDs, mostly because of their limited capacities and the relatively time-consuming

Modern photography nomad: Your author in action in Patagonia. An inverter provides power to my netbook and external hard disk in our rental car. Photo by Ingrid Petrowitz. | Fuji S5Pro • 24 mm • 1/100 s • f/4 • ISO 320 • built-in flash

Discovered too late: The white area in the upper left corner was caused by a gray filter that wasn't properly attached. | Leica D-LUX 6 • 90 mm • 1/1600 s • f/2.8 • ISO 160

process of writing data to them. The same goes for uploading image files to the Internet to be stored on servers or in the cloud. This may be an alternative for travel photographers visiting cities where hotels or public places offer fast Internet connections via wireless networks, but in most parts of the world the connections, if they exist at all, are much too slow for transferring large image files in any practical amount of time.

If you're traveling in a car, you can use a cigarette lighter adapter, also known as an inverter, as a power supply for your notebook, hard disk, battery charger, and cell phone. For trips that require total self-sufficiency, such as a desert trek, an adequately large solar panel with a portable power outlet could be the solution of the future. The technology for this is here, but I've yet to give it a try.

Whether you view or even edit your images while on your trip depends on the amount of time you have and the technology available, as well as your personal preferences. I know photographers who refuse to examine any of their photos while on the road, and others who simply can't imagine not looking over the day's yield every evening. Some guided photo tours even include an evening photo review as part of their program.

When I transfer my photos to the external hard disk, I use the opportunity to perform a quick, initial analysis with Adobe Photoshop

Lightroom. I immediately delete any photos from my digital library that are out of focus or have bad exposure problems – that's assuming I didn't already do this in-camera immediately after taking the picture. I flag the photos that appear to have been particularly successful so that I can quickly find them again later. This helps to limit the number of photos that I will eventually consider editing to a reasonable quantity.

If the need arises, I might spend some time editing a photo at this stage, but this is far from being fun on the Air's 11-inch monitor. The only images I decide to edit are those that I need right away. For example, I might want to give a photo to someone I've met or prepare a photo

for an image analysis discussion that's part of a guided photo tour. Anything more than this is usually not needed and I'd rather be taking pictures than spending valuable travel time in front of my computer.

Even if you don't plan on editing your images at all while traveling, there's value in inspecting them at the very least. This will help you detect technical problems that may not have been visible when checking the photo on the camera's small display.

You might discover a stubborn spot of dust on the sensor, which you would want to remove if possible, or a strange blur that occurs for manually focused shots, which after some investigation turns out to be from an acciden-

tally activated diopter correction in the view-finder. Or you could find that your built-in gray filter got snagged and subsequently affected the light entering your compact camera since it wasn't on or off all the way, which is what ruined the photo of flotsam off the Falkland Islands (page 209). I didn't spot the problem on the camera monitor because of the bright sunlight at the time. After reviewing the file on my computer, however, I took extra care to make sure that the filter was attached or detached properly.

Examining your photos also provides an opportunity for learning. If particular camera settings didn't pan out well or a photo was flawed for whatever reason, you may be able to repeat your effort on the spot. And even if you can't, the settings for the failed image will reveal to you how to make adjustments to get better results next time.

Opposite: Eerily beautiful – the morning fog in Ittoqqortoormiit, eastern Greenland, suits the subject of gravestones in a local cemetery perfectly. | Nikon D700 • 24 mm • 1/800 s • f/14 • ISO 200

Bottom: Drive no further – lava road block at the end of the Chain of Craters Road, Hawaii Volcanoes National Park, USA. | Nikon D700 • 20 mm • 1/400 s • f/11 • ISO 400

24 There Is Life Without a Camera
Why You Shouldn't Take Pictures If You Don't Feel Like It

There will be days when the camera just doesn't feel right in your hands, neither your inspiration nor your desire to take pictures has shown up, and the light everywhere is woeful. I know from personal experience that taking pictures on days like this isn't any fun, and your images tend to show it.

Professional and semi-pro photographers who are on assignment have to be able to produce quality images even during those phases regardless of how they feel. For everyone else, though, there's no reason to have a heavy conscience for taking a day or two off, especially if you're on vacation. These down times can actually end up being productive: perhaps you'll think of an idea for a new picture, or discover a location rich with possibilities for photos, or simply feel unburdened and relaxed without a camera dangling around your neck.

When you turn your attention and concentration away from photography for a bit, your other senses benefit, and you can take in your surroundings more fully – or for the first time at all – than when you're focused so intently on visual perception. At least that's how it works for me. It's not unusual for me to feel uninspired with my photography during the first couple days of a trip. When traveling, adjusting to new surroundings and dealing with new requirements and challenges takes its toll, and inspiration may give me a wide berth on the first few days. With time, I've come to discover that trying to resist this lack of motivation is futile. Embracing a certain serenity is much more useful in regaining my enthusiasm for photography.

Even though this sentiment may seem out of place at the end of a book about photography, there is life without a camera. A day without taking any pictures is not a lost day, so don't beat yourself up about it. Indulge in it as much as you endulge in photography. The joy of using your camera will come back on its own. Just give it, and yourself, some time.

25 Further Reading

Read on: Anyone whose appetite was not satisfied by the previous pages can find additional useful photography references in the following list. The order of the books is based on nothing other than the alphabet.

This list contains titles I've found to be enriching, and I gladly recommend them to others. The breadth of the books mentioned here goes way beyond travel photography, covering other photographic disciplines, photography fundamentals, and matters of perception.

[1] Bruce Barnbaum. *The Art of Photography: An Approach to Personal Expression.*
Santa Barbara: Rocky Nook, 2010.
A revised and expanded new edition of a classic, first published in 1994, which is often, and justly, referred to as one of the most readable and comprehensive photography books out there.

[2] Alexandre Buisse. *Remote Exposure: A Guide to Hiking and Climbing Photography.*
Santa Barbara: Rocky Nook, 2011.

Icon in black and white: Giant Panda in Chengdu, China.
Nikon D300 • 300 mm • 1/200 s • f/5.6 • ISO 1600

A book for those who combine hiking and climbing with photography (or those who want to). It covers how to select the appropriate gear for a mountaineering trip and how to use it to get the pictures you want.

[3] Joe Cornish, Charlie Waite, and David Ward. *Developing Vision & Style: A Landscape Photography Masterclass.*
London: Aurum Press, 2007.
"We bear witness to what we have seen. What we choose to photograph, and how we photograph it says what we think, feel and believe about the subject, about the world and about ourselves. Our photography is the world made visible through the lens of our soul." – Joe Cornish

[4] David duChemin. *Within the Frame: The Journey of Photographic Vision.*
San Francisco: New Riders, 2009.
David duChemin takes up the question of how to captivate viewers by creating images that are more than simple direct representations. In addition to countless fascinating pictures from all around the world, this book delves into the why of photography just as much as the how. Unconditionally recommended!

[5] David duChemin. *The Print and the Process: Taking Compelling Photographs from Vision to Expression.*
San Francisco: New Riders, 2013.
An illustrated book that explains the how and the why behind a collection of images. David duChemin includes photos from four different parts of the world (Venice, Kenya, Iceland, and Antarctica), describes the process that produced the images, and shares his intentions when finalizing them. These explanations contain a glut of practical tips as well as thoughts about whether a photo works better in color or black-and-white.

[6] Michael Freeman. *Perfect Exposure: The Professional Guide to Capturing Perfect Digital Photographs.*
Burlington and Oxford: Focal Press, 2009.
Michael Freeman. *The Photographer's Eye: Composition and Design for Better Digital Photos.*
Burlington and Oxford: Focal Press, 2007.
Michael Freeman. *The Photographer's Mind: Creative Thinking for Better Digital Photos.*
Burlington and Oxford: Focal Press, 2010.
Michael Freeman specializes in travel photography, among other areas. His three volumes deliver comprehensive and versatile information about image composition and design. They also include countless annotated example pictures from around the world.

[7] Philippe L. Gross and S. I. Shapiro. *The Tao of Photography: Seeing beyond Seeing.*
Ten Speed Press 2001.
Surprising insights included! An exciting application of Taoist principles, for everyone interested in taking up the philosophical dimensions of photography.

[8] Uwe Steinmueller and Juergen Gulbins.
*The Digital Photography Workflow Handbook:
From Import to Output.*
Santa Barbara: Rocky Nook 2010.
The photo workflow reference – a comprehensive and approachable handbook covering digital image editing with numerous examples. I used the first edition (whose German title at the time was *Die digitale Dunkelkammer*) to learn how to edit RAW files. Today, I'm still impressed by the immense practical value of this book.

[9] Fil Hunter, Steven Biver, and Paul Fuqua.
*Light: Science and Magic: An Introduction to
Photographic Lighting.*
Burlington and Oxford: Focal Press, 2011.
Enlightenment through reading: The reading is somewhat dry in spots, but there is a good reason it has become a definitive work on the subject of light in photography. Large parts of the book are devoted to lighting in studios, but knowing the basics of light and shadow can only be a plus for travel photographers.

[10] Chris Orwig. *People Pictures: 30 Exercises for
Creating Authentic Photographs.*
San Francisco: Peachpit Press, 2011.
Ideas, considerations, and tips for anyone who ever takes pictures of people. The instructions and exercises in this book also apply to taking portraits on the road.

[11] Andy Rouse. *Wildlife Travel Photography:
A Guide to Taking Better Pictures.*
Lonely Planet, 2006.
Nature and wildlife photographer Andy Rouse gives tips on how to take better pictures of animals in this handy paperback designed for travel. The content covers everything from technical aspects to image design, from equipment to process. It's very readable and has lots of example pictures with relevant information.

[12] Galen Rowell. *Galen Rowell's Inner Game of
Outdoor Photography.*
New York: W. W. Norton & Company, 2010.
This is a great book for anyone who likes to take his or her camera outdoors. An exciting, inspiring collection of essays from a brilliant outdoor photographer, Galen Rowell, who unfortunately died much too early. The variety of the articles originally published in *Outdoor Photographer* magazine is as remarkable as the quality of Galen Rowell's images, which have not lost any of their esthetics and fascination.

[13] Steve Simon. *The Passionate Photographer:
Ten Steps Towards Becoming Great.*
San Francisco: New Riders, 2011.
Comprising 30 years worth of experience and personal tips as well as a slew of pictures from photojournalistic and personal projects. Steve Simon spells out ten essential steps for photographers, which are designed to close the gap between your claim as a photographer and your actual pictures.

Opposite page: Experimenting with shape, color, and raindrops from inside a car, Chile.
Leica D-LUX 6 • 50 mm • 1/250 s • f/2.8 • ISO 160

Further Reading

Thanks

The author traveling on a photo tour in Greenland.
Photo by Michael Lohmann.
Canon EOS 1D Mk IV • 550 mm • 1/640 s • f/8 • ISO 800

It's time to say thank you. Even though there's only one name on the title page, many people played a role in creating this book. Heartfelt thanks to all of you.

I owe Jürgen Gulbins a special thank you for getting this project started and for attending to the entire process. He insisted on helping out in many ways, and difficult moments never shook his confidence in the book (or its completion).

I'd like to thank everyone who not only shared and put up with my wanderlust and my photographic curiosity – including all side effects – but also encouraged and supported it and continue to do so today. Here's hoping for a future rich with wonderful travel adventures and at least a handful of good photos to show for it.

Sandra Petrowitz

Index

A

add depth 53
alternative standpoints 17
ambient lighting 122
anticipate opportunities for
 photos 15
aspect ratio 30
autofocus 168
automatic ISO function 166

B

background 40, 51, 57, 58, 66
 blown out 135
 blurred 110
 dark 76
 distracting 40
 homogenous 110
 how to minimize distracting
 elements 40
 monochrome 26
 overexposed 112
background information 107
backpack 197, 199
bad weather 133
ball head 189
bean bag 192
best light 118
bird's eye view 70

C

camera
 autofocus 168
 automatic ISO function 166

compact cameras 179
equipment 174
exposure metering 167
exposure modes 163
holster 197
image stabilizer 194
ISO speed 166
lens 174
matrix metering 167
mirrorless system camera
 174
modes, metering, focus 161
multi-zone metering 167
shake 148
shutter speed 164
spot metering 167
teleconverter 180
zoom lens 176
central positioning 36
colors 51
colors and shapes 95
commonplace photos 16
composition 30
 central positioning 36
 depth of field 153
 distracting elements 149
 foreground 84
 horizon line 64
 landscape vs. portrait
 format 84
 more variety 153
 off-center 30, 35
 perspective 68

position the main subject 32
reflections 157
rule of thirds 31
rules of design 30
sense of scale 53
shadows 156
splash of color 37, 53
symmetric composition 36
contrast 120, 149
 between sky and landscape
 134
 brightness 108
 color 26, 133
 high-contrast lighting 110, 123
 problem 76
 reduce contrast 76
 reduce contrast with fill
 flash 112
create tension 38
creative ideas 159

D

depth
 add depth 58
depth of field 153
diagonal 58
direction of movement 43
direction of the subject's eyes
 38
distracting background 40
documentary images 142
dust 200
dynamic effect 58

E

early morning light 21
emotional reactions 102
equipment 13, 174
 backpack 197
 ball head 189
 bean bag 192
 insurance 204
 monopod 192
 protecting equipment 197
 quick-release system 191
 tripod 186
 waterproof dry bag 202
exposure metering 167
exposure modes 163
eye level 68, 71

F

file format
 JPEG 170
 RAW 170
 TIFF 170
fill flash 76, 110, 112
 iTTL/eTTL 114
filter 182
flash 64, 88, 110
 built-in flash 88
 fill flash 76, 112
focusing 20
 mental focusing 20
focus of an image
 shapes, colors, textures 51
fog 120, 122, 133, 136, 168, 211
foreground 48, 51, 57, 58, 72,
 76, 114
 colors 110
 composition 84
 to background relation 51

 unattractive foreground 153
format
 landscape format 84, 90
 portrait format 84

G

graduated ND filter 198

H

holster 197, 198
horizon line 40, 41, 64, 134

I

illustrative photo 108
image
 composition 30
 stabilizer 194
isolate subject from a
 background 105
ISO speed 166
iTTL/eTTL 114

J

JPEG 170

K

know your camera 161

L

landscape format 84, 90
laugh lines 107
lens 174, 175
 filter 182
 graduated ND filter 198
 image stabilizer 194
 macro lens 183
 neutral density (ND) filter 182
 polarizer 180

 prime lens 154
 speed 178
 teleconverter 180
 zoom 176
LensPen 203
light
 additional 15
 ambient 122
 best 118
 early morning 118, 120, 130
 late evening 120
 midday 123
 painting with light 118
 reflected off colored
 surfaces 126
 special light 26
 sunrise 118
 sunset 118
line of sight 40, 43

M

matrix metering 167
mental focusing 20
midday light 123
minimalism 92
mirrorless system cameras 174
monopod 192
multi-zone metering 167

N

netbook 207, 208
neutral density (ND) filter 182
night photography 23

O

off-center 30, 35
organized photo tours 10

P

painting with light 118
pan head 189
panorama 84, 190
pattern of lines 26
people photography 100
 get to know the person 104
 use a local guide 104
perception 20
perspective 68
 bird's eye view 70
 surprising perspectives 17
photobag 202
photographic opportunities 11
point of view 16
polarization filter (polarizer) 180,
 182
portrait 38, 103, 110
 of animals 40
 portrait format 86
position the main subject 32
postcard view 18, 26
prime lens 154

Q

quick-release system 191

R

rain 133, 134, 136
rainbow 141
raindrops 136
RAW 170
reflection 36, 65, 66, 67, 76, 120,
 137, 157
 in your subject's eyes 110,
 113
relative proportions 79
rule of thirds 31

S

safeguarding data 206
sense of scale 53
serendipity 15
series of images 154
shadows 156, 159
shapes 51, 95, 98
sharpness throughout the
 frame 57
shutter speed 163, 164, 165, 172
snapshot 8
snow 133, 136
snowfall 137
space in the line of sight 40
special light 26
splash of color 37, 53
spot metering 167
storms 133
storytelling 83
sunrise 11, 118, 120, 121, 123, 193
sunset 59, 118, 120, 157
symmetrical composition 36

T

teleconverter 180
textures 51
three-dimensionality 48
TIFF 170
traveling 8
traveling and photography 8
traveling to photograph 10
tripod 186
 ball head 189
 level 64
 pan head 189
 quick-release system 191
 travel tripod 190

U

underwater housing 202
unusual viewpoint 20

V

viewing direction 42
visual clues 48
visual space 38

W

waterfall 26, 28, 83, 193
waterproof dry bag 202
weather (bad weather) 133

Z

zoom lens 176

Get in the Picture!

c't Digital Photography gives you exclusive access to the techniques of the pros.

Keep on top of the latest trends and get your own regular dose of inside knowledge from our specialist authors. Every issue includes tips and tricks from experienced pro photographers as well as independent hardware and software tests. There are also regular high-end image processing and image management workshops to help you create your own perfect portfolio.

Each issue includes a free DVD with full and c't special version software, practical photo tools, eBooks, and comprehensive video tutorials.

Don't miss out – place your order now!